Contesting Human Remains in Museum Collections

Routledge Studies in Museum Studies

1. Contesting Human Remains in Museum Collections
The Crisis of Cultural Authority
Tiffany Jenkins

Contesting Human Remains in Museum Collections

The Crisis of Cultural Authority

Tiffany Jenkins

Routledge
Taylor & Francis Group
New York London

First published 2011
by Routledge
711 Third Avenue, New York, NY 10017

Simultaneously published in the UK
by Routledge
2 Park Square, Milton Park, Abingdon, Oxfordshire OX14 4RN

First issued in paperback 2014

Routledge is an imprint of the Taylor & Francis Group, an informa business

Typeset in Sabon by IBT Global.

Library of Congress Cataloging-in-Publication Data
Jenkins, Tiffany.
 Contesting human remains in museum collections : the crisis of cultural authority / Tiffany Jenkins.
 p. cm. — (Routledge research in museum studies ; 1)
 "Simultaneously published in the UK" — T.p. verso.
 Includes bibliographical references and index.
 1. Human remains (Archaeology) 2. Human remains
(Archaeology) — Repatriation. 3. Museums — Collection management —
Political aspects. 4. Museums — Collection management — Moral and
ethical aspects. 5. Indigenous peoples — Antiquities — Collection and
preservation. 6. Cultural property — Political aspects. 7. Cultural property — Moral
and ethical aspects. 8. Cultural property — Repatriation. I. Title.
 CC79.5.H85J46 2011
 344'.093 — dc22
 2010015943

ISBN 978-0-415-87960-6 (hbk)
ISBN 978-1-138-80119-6 (pbk)
ISBN 978-0-203-84131-0 (ebk)

Contents

Abbreviations

AIAD American Indians against Desecration

BBC British Broadcasting Corporation

DCMS Department for Culture Media and Sport

HAD Honouring the Ancient Dead

MA Museums Association

TAC Tasmanian Aboriginal Centre

WGHR Working Group on Human Remains

HRWGR Human Remains Working Group Report

Acknowledgments

There are many people without whom this book would not be possible. I want to begin by thanking Claire Fox who encouraged me to research a PhD on this subject. I am grateful to Frank Furedi, my supervisor, who was unstinting in his support. Fellow researcher Sheila Harper kept me going, especially when I was weary. I owe a debt of knowledge to Tony Walter and others I met through the Centre for Death and Society at Bath University, including Duncan Sayer and John Troyer, whose interest in archaeology, dead bodies and death is always stimulating. The Bones Collective at the University of Edinburgh, especially Joost Fontein, John Harries and Howard Williams, helped clarify my thoughts about the significance of human bones. Special thanks go to Tatiana Flessas, and members of the Working Group on Cultural Property and Heritage Law at the London School of Economics. Tatiana never failed to respond constructively to my thoughts on conflicts over heritage. Richard Williams at Edinburgh University and Stacy Boldrick from the Fruitmarket Gallery, organized helpful seminars and presentations on museums and museology, as well as skeletons, where I was given the opportunity to test out my ideas. Sparky students along the way have provoked many interesting discussions in response to much of my thinking and often forced me to reconsider my approach. I am especially thankful to all the interviewees who took considerable time out of their busy schedules to talk to me and answer all my questions. Bruno Waterfield advised me well, in the early and later stages of this project, providing encouraging and helpful advice. Jennie Bristow gave invaluable editorial assistance.

Finally, I wish to thank my close friends, family, and my partner Iain Macwhirter, all of whom were unwaveringly supportive.

Introduction

In 1994, members of the political campaign group called the Tasmanian Aboriginal Centre (TAC) wrote to the British Museum in London, to request the return of two animal skin bags containing human ash. The cremation bundles are thought to have been acquired in Australia in 1828 by George Augustus Robinson, Chief Protector of Aborigines, and to have arrived in the collection of the British Museum via the Royal College of Surgeons in 1882 (BM 2006a). Robert Anderson, director of the museum, refused the request, explaining that it was neither legally possible nor desirable, as the institution was dedicated to preserving the cultural heritage of mankind:

> [O]ur collections are held under Act of Parliament which does not permit us to de-accession them: nor would we want to do so, because we are an international museum and resource devoted to preserving mankind's cultural heritage. (Anderson, cited in TAC 2001: § 36)

In ten years this position was reversed. After vigorous campaigns, the law referred to as a barrier by Anderson was relaxed to permit specific museums to remove human remains. Members of the museum sector came to advocate the repatriation of the bundles, to make reparations for British colonization and improve the lives of contemporary Aboriginal communities. British Museum trustee and prominent barrister, Helena Kennedy, fronted the decision to send the cremation bundles to the TAC. Writing in the *Guardian* newspaper, Kennedy explained that whilst the decision was difficult due to the potential loss of knowledge for researchers, the distress caused to descendants from the colonial period meant that the return of the cremation bundles was the right decision (Kennedy, H. 2006).

In early 2000, Neil Chalmers, director of the Natural History Museum in London, also opposed repatriation and refused requests from overseas indigenous groups for human remains from the collection. Chalmers argued that these were valuable for scientific research and that it was the duty of the museum to hold them for this purpose. Giving testimony to the House

of Commons Culture, Media and Sport Select Committee on cultural property issues, he explained that the institution has:

> [A] duty to the nation to retain those objects and we have a duty to the scientific international community to use them as a very valuable scientific resource. We would find it extremely difficult to return any such objects if there was any doubt at all about their continued safety and accessibility. (Culture, Media and Sport Select Committee 2000: § 162)

Six years later, this position also changed. In 2006, after firmly rejecting requests for human remains, the Natural History Museum trustees transferred the skeletons of 17 Tasmanian Aboriginals out of the collection to the TAC. The human remains were the focus of claims by Aboriginal groups, who consider them to be ancestors. However, these same skeletons are also regarded as unique research objects. Scientists study human remains to chart human origins, population diversity and distribution as well as the past environments in which people lived. These specific remains are of people from a time when Tasmania was isolated from the rest of the world and genetically different from other human populations, including those in mainland Australia. The differences identified through their study can tell us more about how people reached the island, how they lived and how those people were linked with other human groups.

The decisions to repatriate the cremation bundles and the skeletons are significant. Museums in Britain do not usually de-accession artefacts or human remains. There are legal barriers to, and a general presumption against, doing this. The British Museum Act of 1963, the Act of Parliament cited by Robert Anderson, legislated that the power of museum trustees to remove material from collections is limited to exceptional circumstances. The principle against de-accessioning is influenced by the foundational purpose of the museum as an institution. Formed in Britain in overlapping stages in the eighteenth and nineteenth centuries, the role of the museum is to further the pursuit and dissemination of knowledge. One core commitment was to protect material in perpetuity from political and financial pressure, for the purposes of research, dissemination and education. The recent decisions to transfer human remains out of institutions therefore raise some major questions. How has the transfer of remains been achieved when these items were considered to hold high research value, when museums have been limited in removing material, and when senior actors contested the requests; indeed in these two cases the directors of two prestigious national museums?

The use of human remains as research objects and for educational purposes in museums is common practice. Museums have held, researched and displayed human remains since the eighteenth century, for reasons that are historically constituted. Before the nineteenth century, the collecting of

human remains was eclectic. They were exhibited as curiosities obtained by explorers, colonial officers and traders. Throughout the nineteenth century, greater numbers of human remains were collected by scientists on collecting expeditions, or from the British colonies, motivated, in part, by a desire to preserve material from what were considered to be vanishing races (Henare 2005; Greenfield 2007). The specimens in museums were categorized and presented as part of scientific, ethnographic, archaeological or medical classification systems, through a shift in the remit of the museum. With the Enlightenment the museum developed into a rational authoritative space. This, together with the emergence of the scientific view of the body, permitted human remains to be treated as a research object.

Human remains held in British museums today are diverse in kind and purpose. A scoping survey (DCMS 2003a) showed that of the 148 English institutions surveyed, 132 held human remains. Overall, these numbered approximately 61,000; although the number varies widely from institution to institution. The Natural History Museum in London holds the greatest in number: a research collection of 19,950 specimens, ranging from a complete skeleton to a single finger bone, which represent the global human population and a timescale of 500,000 years. The majority of other institutions mostly hold small collections: 64 have fewer than 50 items. Of the 61,000 human remains in British collections roughly 15,000 are from overseas; the remainder are from the British Isles. Of the institutions surveyed, 35 stored most of their collections, whereas 89 had most or all on display. Of the historic human remains from the period 1500–1945, the most common on display are organized and exhibited in contexts that include archaeology, anthropology, anatomy and pathology, and Egyptology, which overlap but have distinct approaches. They include excavated burials and cremations, as well as shrunken heads and objects such as drinking vessels made from skulls.

Despite their common use, since the late 1970s human remains in collections have become subject to a growing number of claims and controversies in different countries. Requests from indigenous movements for the transfer of human remains and funerary artefacts considered culturally affiliated or associated developed in North America, Australia, Canada and New Zealand. Many, often physical anthropologists and scientists who research the material professionally, forcefully opposed the requests for the human remains, because they and their context are important and at times unique evidence of the past. Despite opposition from scientific quarters, however, from the late 1980s codes, policy and laws were passed, advising a sympathetic response to claims. In the case of the National Museum of the American Indian Act (NMAIA) in 1989 and the Native American Graves Repatriation Act (NAGPRA) of 1990 in the United States, legislation compelled the inventory of human remains and associated material from all federally funded institutions and the transfer to lineal descendants and culturally affiliated groups.

The contestation over human remains in Britain has been different in a number of respects to that which took place in other countries. Firstly, there was significantly weaker external pressure on institutions compared to Australasia, America and Canada, which responded to claims from their own indigenous groups. Therefore the first question addressed in *Contesting Human Remains in Museum Collections* is how comparatively limited pressure from overseas groups came to have a profound impact, which succeeded in changing English law, defeating members of the museum sector who strongly opposed these requests, and achieving the removal of valued research material. Secondly, while elsewhere the focus of attention has primarily been on the human remains of groups indigenous to the country, the problem in Britain has an expansionary quality. For a start, contemporary campaigns about human remains in museums in Britain are not confined to requests from the descendants of overseas groups that suffered as a consequence of colonialism. A number of Pagans have requested that human remains be treated with particular care. Emma Restall Orr, a Druid, in 2004 formed the advocacy group Honouring the Ancient Dead, to voice concern about the treatment of pre-Christian remains and to campaign for reburial, ritual and respect. There has been a moderate recognition in the heritage sector of some of these claims, and, in limited cases, a positive endorsement. This is of interest because, unlike indigenous groups from overseas, Pagans are often considered by wider society to be an illegitimate group and their involvement in decisions about human remains cannot be explained as a result of a desire to make reparations for historical wrongs.

Additionally, human remains of all ages, and which are not the subject of claims-making by any community group, have become subject to concerns about their handling, display and storage, expressed by certain members of the museum profession. Clearly some items are far more problematic to hold in museums than others, due to their historical associations, and I will go on to explore these differences. Nonetheless, despite important variations, there are some professionals who currently promote the claim that all human remains should be subject to special attention and new care. A number of policies have been published to deal specifically with human remains, an issue previously ignored by such codes. For example, policy now advises that any display of human remains should be accompanied with warning signs (SM 2001; DCMS 2005; B&H 2006; Bolton 2007; UCL 2007). In May 2008, three unwrapped Egyptian mummies on display at Manchester University Museum were covered with cloth in the name of respect. Bristol Museum now keeps its unwrapped mummies in storage after a major re-display (Kennedy, M. 2008).

The seemingly disparate acts and decisions over human remains in recent years are united around the idea that all remains, regardless of affiliation, claim or age, require attention that museum professionals did not previously afford to them. Whilst a number of different actions and reasons are ascribed to the notion of 'respect', all converge on the new concept that

the holding of human remains requires specific and special care by the sector. The different concerns and activities pertaining to unclaimed human remains of all ages raises the following questions: why has this material, historically held in museums and considered the object of research, become the subject of advocacy work by members of the profession? What is driving claims that human remains require new care in British collections? How has the rest of the sector responded, particularly those who value them as research objects? In short, how did the issue of human remains in the museum, an institution that has historically held and researched human remains, become such a prominent concern in the present?

The scholarly literature on disputes over human remains and cultural property tends to focus on contestation in America, Australia, Canada and New Zealand. In the main, the analysis focuses on the influence of indigenous movements in these countries (see for instance, Jones 2000; Phillips and Johnson 2003; Hole 2007). John Cove's (1995) study of this issue in Australia examines the influences on the problem. Cove charts the rising Aboriginal rights movement's shifting demands from land rights, to cultural heritage, and then to skeletal remains, in relation to the changing values of science. Jeanette Greenfield's *The Return of Cultural Treasures* (2007) is an extensive account of a number of different cases, legal decisions, and 'returns' and 'non returns' such as the Parthenon Marbles. Her work focuses on the transfer of objects considered special to national history or culture. Greenfield analyzes the claims for return as the assertion of national identity, and suggests that the transfer of cultural treasures to their country of origin contributes to refurbishing national identity by nationalizing symbolic capital. Whilst she does not examine the influences on this particular problem, Greenfield appears to assume that cumulative external pressure from community groups or government has brought moderate results. In a similar vein, the edited collection by cultural theorists Barkan and Bush, *Claiming the Stones, Naming the Bones: cultural property and the negotiation of national and ethnic identity* (2002), interprets contestation over cultural property, in which they include human remains, as negotiating ambiguous and shifting conceptions of identity. The objects and claims for objects function to anchor fluid or difficult identities.

For these theorists, the drivers of this issue are indigenous groups who claim human remains, because they hold socially influenced and politicized meanings pertaining to identity—claims that are interpreted as being resisted by museum professionals. These important observations, however, have limitations when applied to the British context. In Britain, where the claims-making activity from overseas indigenous groups is comparatively weaker, it is not adequate to interpret significant shifts in English law and British museums policies as primarily due to external claims from overseas groups that seek to reclaim identity. Furthermore, the analysis does not address why *all* human remains have become the focus for campaigning

activities, and cannot account for the extension of the problem to unclaimed human remains.

Contesting Human Remains in Museum Collections analyzes the influences at play on the contestation over human remains, and examines the construction of this problem. I demonstrate that one of the most significant aspects contributing to the problem in Britain is that the strongest campaigning activity has been waged, not by social movements external to the institution, as they are frequently characterized, but by actors inside it. Senior curators, directors and policy makers within the sector have been instrumental in raising various manifestations of the treatment of human remains as a problem. Some were highly visible members of major museums and the professional body for the sector, the Museums Association. Indeed new individuals within the profession emerged during the contestation and the promotion of this issue, to expand it to all human remains and those that are unclaimed. Furthermore, while the problem was vigorously contested initially by senior professionals, over a period of time the resisting individuals have accepted many of the initial arguments put forward by claims-makers within the sector. As indicated by the case study on Pagan claims-making in Chapter 4, members of the sector find it difficult to articulate consistently a rationale for resistance.

At the heart of this book is an analysis of the interaction between professionals and their tussle over human remains, identifying underlying drivers of this controversy. My central argument is that the activities of campaigning museum professionals in promoting this issue is a response to a crisis of cultural authority, which has come about after decades of unremitting questioning of the purpose of the museum. Professionals' response, in promoting this issue, is an attempt to secure new legitimacy by distancing themselves from a discredited foundational remit. This is something of a new departure in the analysis of museums. There is a substantial body of literature on the role of the museum as an institution, which has reflected on external influences, primarily market and intellectual currents. However, this work has broadly overlooked and underestimated the role of members of the sector themselves in questioning the role of the museum and aiming to re-orientate the remit in response. In particular, the common characterization of contestation deriving from external challenges to the institution and existing in tension with a resistant profession, neglects an exploration of the internal contribution to such contestations. The identification of the sector as influential in questioning the foundational purpose of the museum has implications for how we theorize the institution. It is commonly observed that museums contribute to the cohesion and reproduction of capitalist society: that the development of museums in Western societies actively supports the dominant classes, conserving the social order (Duncan and Wallach 1980; Bourdieu 1984; Prior 2002). The question raised in *Contesting Human Remains in Museum Collections* is, what is the impact on this function when there is a challenge to the authority of the museum from within?

In the analysis of the construction of this problem, I also address why human remains became the focus of this contestation with a greater intensity than artefacts. Human remains have been a subject of fascination throughout history, but in recent times they have acquired a new set of functions in a range of discourses, movements, and institutions: from human rights investigations, nation-building projects and repatriation claims, to art exhibitions, museum displays, popular fiction, and TV crime drama. From the late 1990s, several exhibitions in London displayed dead human bodies—these were popular but were met with divided reaction. What explains this increased interest and focus on human remains? Although sociologist Tony Walter (1993) has observed that sociologists have been slow to engage the issue of the dead body, there is an emerging sociological literature that begins to address questions about the meanings of the dead body; especially in the late modern period where it is widely recognized that the body has increased significance for identity work (see for example, Hallam, Hockey and Howarth 1999). The theory that has begun to address the gaps in sociological thinking on the dead body tends to focus on the recently deceased, where human remains are clearly once a person, where their liminality is most acute, and where there is a continuity with live social relationships. Older remains, such as those that are the subject of this work, which are hundreds or thousands of years old and can have come from overseas, have previously been considered more object-like because of their location outside of immediate social relationships. Therefore they have been considered less problematic and viewed as anatomical objects.

I examine how human remains are an effective symbolic object that can locate issues due to unique properties. That is, they have special qualities that mean they can be effective as symbolic objects. Crucially, however, they are manipulated by the living, in a context that is culturally located. To explore the contemporary influences on the symbolic work of human remains, I draw on sociological theory of the body, and establish how the symbolic character of human remains in locating this problem is influenced by the significance of the body as a scientific object; its association with identity work; and as a site of political struggle.

ORIGINS OF THIS STUDY AND APPROACH

I first became interested in the controversy over human remains in collections while working at the London-based Institute of Ideas, where I was director of the arts and society programme. As part of this brief I attended the Museums Association conference in 2002, which included a lively debate on human remains. I subsequently wrote a number of opinion articles in newspapers (see for example, Jenkins 2003) and an Occasional Paper (Jenkins 2004), arguing against repatriation and advancing a case for the scientific value of human remains. In the course of writing these pieces

and engaging with key protagonists, I found that a number of questions arose that were not interrogated. In my view, both 'sides' of the contestation were unable to explain the rapid rise of the issue, the success of repatriation arguments, the failure of the scientific case, and the problematizing of unclaimed human remains. In short, the outlets in which I discussed this issue—journalism, essays and a few public events—did not address the complexity or the significance of the issue and the extension of concerns to unclaimed human remains, and there was little, if any, analysis of why it has become so important to professionals within museum institutions. But by this stage, animated by such issues and wanting to address these questions, I decided to explore this question sociologically. Academia, I felt, was the best place to conduct credible and extensive research in an open-ended fashion with peer support and review.

Sociologists have developed an approach known as the social construction of social problems, which has gained ground since the 1970s. This method explores why and how a condition or behavior becomes constructed as a problem through social activities (Spector and Kitsuse 1977; Loseke 2000). The contribution social constructionists have made is to argue that perceived problems are so understood because of the process of interaction between competing interest groups and social, political and bureaucratic forces, which influence how a problem is regarded. There are variations within the approaches of social constructionists. Strong, or strict, social constructionism argues that social problems are created without reference to social context. Weak social constructionism, on the other hand, contends that social problems are created in reference to a broader cultural context, although subject to constructionist processes. This approach recognizes that problems and claims draw on and relate to an existing social context which may also constrain problem construction. Theorists following this approach seek to examine the motives, ideas and conditions that result in popular understandings and responses to issues.

Inspired by the work of social constructionists, and in particular Joel Best and Philip Jenkins, I took a similar approach to analyzing the construction of the problem of human remains. I favor the weak approach. This is primarily because, as Best (1993) argues, strict constructionism's focus on language is illogical and circular. All language must mediate a broader social context, which also needs to be analyzed. Activists can achieve little unless external events or underlying changes in social attitudes contribute to creating ideas that are receptive to those argued (Best 1987; Jenkins 1996). My aim was to isolate the key influences on the construction of this problem: to ask how and why the treatment of human remains has become troubled in the collections of Britain. Thus while I analyze rhetoric, discourse, and the campaigning activities, I also demonstrate that problems are constructed successfully in this instance because they draw on a broader cultural context.

I gathered a wide range of data for analysis. Drawing on a range of sources—media reporting, and documents in the form of written papers, articles, and statements produced by participants on this issue—I examine the different rhetorical idioms and motifs that were promoted in the different manifestations of this issue. Over the time frame of 2006–2008 I interviewed 37 professionals involved in this debate, anonymously, using semi-structured interviews. I selected these individuals first by identifying those prominent voices in the debate, which I ensured encompassed a number of different attitudes and positions. I then expanded this group by identifying and interviewing individuals at all the museum institutions which had published policy on this issue, or where the institution had been involved in the discussion in some way, either through a particular decision, or actions around human remains. I repeated ten of these interviews eight months after the first one. Throughout my time of study I attended a number of sector events to sensitize myself to the salient issues pertaining to this problem, and to museum practice more broadly. These did not only address the specific issue of human remains, although many did, but also concerned developments in the museum sector more generally, most notably the annual conference run by the Museums Association (MA), which I attended in 2005, 2006 and 2007. This was to deepen my understanding of the issues within the museum profession more broadly and to develop an appreciation of the status of this particular problem within the sector. In relation to the case study, the subject of Chapter 4, I interviewed a further five professionals and twelve Pagans as well as observing a number of conferences, consultations and events and speaking to participants.

STRUCTURE OF THE BOOK

Chapter 1 charts the development of this issue and how it emerged. Through an analysis of the claims-makers, we see that direct contact between key individuals internationally, coupled with an ideological receptivity, was instrumental in the diffusion of this problem from North America to Britain, and into the museum profession, where key issue entrepreneurs advanced the case for repatriation and respect for human remains. Advocates argue for the transfer of human remains to culturally affiliated claimants, through a discourse of therapeutic reparations drawing on broader social trends. Crucially, claims-makers successfully extended the domain of their claims by linking to high profile contemporary controversies over the retention of body parts by hospitals, which expanded the problem to one that included the treatment of uncontested remains from the British Isles. In Chapter 2, I analyze the counter-claims mounted by professionals who contested the shifts in practice around this issue. Those resisting repatriation, often scientists, framed their claims for the retention of human remains in a discourse that warned of the potential loss to science and the negative

impact of the destruction of vital historical material, appealing to ideas of future potential. However, those contesting repatriation failed to advance a case for their scientific research that had purchase, and the arguments for repatriation were rapidly institutionalized in a number of government reports, government support, legislation and museum policy.

Chapter 3 examines why senior museum professionals have been issue entrepreneurs, promoting this problem. Following a discussion on cultural authority and the establishment of the rational remit of museum institutions formed in the eighteenth and nineteenth century, I chart the external influences on the museum profession which, I venture, have contributed to a crisis of cultural authority. The influence of market forces and the widespread disenchantment with Enlightenment thinking, under the influence of postmodernism, cultural theory and postcolonial theory, has subjected the traditional justifications of the museum to significant questioning. This chapter argues that there are significant internal influences on challenges to the museum and the questioning of its remit, suggesting that the new museology, a body of critical thinking on museums, exemplifies a broad self-questioning within the profession and an attempt to re-orientate the purpose of the institution by professionals. The problem of human remains emerged in conjunction with these ideas.

Chapter 4 is a case study of Pagan claims on human remains in museum institutions. An analysis of the formation of the group Honouring the Ancient Dead (HAD) reveals how prevailing cultural ideas about human remains and the role of museums creates new claims-makers. The newly-formed group uses human remains to try to authorize its voice and to give weight to its demands for recognition. This case study also elucidates the central importance of the response to claims-makers in the construction of problems. The reactions by the profession to HAD are divided into two camps. One was a highly positive endorsement of its claims, primarily, but not exclusively, from issue entrepreneurs at Manchester University Museum who formed a coalition with HAD. The second reaction was from those in the sector who did not consider Pagan claims-makers as legitimate. Despite considering HAD as illegitimate, there was little active resistance, indeed relatively weak contestation of its claims, by professionals. Significantly, members of the sector were unable to mount an effective rationale for the exclusion of Pagan claims-makers due to confusion about the purpose of the museum institution and the basis of its legitimacy.

Chapter 5 explains why the focus of this contestation is over human remains, rather than artefacts in museum collections. Human remains have unique properties that make them effective symbolic objects. Crucial, in this case, are the contemporary social influences on the symbolic work of human remains: the rise of the body as a site of identity, and the body as a site of political struggle, which informed and gave purchase to the argument that human remains are a special object. Chapter 6 follows this by looking at specific examples of the display of human remains in

museum collections, influenced by these trends: Lindow Man, the covering of Egyptian mummies, and the exhibition *Skeletons: London's Buried Bones*. These different studies discuss the ongoing impact of contestation over human remains and how it has impacted the display of different bodies. I argue that the different approaches to display are influenced, not by the particular human remains, but by the interests of the actors who seek to manipulate them for their own agendas. Finally, I turn to my concluding thoughts, considering the implications for the museum of a profession that continues to challenge its own authority.

1 Transforming Concerns about Human Remains into an Issue

It is helpful to situate the emergence of the problem of human remains in British collections within the context of the rise of this issue in other countries, drawing out the similarities and identifying diverging trends. Although the contestations over human remains in Australia and America, and indeed in Canada and New Zealand, are different in each country, there are parallels in the way in which they emerged. In the early 1970s, a developing American Indian political movement and the Australian Aboriginal land rights movement gained support and achieved legislation on questions of religious freedom and land rights (Cove 1995; Tilden Rhea 1997). In this context, prominent debates were conducted over the failures of assimilation, the definitions of identity, and the rights of such groups to land (Smith 2004a). There was a congruent concern about the fate of cultural heritage and an interest in preserving the past, with a growing focus on heritage and its significance to Western societies (Lowenthal 1985; Hewison 1987). Ideas about the problems of indigenous groups became linked to ideas about the importance of the past, and broader, anthropological concepts of culture (Brown 2003). As anthropologist John Cove (1995) observes, the Tasmanian Aboriginal rights movement formed in the 1970s, asserting its rights to land, as did similar movements in America and Canada, but broad social trends helped to reframe these demands over land into claims on historic cultural heritage.

Emerging requests on institutions to transfer remains were therefore framed with a motif of recognizing the needs of indigenous groups to interpret their own history (see for example, Tivy 1993; Hurst Thomas 2000). From the mid 1980s onwards, codes and policies were published advocating a more sympathetic attitude towards repatriation. In the case of the National Museum of the American Indian Act (NMAIA) of 1989 and the Native American Graves Repatriation Act (NAGPRA) of 1990, passed in North America, legislation compelled the inventory of human material and associated funerary items from all federally funded institutions and its delivery to lineal descendants and culturally affiliated tribes. In law, policy and codes of conduct, the problem identified was the rights and needs of the indigenous groups to their histories.

The contestation over human remains in British collections arose a decade later, in the 1990s. While holding similarities to America, Australasia, Canada and New Zealand, the issue in Britain saw different motifs develop over time. From the outset this was primarily due to the weak pressure from overseas indigenous groups on British institutions. This is not to present these groups as a single or fixed grouping. The politics of who is part of what tribe and who is considered legitimate is complex. Nor is it to compress the differences between these contestations. Despite such variations, the aim here is to indicate that there has been comparatively limited pressure from overseas indigenous groups on British institutions. Although there were requests for human remains from overseas indigenous groups, these were not high in number and nor was there a rise in requests. Indeed, the Human Remains Working Group Report, written by a government-appointed committee, noted that claims from overseas indigenous groups on institutions are 'low' (DCMS 2003b: 16). A survey conducted to evaluate the number of claims discovered only 33 claims on English institutions, seven of which had already been agreed to, and some of which were repeat claims (DCMS 2003a). This relative lack of pressure from groups, and the less pertinent comparable question of indigenous issues, explains why the problem of human remains developed more slowly in Britain than in some other countries.

The emergence of a problem like that of human remains in collections is most usefully understood as the outcome of the activities of individuals or groups making claims and complaints with respect to some condition that requests attention. Sociologist John Hannigan (1995) highlights the influence of 'issues entrepreneurs' in the creation of social problems: individuals who vocalize concerns and raise awareness to build a case for change. This first chapter introduces the individuals campaigning for shifts in museums and the treatment of human remains. It analyzes how they framed this problem and gained attention for it, and how their claims were legitimized. Many activists were initially from the United States and Australia. Others in Britain quickly adopted the problem through a process of diffusion: the process by which ideas spread among people. Significantly, many were archaeological, anthropological and museum professionals, who campaigned within the institutions and their disciplines.

INTRODUCING THE CLAIMS-MAKERS

It is possible to locate the surfacing of the problem of human remains and identify the diffusion of the issue to museum professionals in Britain by following the activities of the World Archaeological Congress (WAC), a non-governmental organization that runs an international congress every four years on the theory of archaeology. The anthropologist Peter Ucko

organized the first Congress in Southampton in 1986, where he was based at the university. Ucko came to be an influential campaigner, with experience and contacts in Australia and America, where the issue was developing into an important concern. Previously Ucko had been Principal of the Australian Institute of Aboriginal Studies in Canberra, an independent Australian government statutory authority, designed to record the language and customs of the Aborigines.

Although the first WAC was dominated by debates about academic freedom, it was here that concern about the holding of human remains of indigenous groups arose. In one conference session, Jan Hammil, a representative of the organization American Indians Against Desecration (AIAD), spoke about the storage of her ancestors, the desecration of sacred sites, and how this affected American Indians (Hammil 1995; Hammil and Cruz 1989). There was great interest in her speech, which resulted in a request for her to repeat the session, to participate in other sessions, and to address the plenary session, after which she was co-opted onto the Steering Committee of the WAC (Ucko 1987). Additional speakers at the WAC from America and Australia were campaigning against the excavation and holding of indigenous human remains. Papers were presented by the American anthropologist and activist Larry Zimmerman, British anthropologist and activist Jane Hubert, American anthropologist and activist Randall H. McGuire, Robert Cruz, a Tohono O'odham Indian from Arizona, and Lori Richardson, the Aboriginal advisor to the National Museum of Australia (Layton 1989).

The holding of indigenous human remains subsequently became a 'crucially important' issue for the WAC (Ucko 1987: 228). Ucko consulted with AIAD about the treatment of American Indian human remains, traveling across Indian reservations with Jane Hubert, Robert Cruz and Jan Hammil to discuss the issue. The Steering Committee, including Ucko and Hammil, encouraged museums in Britain, such as the Pitt Rivers Museum in Oxford, to remove skeletal material of overseas indigenous groups. They 'raised the problem' (Ucko 1987: 231) amongst the museum sector, arranging meetings and forging links between museum professionals, archaeologists, and indigenous groups. Direct contact between key individuals internationally, facilitated by the WAC network, was instrumental in the diffusion of the problem from North America to Britain, where adopters were members of the museum sector.

Peter Ucko and Jane Hubert assumed ownership of the campaign while they worked in Britain. Cressida Fforde, Ucko's research student, built direct links with other activists and groups through the WAC and museums, significantly contributing to the promotion of the issue to the profession. Her research work gave the problem a British focus. Fforde researched the historical circumstances of the acquisition and collection of human remains, examining various separate collections.[1] In 1997 she worked with FAIRA, the Foundation for Aboriginal Islander Research Action, and the

London-based Aboriginal activist Lyndon Ormond-Parker, to identify and document Aboriginal Torres Strait Islander ancestral remains held in European institutions (Ormond Parker 1997). In 2004, she conducted a scoping survey of pre-1948 human remains in University College London collections (Fforde 2004a). Fforde also contributed a submission to the Human Remains Working Group Report (Fforde 2001) and the government and museum sector's joint code of guidance (DCMS 2005). She has acted as an archives researcher, searching the museums for human remains to transfer to communities. For example, one set of bones she found was repatriated out of the University of Edinburgh to the Ngarrindjeri people of South Australia, in July 2008.

Receptive Museum Professionals

Theorists of diffusion make an analytic distinction between relational channels involving direct interpersonal contact between transmitters and adopters, and channels that do not involve personal ties (McAdam and Rucht 1993). Strang and Meyer (1993) observe that linkages may be cultural as well as relational, which may help to explain diffusion that is especially fast. Although it is possible to chart the direct relationships formed between campaigners in the WAC, Peter Ucko, Cressida Fforde and the museum sector, many were highly receptive to their campaigning and adopted concepts quickly, suggesting cultural purchase for these ideas. It is unlikely that a few individuals could otherwise have had such an impact.

In the 1990s, the professional body for the museum sector, the Museums Association (MA), commissioned the museologist and activist Moira Simpson to undertake two research projects to determine its members' views about repatriation in general. She found the vast majority of respondents accepted the notion of repatriation (Simpson 1994: 28, 1997: 17). Out of the 123 respondents, only three were categorically opposed. Of these respondents only 17 institutions out of 164 had received enquiries or requests for repatriation (Simpson 1997: 17). Historic Scotland (1997: 9) notes a similarly sympathetic reaction in relation to the issue of reburial amongst archaeologists and museum professionals, which it comments is 'surprising'. The act of repatriation also had support from the *Museums Journal*, the professional journal published by the MA. Two editorials published in the 1990s advocated the transfer of human remains out of collections (Davies 1993, 1994). The first editorial argued that UK museums should 'stop dragging their heels over the return of human remains' (Davies 1993: 3). The editor and writer of both editorials was Maurice Davies, later deputy director of the MA and member of the Working Group on Human Remains (WGHR). The articles included in the 1993 issue of the *Museums Journal* were primarily concerned with the relationship between museums and indigenous groups, with one article written by a Canadian scholar Dan Monroe, one of the authors of the Native American Graves Repatriation

Act (NAGPRA). In 1994 the *Museums Journal* devoted an issue to the problem of human remains in UK museums. In that edition, British professionals and museologists took up the baton. The editor of the Society of Museum Archaeologists, Edmund Southworth, advocated that general policy and principles should be established to deal with human remains and restitution (Southworth 1994). Moira Simpson reported on her survey and discussed a positive case study of the transfer of Aboriginal remains from Glasgow museums (Simpson 1994).

The receptivity of certain members of the sector is further demonstrated by decisions taken by senior professionals to repatriate human remains to overseas indigenous groups. In the 1990s Bradford, Peterborough, University of Oxford Museum of Natural History, Pitt Rivers, Manchester University Museum, Horniman Museum, Exeter, and Whitby museums took decisions to transfer human remains to Australia, Canada and New Zealand (see DCMS 2003a; DCMS 2003b; Alberti 2009). In 1991, Edinburgh University began to repatriate its collection of skeletal remains, initially requested by the Tasmanian Aboriginal Centre (TAC) in 1982 (Greenfield 2007: 304). In 2000, it repatriated its remaining collection of Aboriginal remains and its collection of Hawaiian remains. In 2002, the Royal College of Surgeons returned remains to Tasmania (RCS 2002). Whereas these decisions were made in response to requests from overseas groups, one was initiated by a museum professional, as one report acknowledges: 'Nor did the impetus to return material always come from overseas. The return of Maori human remains from the National Museums and Galleries on Merseyside was instigated by the then Keeper of Ethnography.' (DCMS 2003a: 28)

MAKING AMENDS: HOW ACTIVISTS FRAMED THEIR CAMPAIGN

To understand the construction of a problem, sociologist Joel Best (1987, 1995) analyzes rhetoric: the deliberate use of language in order to persuade. In this case, advocates argue for the transfer of human remains to culturally affiliated claimants through a discourse of 'making amends' and the therapeutic impact of return. Overseas indigenous communities still suffer from the impact of colonialism, they contend, leaving a detrimental legacy that can be alleviated by repatriation. Such motifs had broader cultural purchase and lent authority to their demands. Significantly, departing from other contestations over human remains, activists successfully extended the domain of their claims by associating their campaign with high-profile contemporary controversies over the retention of children's body parts by hospitals. This expanded the problem to one that included the treatment of uncontested remains from the British Isles.

The March 1993 issue of the *Museums Journal* was dedicated to the question of human remains in museums.[2] The front cover stated in

prominent text: 'REBURYING HUMAN REMAINS: Making amends for past wrongs'. The magazine devoted five opinion articles, one news item and the editorial to the problem. The reference to reburial in the cover headline was borrowed from campaigners in America and Australia, where campaigners had named the problem the 'reburial issue'. The use of the term 'reburial' rhetorically acts to suggest that all remains had been uprooted, or exhumed unnaturally, presenting burial as the original and normal state—even though once transferred to communities, remains are not always buried, nor had they necessarily been recovered from a burial ground. The term 'reburial' was soon dropped by the majority of activists in Britain in the 1990s, and replaced with a focus on the need for 'repatriation'. Repatriation is a term that is used by all participants in this debate, regardless of their position on the question, but it should be noted that the word, used accurately, describes the return to 'home' of an object or person. The assumption within the use of the term 'repatriation' is that the human remains have a home to return to, but this is not strictly the case in many instances. The human remains may be sent to a museum for holding, and the original tribe or person from who they were obtained may never be known. The dominance of the term and the use of it by campaigners from very different positions, as well as in other accounts of the issue, indicates an acceptance of a value-laden term that suggests that there is a rightful home to which the remains could be returned.

'Making amends for past wrongs' was the dominant frame for claims-makers in Britain in the 1990s. Activists, mostly professionals with a background in archaeology, anthropology or museology, aimed to change the minds of those in the sector who contested the repatriation of remains, predominately the scientists who research the remains. The case that the transfer of remains is essential to 'make amends' is clearly present in the secondary literature advocating the repatriation of human remains and demanding changes in museum policy. While a motif of making reparations for colonization is present in campaigning material in America and Australia in relation to the problem of settler societies (see for example, Monroe 1993; Mihesuah 2000; Hurst Thomas 2006), there is a greater focus on it in Britain, emphasized in research by activists specifically on the role of British collectors and museums in acquiring and using human remains.

The first reason given by campaigners for making amends, using powerful rhetoric, is the problem of the original acquisition. Anthropologist Jane Hubert is one of many who refer to this as 'grave-robbing' (Hubert 1989: 136. See also Zimmerman 1989; Fforde 2002; Macdonald 2006). Moira Simpson describes 'the removal of bodies from battlefields, the theft of bodies from mortuaries, graves, burial caves and other mortuary sites' (1996: 176). Tristram Besterman argued, at a public debate, that 'the collections in our Western museums derive, at their most innocent, from grave robbing, and at their worst, from wholesale slaughter' (IoI 2003: 3. See also Richardson, L. 1989; Bromilow

1993; Hinde 2007). Speaking on BBC Radio Four's *Today* Programme, Marilyn Strathern, Professor of Social Anthropology at Cambridge University and a member of the Working Group on Human Remains (WGHR), stated: 'We are thinking of theft of a very brutal nature'. She continued:

> Bodies were dug up from graves, taken off battlefields, butchered on the spot—that's no more or less brutal than what happened here in this country, but that abuse—to borrow a late twentieth-century term—that abuse does weigh with people and we need to know they are affected by it.[3]

Strathern's use of the currently fashionable term 'abuse', while self-conscious, is another reference to a recognized social problem that adds force to rhetoric aiming to establish that the historical removal of human remains has caused harm to communities.

Campaigners conducted original research on how human remains were acquired during the time of British colonial expansion in Australia. This was predominately undertaken by the archaeologist Cressida Fforde. Her research adds to the documenting of historical material during the period of British colonization, to use in building the case for repatriation on the basis of the problems with acquisition. For example, Fforde's submission to the WGHR reads:

> The Working Group, may, for example, wish to examine as a case study [. . .] remains such as those currently held by a UK museum that are Australian Aboriginal individuals killed in a 'punitive expedition' in 1920. The leader of the expedition boiled down the bones of the massacre victims after slaughter was complete in order to prepare them as museum specimens. (Fforde 2001: 4)

In this excerpt, Fforde uses an especially graphic case to illustrate the treatment of individuals whose bones were then given to museums. The words 'boiled', 'massacre', 'victims' and 'slaughter' are all forcefully employed to suggest that this is how museums obtain their collections. The use of the word 'specimens' contrasts with the others, implying that people are killed in order to be prepared into museum objects.

A similar account, which appears to reference the same case and employs the use of numbers, was included in a newspaper article in the *Guardian* newspaper by the then editor of the *Museums Journal*, Jane Morris. Statistics or numbers are often an important element in building an argument (Best 1990). This excerpt indicates that the number of remains in museums becomes a rhetorical tool for campaigners.

> The Natural History Museum's collections (of 20,000 body pieces) include a skull and leg bone from a 25-year-old man shot in 1900 in a punitive expedition near the Victoria River, Australia. The bones were

prepared for a collector on the spot, with the skin boiled off in a pot. (Morris 2002: 15)

In this article, the editor of the *Museums Journal* describes the remains as 'body pieces' instead of 'specimens', which is more empathetic and emphatic, sounding more person-like than remains from hundreds if not thousands of years ago. A striking comparison is the following description of the same collection, produced by the Natural History Museum:

The Natural History Museum holds the national collection of human remains, comprising 19,950 specimens (varying from a complete skeleton to a single finger bone). The remains represent a worldwide distribution of the human population and a timescale of 500,000 years. The majority of the collection (54 percent) represents individuals from the UK. (NHM 2006a: unpaginated)

The use of the number of body parts, instead of the number of requests for return, acts to suggest the scale of the problem is great. The reference to body pieces, as opposed to human remains, is more effective. Crucially, there is no mention of the low number (33) of recorded requests from communities for return. The implication in the article is that the 20,000 body pieces are suspect and may have been acquired in a similar fashion to that of the 25-year-old man whose skin was boiled off.

The sociologist Philip Jenkins (1992) notes that a cause can be effectively promoted if it is related to a specific individual or known event with which people can identify or sympathize, functioning as an exemplar. Individual cases were highlighted that functioned in this way, demonstrating 'barbaric' and 'inhuman treatment', including that of the removal of the body of Tasmanian Aboriginal William Lanney, who was 'decapitated and mutilated less that 24 hours after his death', his 'head cut off and stolen', and 'a tobacco pouch was made from a portion of his skin' (Ryon cited in Richardson, L. 1989: 186). Activists most frequently refer to the plight of Truganini (see for example Richardson, L. 1989; Hubert 1989; Fforde 2002, 2004; Simpson 1996). Truganini was one of the last surviving Tasmanian Aborigines moved to Flinders Island. Although her wishes were for undisturbed treatment of her remains, two years after she died in 1876, her body was exhumed by the Royal Society of Tasmania and placed on display at the Tasmanian Museum and Art Gallery. During the 1970s her bones became the focus of a struggle between the Tasmanian Aboriginal rights movement and the Tasmanian State Government over Aboriginal status, identity and land claims. Truganini's skeleton became the focus of debate about Aboriginal Tasmanian extinction and came to symbolize the impact of colonization on all Aboriginal people in Australia. This had purchase with the Australian media and public, and played an important role in the promotion of the issue (Cove 1995; Perera 1996).

In 1976 Truganini's skeleton was cremated and her remains scattered, as she initially had wished. Campaigners in Britain adopted her story to suggest that the holding of human remains is questionable due to the circumstances under which remains were acquired and treated (see Barkham and Finlayson 2002; Morris 2002; Woodhead 2002). The British legal scholar Norman Palmer, a repatriation advocate and the chair of the WGHR, was reported in the press as having visited Bruny Island to see her ancestral home.[4]

The second aspect to the claim that museums need to make amends for past wrongs is that the institutions were actively involved and implicated in colonialism. Campaigners argued that museums were established during the colonial period and that they are therefore associated and should make some kind of reparation. The then editor of the *Museums Journal*, Maurice Davies, stated in an editorial:

> Many UK museum collections were built up in the 19th and 20th Centuries, a time when a certain set of political attitudes prevailed. Britain was a major—probably the major—colonial power, science had enormous confidence in its own certainties, the UN did not exist, and there was no strong sense that people were equal. Indeed, the majority of the population of Britain (let alone the population of the colonies) did not have the vote. (Davies 1993: 7)

The bodies of indigenous groups still in these museums are, in Davies' view, 'a legacy of colonial collecting' (Davies 1993: 7). Davies concluded that UK museums should agree to return human remains. This standpoint extended the argument from the wrongs of acquiring material to the wrongs of the historical period in general, regardless of how it was collected. As Moira Simpson makes explicit in the *Museums Journal*:

> The fact that material of human origin was acquired legally is often used as a defence against possible repatriation. However, the debate cannot ignore the colonial ancestry of the collections or the insensitivity of the methods with which many items were acquired. (Simpson 1994: 31)

In the 1990s and early 2000s, human remains were transferred to Australia from museums in Britain. Museum professionals and activists cited the injustice of colonialism as a primary reason for this (Besterman 2004; Mclaughlin 2008). Tristram Besterman, director of Manchester University Museum, stated in the press release pertaining to the decision and transfer of remains from that institution:

> These remains were removed during the colonial era at a time of great inequality of power. Their removal more than a century ago was carried out without the permission of the Aboriginal nations, and they have been

held in the Manchester Museum ever since, in violation of the laws and beliefs of indigenous Australian people. (Besterman 2004: 8)

Joel Best (2001) argues that a successful claim for a problem requires the diffusion of an idea about the villains who perpetrate the harm. In this case the villains are the scientists who use the remains for research. Activists contend that the high social value accorded to science legitimated the acquisition and scientific analysis of human remains during this period, which was used to identify and measure racial characteristics. Science, they posit, was central in constructing the case of Aboriginal and Native American people as inferior (see for example Peirson Jones 1993; Hurst Thomas 2000; Riding In 2000.). As Cressida Fforde writes: 'it is also clear that even those collectors who regarded grave robbing as perhaps less than morally correct believed that such actions were justified in the name of science' (Fforde 2002: 27). Peter Stone of the World Archaeological Congress (WAC), and lecturer in museum studies at Newcastle University, identified science as legitimating wrongful acts: 'the pursuit of "science" was believed by non indigenous people to justify what they knew were offensive acts' (Stone 2001: 5). For Moira Simpson, the very presence of human remains in museum collections is 'in itself' evidence of the fact that the 'academic and scientific interests have been placed before the interests and wishes of the deceased and their descendents': a situation which, she argues, should be reversed (Simpson 2001: 2).

Activists Jane Hubert and Cressida Fforde both suggest that medical detachment has permitted terrible treatment of the dead: 'Such "medical detachment" would perhaps explain why early scientists with close indigenous friends felt able to deflesh their bones as soon as they died' (Hubert and Fforde 2005: 116). The use of the word 'deflesh' powerfully describes the physical material of the body in their rhetoric, with connotations to horror fiction. The use of the term 'friend' instead of the less emotive term 'human remains', is also noteworthy. The Australian academic Paul Turnbull, and Cressida Fforde, contend that the specific study of the body conducted on human remains was central to the domination of the Aboriginal people (Turnbull 1991, 1993, 1994; Fforde 1997, 2004b). Fforde draws on Michel Foucault's analysis that from the seventeenth century the body became an object and target of power, realized through a technique of scientific classification and regulation (Foucault 1977, cited in Fforde 2004b: 84–85). Fforde and others argue that scientific knowledge about the Aboriginal body has been fundamental in sustaining and constructing relations of power (see also Peirson Jones 1993; Riding In 2000).

Philip Jenkins (1992) argues that successful claims-makers must show that the problem is widespread, that it is growing worse and that it causes real harm. In the third aspect to the 'making amends' frame that developed in the late 1990s and early 2000s, it is possible to see the construction of a more forceful idea about the harm caused to contemporary communities.

Activists contend that the historical removal of human remains, along with colonization in general, has caused suffering in the present day that could be alleviated by repatriation. In an important anthology edited by Cressida Fforde, Jane Hubert and Paul Turnbull (2002), American anthropologist Russell Thornton refers to the theory of a 'trauma of history', by which, he explains, 'is meant events in the history of a people which cause a trauma to that group much in the way that events in the lives of individuals may cause a trauma to them' (Thornton 2002: 20). For Thornton, repatriation can achieve a therapeutic impact on indigenous groups:

> The 'repatriation process' helps Native American to achieve some closure on traumatic events of their history, a closure which was not possible as long as human remains and cultural objects associated with these events were held by museums and other institutions. (Thornton 2002: 22)

Here there is a broad inclusion of who is considered harmed by historical acts. It can include any member of a cultural group that was wronged in the past, extending beyond identifying specific individuals who were involved, and responding to individual definitions of harm.

Tristram Besterman, director of Manchester University Museum and a prominent campaigner, made a link between the return of human remains to communities and healing the 'wounds' of colonial history. During a public debate in London, Besterman declared: 'We now have the opportunity to redress that historic imbalance acknowledging that this may well mean a loss to science that will in its turn heal open festering wounds' (IoI 2003: 4). In this quote, the wounded body—'open festering wounds'—is metaphorically employed to describe the damage to the community that could be alleviated by the return of human remains. The Human Remains Working Group Report (HRWGR) also cites the damage of colonization, compounded by retention of human remains, and discusses the healing role that repatriation could perform:

> Until this wrong is redressed, there will be no closure in respect of past injustices and an arguable enduring violation of fundamental human rights. The physical and psychological health, and indeed the social advancement, of indigenous communities are in consequence impaired. (DCMS 2003b: 123)

The report concluded that repatriation stimulates a 'healing process' (p. 252), a discourse that attributes therapeutic properties to the process of repatriation and the return of human remains.

Claims-makers often use evidence to back up their statements, but apart from one reference to evidence in the Human Remains Working Group Report, which cites the testimony of an Aboriginal Tasmanian group

(DCMS 2003b: 48), there is no use of evidence in claims for the therapeutic benefit of repatriation. Indeed there is little research conducted on the process of the transfer of human remains and the impact on communities. This is significant in the light of the strong claims that are made in favor of this process. The two pieces of minor research conducted, only one of which addresses human remains specifically, arrive at different conclusions. Museologist and activist Moira Simpson (2005) examined two cases from Canada, observing the repatriation of human remains in one case and objects in the other. She found that it revitalized knowledge, skills and ceremonial practices. Simpson concludes that the returns had benefits and positive influences upon the cultural and spiritual well-being of the groups. Philip Batty (2005), curator of Anthropology and Indigenous Cultures at the Victoria Museum in Australia, researched the repatriation of secret-sacred material in Australia, finding 'ambivalence' on the part of the owners about accepting the objects, and 'a sense of confusion' about what to do with them. 'Repatriation was a low priority and could trigger old intra-communal hostilities for communities suffering from poverty and declining health,' he commented (Batty 2005: 74).

LEGITIMIZING CLAIMS

Claims about different problems are connected and validated through different cultural resources upon which claims-makers draw when promoting the issue. Picking the right cultural resources helps in establishing that there is a problem that requires change. Joel Best argues that the choices made are not 'random' but 'patterned' (Best 1999). There may be a large number of different cultural resources from which activists can choose, but they do not pick the issues they promote, or the frames, by accident; these may be consistent with the ideology of advocates, or because they seem likely to appeal to the claims-makers' audience. Crucially, activists can achieve little unless external events or underlying changes in social attitudes contribute to creating ideas that are receptive to the claims (Best 1987; Jenkins 1996). The lack of evidence promoted by activists to validate their claims for the therapeutic transfer of human remains, as well as the limited resistance to this argument illustrated in the following chapter, suggests that these ideas have broader cultural purchase. In the construction of this problem activists draw upon and reference a number of concerns that were already established in wider society. Two of these concerns—making reparations and a therapeutic sensibility—were borrowed from extensively by campaigners to give their statements force.

Following the Second World War, a role was seen for nations or governments in acknowledging past wrongs they committed. According to political theorist Hannah Arendt 'the "subterranean" stream of Western history has finally come to the surface and usurped the dignity of our tradition.'

(Arendt 1973: ix) Historian Elazar Barkan (2003) observes that the demand that nations act morally and acknowledge their own historical injustices took the form of restitution for past victims, and that this increased after the end of the Cold War in 1991. Restitution is commonly defined as the payment of compensation or the return of objects or property, a trend that Barkan suggests has subsequently become a major part of national politics and international diplomacy. Sociologist John Torpey (2006) documents that while the term 'reparations' was initially used exclusively to describe what were effectively fines exacted among states before the Second World War, it now refers to a much broader making of amends towards non-state groups and individuals. Sociologists Olick and Coughlin (2003) also note the expansionary element of these terms, which seek to recognize past wrong doings by nations and organizations. Grouping together different types of retrospective practice—restitution, reparations, apologies, and criminal prosecution—under the identification of a general trend they term the 'politics of regret' (p. 56), Olick and Coughlin situate the explanation for this shift towards making amends within the decline of the nation state and the failure of the state. For Olick and Coughlin, the politics of regret is no passing fad, but characteristic of our age. Torpey (2006) has identified the extensive contemporary concern with past injustices as a significant shift in progressive ways of thinking about politics. He argues that efforts to rectify past wrongs have arisen on one hand as a substitute for expansive visions of an alternative human future, and on the other as a response to the rise of identity politics.

The central motifs of harm, suffering, pain and the therapeutic healing brought by repatriation had considerable purchase due to the rise of what has been termed 'therapy culture'. Social theorists have identified the complicated and shifting ascendancy of therapeutic culture in contemporary society (Rieff 1966; Lasch 1979; Nolan 1998). Sociologist Frank Furedi (2003) identifies that the expanding effect of psychology was one of a number of influences in western culture until the 1960s, when it started heavily to influence contemporary culture and dominate the public's system of meaning. The origins of this trend towards a psychologized and increasingly individuated understanding of the social world can be traced to social changes over the second half of the twentieth century, including the weakening of tradition, religion and shared moral values, and the development of psychology. Furedi suggests that therapy culture become institutionalized in the 1980s, alongside the decline of major political ideologies, and has been widely promoted by institutions since the end of the Cold War. The decline of older forms of ideology, Furedi explains, has entailed a profound loss of meaning in society, resulting in a 'therapeutic ethos' in which selfhood and individual psychology have become the focus of political and cultural concern. For Furedi, the discourse of emotions, the confessional mode, and the blurring of the line between public and private is now a major cultural force.

Political theorist Wendy Brown (1995) notes the incorporation of the therapeutic sensibility into state actions. She argues that it reflects a re-orientation of state activities towards the provision of social repairs on a society damaged by secularizing and atomizing effects of capitalism. Like Furedi, Brown charts the orientation towards identity politics with a thera-peutic sensibility as resulting from the demise of class politics. The ten-dency for state policy to address the condition of suffering is supported by broad cultural norms, she writes, which establish 'suffering as the measure of social virtue' (Brown 1995: 70). This insight—that suffering has become something that is valuable and virtuous—indicates one of the reasons why the claims made regarding individual suffering in the discussion of human remains have not needed to draw upon evidence. The language of emo-tions and suffering, such as the pain and distress described of the feelings of overseas indigenous groups and the therapeutic properties attributed to the transfer of human remains, had a broad cultural purchase because of its already-established authoritative status in contemporary culture. As a consequence, the claims for the significance of the distress of indigenous groups and the therapeutic impact of the repatriation process had broad appeal.

PIGGYBACKING ONTO SOCIAL PROBLEMS

Social problem frames evolve over time and claims-makers will often aim to 'piggyback' onto other prominent issues to give their campaigns cred-ibility and weight (Best 1990). Through frame alignment, they tap into and manipulate existing concerns and perceptions to broaden their appeal. Repatriation advocates associated their cause with prominent issues, high on the political and media agenda, which raised questions about how con-temporary body parts were acquired, stored and used by the medical pro-fession and by artists. Linking to these controversies gave their issue greater weight and credibility as a problem. It also helped to extend the problem, from an issue associated with human remains from overseas groups, to one where the holding of *all* remains—including those from the Britain—is deemed problematic.

While a number of problems are referenced, the most important issue to be linked to was what came to be termed, by the popular press, the 'scandal' at Alder Hey. During the late 1990s and early 2000 there were a number of controversies over the retention of children's body parts by hospitals. In 1999, a medical scientist giving evidence to the Bristol Royal Infirmary Inquiry, set up to investigate the quality of pediatric cardiac surgery, made reference to a large collection of children's hearts stored at the Royal Liverpool Children's National Health Service Trust [Alder Hey]. The storing of children's body parts was picked up by the media and presented as a scandal, and a major controversy broke with a group of

parents protesting about the retention of their deceased children's hearts, of which they were previously unaware. Subsequently, the Bristol Royal Infirmary Inquiry (2000) and the Royal Liverpool Children's Inquiry (2001) investigated the circumstances leading to the removal, retention, and disposal of human tissue, including children's organs. The inquiries established that organs and tissues had been removed and used without what was considered proper consent. These findings contributed to large scale public outcry when it was further revealed that the pathologist who was Liverpool Health Authority Chair of Fetal and Infant Pathology, Dick van Velzen, ordered the illegal stripping of every organ from every child who had a post mortem. These events dominated the media and raised questions about consent in the donation of body parts. A survey of the media reporting of the 'body parts scandals' at the different hospitals observed that this became so dominant a frame that it operated as a news template for other stories about the use of other human tissue, regardless of whether they concerned organ retention (Seale et al. 2005: 403). The Inquiries recommended changes to procedures for obtaining consent for post mortems and retaining organs and tissues for research or education. Some of the recommendations became law with the Human Tissue Act 2004.

Other events during this period were to influence questions about the dead as an object of display. From the late 1990s, several exhibitions in London displayed dead human bodies which were popular but created an element of controversy. These included: *London Bodies: The Changing Shape of Londoners from Prehistoric Times to the Present Day* at the Museum of London (October 27, 1998 to February 21, 1999), *Spectacular Bodies: The Art and Science of the Human Body from Leonardo to Now* at the Hayward Gallery in London (October 19, 2000 to January 14, 2001), and *Body Worlds: The Anatomical Exhibition of Real Human Bodies* in the Atlantis Gallery, London, a non-traditional gallery space (March 23 to September 29, 2002). *Body Worlds* was an exhibition presented by Gunther von Hagens, who has since repeated and extended this show across the globe. The exhibition consists of dead bodies, preserved by an injection with formaldehyde and liquid polymer, and posed for display. The von Hagens exhibitions have been met with divided reaction (Woodhead 2002; Stern 2006). They have been the focus of a number of newspaper articles that raised questions about the ethics of displaying such bodies and questions pertaining to where and how they were obtained (see for example, Jeffries 2002; Searle 2002). One news report in the *Observer* newspaper (Harris and Connolly 2002) suggested that the bodies were taken from among mentally ill people and prisoners, as well as from Eastern Europe or China, keying into the contemporary concern that body parts are taken without consent from the vulnerable. Pity II, a pressure group formed by parents involved in the Alder Hey scandal, called for the exhibition to close (Jefferies 2002).

Linking to the Holocaust

John Torpey (2006) argues that the Holocaust has emerged as the principal legacy of the twentieth century with respect to the way people now think about the past. He ventures that the Holocaust has a paradigmatic role in the contemporary consciousness of catastrophe, encouraging attention to other catastrophic pasts. Campaigners link the problem of human remains to the Holocaust, which by association links the collecting and display of human remains both to colonization and the Holocaust. The deputy director of the Museums Association, Maurice Davies, made the following point at a public debate, employing the description of killed Jewish babies, to advocate the curtailment of research on human remains:

> [A] couple of years ago they were digging around in the vaults of a hospital in Austria; they found the remains of some tens of babies, Jewish babies who had been killed by the Nazis. They're not being studied by scientists; those remains have been respectfully laid to rest. So there are a lot of double standards around. (IoI 2003: 12)

Ratan Vaswani, also from the Museums Association, associated proposed restrictions on research on human remains with good practice, comparing it to the restricted use of material from the Holocaust. In a conference paper he presented to the museums sector, Vaswani argued:

> Academic freedom is not the absolute right to study anything you wish in any way you wish. The principle that some research is unacceptable is firmly established by precedent such as treatment of results from Nazi experimentation on unwilling human subjects. (Vaswani 2003: unpaginated)

The remarks by Davies and Vaswani could be seen, if inadvertently, to draw an implicit connection between Nazi experimentation and the scientific study of human remains, thus inferring dubious aims and motives to scientists and reinforcing the idea of science and scientists as villains.

Writing in *Science and Public Affairs*, the magazine for the British Association for the Advancement of Science, Jane Morris linked the return of objects 'looted' from families by the Nazis with the return of human remains taken from communities in Australia and North America (Morris and Foley 2002: 4). In the *Guardian* newspaper, Morris evoked the Holocaust together with wars in Vietnam and Bosnia to suggest that the collection of Aboriginal human remains was uniquely horrific. No one would collect other bones or victims like this, she argued:

> Widespread collecting of Tasmanian bodies was happening at the time of the 'black war', the genocide which by 1830 had almost wiped out

the Aboriginal population. No one would, or could, collect like this today. There are no collections of Holocaust victims, or Vietnamese or Bosnians. (Morris 2002: 15)

Moira Simpson has argued that human remains on show are problematic and compared this to material from the Holocaust: 'one would not wish, for example, to see the remains of Jewish holocaust victims of Auschwitz or Belsen displayed for all to see, as they were found in the gas chambers and incinerators' (Simpson 1996: 177). Simpson's use of the Holocaust reference is different to that of Davies and Vaswani, but similar to that of Jane Morris. She does not associate scientific research with Nazism, but associates exhibitions of human remains with the remains of Jewish Holocaust victims. The focus for Morris and Simpson are the human remains on display. This is a shift in focus away from the problems of communities' relationship with human remains, to the human remains themselves.

Body Parts Controversies

In the same speech to the sector that referenced Nazi experimentation, Ratan Vaswani raised the issue of the body parts controversies, arguing they were part of the same problem: 'Logical and ethical consistency demand that the debate about human remains in museums cannot, at least in Britain, be separated from debate about body parts held in other institutions' (Vaswani 2003: unpaginated). In the early 2000s campaigners began to refer to the body parts controversies in their writing, papers and speeches on the need for repatriation, focusing on events at Alder Hey. There are a number of different issues that are identified. Firstly it is suggested that the feelings of the parents at Alder Hey are similar to those experienced by indigenous groups. Cressida Fforde and Jane Hubert write that:

[T]his desire to bury the remains of a relative appears to echo the responses of indigenous people, who have for many years been trying to take home the various human remains of their own dead, to dispose of them with due rituals. (Hubert and Fforde 2002: 14)

The Human Remains Working Group Report also suggests equivalence in the 'distress' experienced by parents and indigenous groups, noting:

The Working Group feels that there are strong resonances between the recent distress suffered by the relatives involved in the Alder Hey revelations and the distress of those indigenous peoples who are still mourning the loss of their ancestors taken from them decades ago. (DCMS 2003b: 81)

It is worth noting the description of the removal as 'decades ago'. This is not wrong in a formal sense, but it sounds like the remains were taken more recently than 200 years ago, the correct time-frame. It is more dramatic to give the impression that the remains were taken in recent times. Writing in the *Guardian* newspaper Jane Morris also made the link between the remains from overseas communities with the events at Alder Hey, complaining that indigenous groups were not receiving the same public sympathy accorded to the Alder Hey parents:

> Contrast this with the public outcry when Alder Hey hospital revealed it routinely held children's body parts without parental consent. Is it one law for today's British children and another for the ancestors, for example, of the Aboriginal people of Australia and indigenous tribes of North America? (Morris 2002: 15)

Linking the two groups—parents and indigenous communities—reinforces the case for the repatriation of human remains, by suggesting that overseas indigenous groups had been traumatized in a similar fashion to the parents at Alder Hey, who had received considerable public sympathy. It also suggests that the problem is contemporary and immediate rather than an historical issue.

The second problem identified is the question of consent. With the concept of consent high on the political and media agenda, campaigners now sought to use the term to indicate that human remains in museum collections were taken without it. Peter Stone on behalf of the World Archaeological Congress argued in his submission to the Working Group on Human Remains (WGHR): 'In the past, collecting was rarely—if ever—carried out with what would now be termed "informed consent", and such practices would now, in almost all cases, be deemed unethical.' (Stone 2001: 5) 'Surely there is a parallel?' between Alder Hey and the need for repatriation, Jane Morris asserted in the publication *Science and Public Affairs*, arguing: 'Consent is a crucial issue' (Morris and Foley 2002: 5). In the introduction to *Collecting the Dead,* Cressida Fforde opens with a passage that links the problem of human remains in British collections with the controversy at Alder Hey and the issue of consent:

> In the United Kingdom, museums and other collecting institutions contain human remains [. . .] As exemplified by the scandal that surrounded the discovery that a doctor at Alder Hey Hospital in Liverpool had removed and kept organs from deceased babies without the consent of their parents, feelings can run high if it is perceived that body parts have been removed or used without the prior and informed consent of relatives. (Fforde 2004b: 1)

Identifying a third problem, campaigners try to suggest that the British public is seriously worried about how human remains are treated. In her submission to the WGHR, Cressida Fforde referred to the Marchioness disaster of 1989, when the pleasure boat sunk, drowning 51 passengers. There was a debate over the removal of the hands of passengers to ensure identification, which some deemed disrespectful. Fforde compared this with Alder Hey, and the problem of human remains in museum collections, to suggest that there is public disquiet about the holding of all this material and the general treatment of human remains:

> The Alder Hey scandal has further highlighted the inequitable treatment of human remains under the law in Britain. This scandal, as well as that which followed the discovery of the treatment of the bodies of those who had died in the Marchioness disaster, demonstrates that not only is concern for appropriate treatment of the dead by no means an indigenous matter, but that there is a wide void between general public assumptions about how remains are treated and the reality of what actually takes place. (Fforde 2001: 4)

Here we can see the linking of Alder Hey and the Marchioness disaster to emphasize the idea that human remains should not be kept in collections. Fforde introduced the idea that that the public feel major disquiet over the way human remains are currently treated. Peter Stone made the same link and suggestion in his submission to the WGHR:

> The outcry over the treatment of the remains of infants at Alder Hey Hospital, Liverpool and those of the victims of the Marchioness disaster demonstrates the high level of UK public concern about the treatment of human remains in UK collections. (Stone 2001: 5)

Fforde and Stone's submissions are constructed in a similar way to an article written by the historian Ruth Richardson (2001a) and published in the *British Medical Journal,* forming part of her forceful critique of the medical profession and its attitude towards dead bodies. It demonstrates a crossover of rhetorical frames between the campaigners of the problem of body parts and consent in contemporary controversies, and the issue of overseas human remains in museum collections[5]. Richardson wrote: 'Recent scandals—at Bristol, at Alder Hey, and the Marchioness disaster [. . .] revealed the prevalence of a callous medicalized attitude towards dead bodies that permits abuse of corpses' (Richardson, R 2001a: 398). It is worth pointing out that, in this article, we can identify the construction of the dead body as the victim in the problem of the retention of body parts.

Activist Laura Peers, a curator from Pitt Rivers Museum Oxford and a member of the WGHR, referenced the reaction to Alder Hey and Gunther von Hagens in the journal *Anthropology Today.* She argued that the

treatment of all human remains is a widespread concern, aiming to make the same point as Fforde and Stone—that there is a public disquiet about the use and display of human remains:

> Recently, the issue of human remains has sparked controversies in Britain ranging from the Alder Hey scandal, through reactions to Gunther von Hagen's 'Body Worlds' show, to the debate over the disposition of remains from overseas indigenous groups held in museum collections. (Peers 2004: 3)

The suggestion that the public are concerned about the treatment of human remains is an attempt to orientate the problem away from only addressing human remains from overseas, towards the idea that the treatment of all human remains is of concern to the public. However, research conducted to investigate audience concern about human remains on display suggests the public are not distressed by the display of human remains and that they expect and want to see human remains on display in museums (Barbian and Berndt 1999; Barham and Lang 2001; Swain 2002). Indeed, human remains are often exhibited to raise audience numbers (Swain 1998).

In a revealing study, Hugh Kilmister from the Petrie Museum of Egyptian Archaeology in London set out to investigate whether museums were becoming 'unduly sensitive' about the issues surrounding human remains, by interviewing visitors about their attitudes to display (Kilmister 2003: 58). Kilmister found that there was a 'very high proportion'—82.5 percent of visitors surveyed—who believed that the museums should be allowed to display human remains in 'whatever way they see fit' (p. 62). Kilmister's reaction to these findings is instructive. Despite this public interest, he concluded that the display and treatment of human remains needs to change: 'Although not as contentious as the display of Aboriginal or Native American remains, the public is generally positive about the display of ancient Egyptian remains, but we perhaps need to look at the future re-display of these remains' (p. 65). Kilmister further commented in relation to the high public trust in professionals to decide the future of human remains: 'this trust is perhaps not justified' (p. 66), which reveals that while the public may trust the profession, this curator is more circumspect. Kilmister suggested that the profession should in future restrict the way human remains are treated in collections and that the public should view more respectfully:

> A possible, more appropriate, future display arrangement could be a separate museum area, thereby giving visitors the choice to view the remains or not. Such a special exhibition area might be darkened with a more subdued atmosphere [. . .] This public control might encourage more respectful viewing. (Kilmister 2003: 65)

Kilmister concluded that long-term exhibitions should not show this material, even though it is uncontested and not claimed by any group: 'Perhaps in a permanent display of death from ancient Egypt one no longer needs to see actual human remains.' (p. 66) In this response, by a curator, it is possible to identify again the shift away from the idea that holding of human remains is a problem because of the needs of indigenous communities, or because of a public reaction, to the idea that human remains need special care and that their display is of concern full stop. It is of interest to note in our analysis of the construction of the issue that there is no evidential demand for the withdrawal or change in treatment of human remains on display or in storage in museum collections by the public, borne out in other work and studies (see for example, Chamberlain and Parker Pearson 2001; Carroll 2005). This would indicate that despite Fforde's suggestions, and despite the controversies over the retention of body parts and the display of human remains, this problem is not influenced by public demand, but actively promoted from within the academy and profession.

2 Scientists Contest Repatriation

The arguments for repatriation were vigorously contested by those who argued that human remains are essential research material, and that such vital evidence should not be removed from museums, institutions dedicated to the pursuit of knowledge. Strong counter-claims advanced the case that repatriation would mean a great loss to science. With powerful rhetoric, those resisting repatriation questioned the ownership and affiliation of the communities to the human remains, arguing that the removal of human remains for research would be deleterious to future generations of researchers of all nationalities, that it promoted identity politics that racializes peoples, and that it would destroy humanity's historical knowledge. As we shall see, the interaction between campaigners for repatriation, and those contesting it, contributed to creating a number of oppositions. One, between science and the needs of communities; two, between the future potential of research versus the present needs of communities; three, between ignoring and endorsing the wrongs of colonization versus the possibility of making amends; four, between changing the law or not, and overall sharpening the central question of this debate: who decides—scientists or disenfranchised communities?

While those resisting the claims for repatriation initially included members of the museum, archaeological and anthropological disciplines and professions, by the late 1990s the most vocal opponents were, primarily but not exclusively, scientists, anthropologists and archaeologists who use human remains in their research. However, despite concerted resistance to repatriation campaigners, in a relatively short space of time the arguments for research on human remains lost support. By the end of 2003, it became clear that the British government's support was with repatriation campaigners, rather than with the scientists. A number of reports, policy and pieces of legislation were passed, signaling, in certain cases, that human remains would be returned to overseas indigenous communities, even when the remains were considered to hold a high research value. The activism of scientists in contesting the claims for repatriation was to hold little sway.

WHOSE BONES? HOW SCIENTISTS
FRAMED THEIR ARGUMENTS

A central controversy in this debate in Australia and America has been around the question of who is considered related, or affiliated, to the remains. This was triggered in part by particular cases of the burial of ancient skeletons that, critics argued, could not be related to contemporary communities. The Kow Swamp collection of Pleistocene human remains from southeast Australia was one such case. In August 1990, the museum of Victoria presented to the Euchuca Aboriginal Cooperative the collection of human remains and grave goods from this area, aged between 9,000 and 15,000 years old, which were then buried. The prehistorian DJ Mulvaney launched a critique of this action in the journal *Antiquity*:

> Archaeologists support the return of remains from recent generations to local communities for reburial, because social and spiritual factors outweigh other factors. The Kow Swamp bones, however, are rare survivals from the millions of burials which have occurred and vanished across the past 15,000. Their kin cannot be presumed to have shared the same cultural values or religious concepts of this generation. Neither can a few people 'own' them in the sense of being free to destroy them. (Mulvaney 1991: 16)

Mulvaney was one of many vocal opponents who argued that it is not possible to credit a relationship between people of today and human remains from hundreds of years ago. Mulvaney argued, in the same article, that even if a relationship could be traced, the variability of beliefs and cultural practices are too varied to hold any continuity, and that therefore such communities should not decide what happens to such ancient human remains.

In the previous chapter we saw how campaigners referred to the plight of Truganini, who functioned as an exemplar, her tale becoming symbolic of the decimation of the Tasmanian Aboriginals. For those resisting repatriation, the case of the Kennewick Man skeleton is used in a similar fashion to make a very different point: that present-day cultural groups have no claim on human remains, because they are too distant to be related. Kennewick Man is a human skeleton found on the banks of the Columbia River in Washington State, North America, in 1996. At first, it appeared to have more of a European than a Native American form, and anthropologists thought that it could be the remains of a nineteenth-century European settler. But, after radio-carbon testing, they realized the skeleton was over 9,000 years old.

In North America, under the Native American Graves Repatriation Act (NAGPRA) passed in 1990, 'cultural affiliation' is defined in the statute as 'a relationship of shared group identity which can be reasonably

traced historically or prehistorically between a present day Indian tribe or Native Hawaiian and an identifiable earlier group.'[1] This means that human remains more than 500 years old are considered 'Native American', and under the law, the affiliated tribes then decide what happens to them. Kennewick Man was taken into custody, pending a NAGPRA claim, by the US Army Corps of Engineers, the landowners of the site and the body mandated by the US government for dealing with these matters. Under its NAGPRA obligations, the army informed local Native American tribes with links to this area of land. The bones were claimed by the Confederated Tribes of the Umatilla Indian reservation (comprising the Umatilla, the Naz Perce, the Colville, the Yakama, and the Wanapum), who insisted that there should be no study of the bones (Chatters 2002). What then followed was a high-profile and fractious legal battle, lasting eight years, between anthropologists wanting to study the skeleton and the tribes wishing to bury Kennewick Man. Those wanting to study the skeleton questioned whether remains this old could be considered Native American or associated with any modern people. In February 2004, after debates over affiliation, identity and ownership, an appeal court decided in favor of the scientists. A year later, the government permitted research to start. The case is evoked by those resisting repatriation to question the right of the tribes to decide the future of human remains that, it is argued, bear no relation to them.

Affiliation and the legitimacy of claims became focus of debate in Britain, where many queried the lineage or relationship of claims-making groups to human remains. Don Brothwell, Emeritus Professor in the Centre for Human Palaeoecology at the University of York, explained that genetic ties become watered down and shared between ethnic groups over generations. This means, he argued in a press release and in academic journals, that establishing the strength of a group's claim for repatriation is complex, and likely to degenerate into political and religious wrangling (Brothwell 2004). As the biological anthropologist Marta Mirazón Lahr, director of Cambridge University's Duckworth Laboratory, put it in an interview I conducted for an article for the website *Open Democracy*:

> Claims for repatriation are based on ideas of biological and cultural descent, but human populations are not bounded entities through time, and biological and cultural ancestral affiliation are fluid concepts—who are the descendents of our Saxon skeletons, or Iron Age or Norman ones? (Mirazón Lahr, cited in Jenkins 2003)

Sebastian Payne, chief scientist at English Heritage, also questioned the link between present-day communities and the human remains they were claiming, when he commented on *BBC News* that it was important to be clear 'about how closely a group needs to be related to the remains in order for a claim to become pre-eminent'. He continued:

It's easy enough to see that a descendent or close relative can speak legitimately for the remains of a dead human being, and their views should in principle be pre-eminent. [. . .] But it's more difficult when one starts to consider the position of groups that are more distantly related. Groups are made up of individuals and are not necessarily unanimous in their views, and more than one group can claim to speak for the same human remains.[2]

Sebastian Payne tried to separate the claims on ancient human remains from those that might apply to more recent people. In an article in *Antiquity*, he evoked the case of Kennewick Man to try to emphasize the distance between contemporary communities and ancient human remains:

[I]t seems to me that the recent repatriation to Tasmania of an individual whose identity was known, and who was killed less that 200 years ago, was almost certainly right [. . .] But that principle should not be extended unreasonably, as seems to have happened in the case of Kennewick Man. (Payne 2004: 420)

By arguing over the affiliation of ancient human remains, those resisting repatriation suggested that the remains under question were thousands of years old. But the majority of human remains that have been requested by community groups, from institutions in Britain, are between one and two hundred years old.

The response of those sympathetic to repatriation to the questioning of affiliation is revealing. They criticized the argument that no link over hundreds or thousands of years can be legitimate. Firstly, science can hardly claim to be the only truth, they posited. 'It is simply incorrect', argued David Hurst Thomas, anthropologist and author of *Skull Wars,* to assume that anthropologists are always objective: 'Like it or not, the historical disciplines are the products of Western tradition, and even anthropologists, protest as they might, are the prisoners of their own cultural backgrounds.' (Hurst Thomas 2000: 244) There are different approaches to lineage, which are equally valid, suggested the Human Remains Working Group Report:

[T]here is a risk that placing exclusive emphasis on close family and direct genealogical association fails to accord proper recognition to cultural diversity, by attaching predominant value to local or Western notions of kinship and insufficient value to other belief systems. (DCMS 2003b: 137)

Furthermore, argued those sympathetic to repatriation, lineage is unimportant. What needs to be considered is that indigenous groups' cultural values have not been recognized and they have not had a voice in the writing of their histories. 'It is about politics. The dispute is about control and

power, not philosophy. Who gets to control ancient American history—governmental agencies, the academics community, or modern Indian people,' declared Hurst Thomas (2005: 68). What matters, repatriation campaigners argued, is that the groups gain some kind of power or recognition and possible control over their pasts, rather than that they can prove a genetic or cultural relationship.

The Global History of Mankind

For many scientists the idea that the human remains belong to any one group, to the exclusion of others, is unscientific and morally wrong. 'I explicitly assume that no living culture, religion, interest groups or biological population has any moral or legal right to the exclusive use or regulation of ancient human skeletons since all humans are members of a single species,' Douglas Ubelaker, a bioarchaeologist from the Smithsonian Institute, argued. 'Ancient skeletons are the remnants of unduplicable evolutionary events which all living and future peoples have the right to know about and understand. In other words, ancient human skeletons belong to everyone.' (Ubelaker, cited in Turner 1986: 1).

Critics contesting the claims for repatriation questioned the idea that one community group should be able to decide the future of human remains. They tried to counterpoise these claims to the argument that human remains were owned by the whole of humanity, appealing to concepts of a universal and shared history. They refuted the charge of racism; indeed, they ventured, repatriation campaigners promote a racialized view of humanity, and it was the research on human remains that helped to dispel racist concepts of separate and fixed races. For Sebastian Payne, research on human remains countered racist thinking by telling us about the 'shared past' of human history and the relationships between peoples (Payne 2004: 419). Robert Foley, director of the Leverhulme Centre for Human Evolutionary Studies and Leverhulme Professor of Human Evolution at the University of Cambridge, stated in the *Observer* newspaper that research on human remains would shed light on the whole of human history. Foley challenged the suggestion that collections were simply a result of colonization: 'Nor is it fair to depict the Duckworth as a vast repository of colonial pillage: 7,000 of our remains are of ancient Egyptians and 5,000 are British. They are here for what they can tell us about human history.' (Foley, cited in McKie 2003) Chris Stringer, a senior palaeontologist from the Natural History Museum, also disputed the inference that science permits or encouraged domination and racism, countering that it was research on human remains that led to insights about human evolution and which showed relationships and similarities between cultures, breaking down the notion of static and separate races (Stringer 2003a, Stringer 2003b). As Robert Foley asserted, in response to a comparison put forth by Jane Morris from the *Museums Journal* between human remains and the return of art looted by the Nazis:

I was disappointed that you linked the issue of skeletal collections to Nazi art loot. However, since you have made the comparison, let us remember that it was Nazi science that promoted the idea that cultures and their biology were all one. The scientific study of collections from around the world has dispelled that myth, and it would be sad to see it return in however well-intentioned a manner. (Morris and Foley 2002: 4–5)

Indeed, what is essential, argued Marta Mirazón Lahr in the *Observer*, is a diversity of material, so that scientists can compare and identify links and breakages: 'if we lose our Australasian samples that will damage the collection irreparably' (Lahr, cited in McKie 2003).

The archaeologist Laurajane Smith, based at the University of York, responded by arguing that researchers in the present may not have been involved in past colonization and domination, but that they still benefit from such practices. Not to acknowledge the wrongs of the past suggests that the research community sees itself as outside the consequences of colonial history. They must play a part in reparations, Smith argued, or they are complicit in past wrongs:

The retention of collections of Indigenous human remains by British institutions conveys a powerful symbolic message, however unintentional that may be. At best, the message that is conveyed is that the British community sees itself as positioned outside the consequences of its own colonial history, while at worst, it affirms the legitimacy of that history and the negative continuing consequences it has for Indigenous peoples and their campaigns for recognition and equity. (Smith 2004b: 408–409)

While Robert Foley and Chris Stringer questioned the implication that human remains in their collections were taken under dubious circumstances during the period of colonization, activists asserted that museums contained the bodies of people stolen under duress at the time of a great imbalance of power. Not to acknowledge this by removing human remains from collections would endorse this history and, they said, would have negative consequences.

The Loss to Science

In the 1990s, requests made to the British Museum and the Natural History Museum in London from activist groups supported by the Australian and New Zealand governments were refused by the trustees and directors, who cited the importance of the commitment of the institution to broad concepts of science and heritage (TAC 2001). Neil Chalmers, director of the Natural History Museum, stated that museums had:

A duty to the nation to retain those objects and we have a duty to the scientific international community to use them as a very valuable scientific resource. We would find it extremely difficult to return any such objects if there was any doubt at all about their continued safety and accessibility. (Culture, Media and Sport Select Committee 2000: § 162)

Robert Foley was quoted in the *Observer* claiming that, 'the loss to science would be incalculable', stressing that the potential loss due to the transfer of material that was valuable to science was so great it was impossible to estimate (Foley, cited in McKie 2003). In a comment piece in the *Observer*, Foley warned, 'In Australia, skeletons that are older than the Flores pygmy have already been reburied and lost to science.' (Foley, 2004) At the height of the debate, Chris Stringer vigorously defended his research on human remains, depicted as being under serious threat, in a similar fashion. In an article in the *Telegraph* newspaper, he warned of the loss of 'ground-breaking research'. Stringer claimed that '[w]e could see whole fields closed off to research if we lose key specimens, not least the quest to understand our origins', and explained that it was through the study of human remains that scientists 'like me developed the "Out of Africa theory"' (Stringer 2003a). Stringer criticized the decision to return the skeletons, quoted in the *Independent* newspaper as saying: 'This is an important population in terms of human history. If the material goes back and is cremated it will be a loss for scientists and a loss for future generations of Tasmanians.' (Stringer, cited in Connor, 2003) It is interesting to note that Stringer refers to the human remains as specimens and material, language that contrasts to how the activists, discussed in Chapter 1, describe human remains. Cressida Fforde, Jane Hubert and Jane Morris refer to such material as 'body parts' or with terms such as 'defleshed'. Stringer uses language that describes human remains as objects of science—'specimens'—rather than as people at risk.

Speaking at the Hay Literary Festival in 2007, the evolutionary biologist and prominent atheist Richard Dawkins warned of the threat to science from creationists and the religious right. He also warned of the threat emanating from the political left in the form of cultural relativism, citing the Kennewick Man as an example. Dawkins' reference to creationism was not common to scientists in Britain, but it had been a feature of the discussion in North America, where a common framing of the debate over Kennewick Man was as a dispute between religion versus science and rationality (Coleman and Dysart 2005). Writing in *Nature* magazine, Chris Stringer argued that a range of diseases could potentially be treated with research information, including malaria and tuberculosis (Stringer 2003b). The potential medical benefits of research were promoted, but not to the same degree as what could be learnt about evolution and broader concepts of science.

Destroying History

The strongest rhetoric employed by repatriation critics was used by those who argued that repatriation of human remains was 'destroying history', as the material would no longer be available for scientific research. The term is used to stress that the actions consequent to repatriation, often burial, are highly damaging. Speaking at a public debate, Robert Foley warned of the threat to the skeletal record: 'Destroy that record and we destroy large chunks of our history, just as we would if we were to destroy libraries and books written in the past' (IoI 2003: 6). Foley also commented in the *Observer*: 'There is a real chance some of the most important parts of the Duckworth could be removed and destroyed or put in inaccessible places' (Foley, cited in McKie 2003: 14). Marta Mirazón Lahr used a similar phrase in a press release when comparing the action of burying bones to the actions of the Taliban, which at the time was prominent in the news: 'I believe no one generation of people has the right to destroy that heritage, the same way that a particular government of Afghanistan did not have the right to erase that country's Buddhist history, however strongly held those views.' (SMC 2003) Elsewhere, Robert Foley also made this comparison, arguing: 'Destroying history is not the answer to the problems of these communities. The parallels with the destruction of the Buddhist statues by the Taliban are perhaps closer, and I'm sure you would not want to justify that.' (Morris and Foley 2002: 5) The description of repatriation and reburial as 'destruction', and the specific example of the demolition of the Buddha statues in Bamiyan, could be seen as presenting those seeking repatriation, which could end with the burial of human remains, as vandals who obliterate important and valuable cultural artefacts, and by association, as like the Taliban.

Those resisting the calls for repatriation tried to chime with the popular interest in history. 'In Britain, television programmes like the BBC's "Meet the Ancestors" attract large audiences. Underlying this is a widely shared belief in the value of knowledge and increased understanding of ourselves,' said Sebastian Payne (2004: 419). This attempt to capitalize on the public's interest in the past, as evidenced by the popularity of historical programmes, is a very different approach to the past as promoted by campaigners for repatriation. The latter approaches history as something for which actors in the present should atone, in order to repair the problems caused by a destructive legacy. For those resisting repatriation, the past is to be investigated and history studied to educate about the lives of past peoples.

In the previous chapter we saw that campaigners described the healing properties of repatriation. In the counter-claims of those contesting the case for repatriation, there is little that challenges these therapeutic claims, suggesting that they are difficult to question. Only two critics who resisted

repatriation queried the claims for the therapeutic impact of repatriation and then only in passing, echoing the debates within the politics of recognition about therapeutic benefits versus material provision. Norman H. Nail, a consultant to the Royal Cornwall Museum, argued in the *Museums Journal* that demands for human remains are a 'smoke screen for the real needs of oppressed communities.' (Nail 1994: 32–34) Commenting on the problems of Australian Aborigines, Robert Foley suggested their circumstances required political and material solutions rather than human remains: 'it is a strongly disadvantaged community. It does not have access to health in the same way as other Australians; and that is a major political, cultural and economic issue.' (IoI 2003: 19) With the exception of these two minor examples, the activists' argument that repatriation would heal the suffering of communities went unchallenged. Similarly, scientists did little to decouple the links made between the retention of human remains in museum collections and the controversial 'body parts' scandals in Britain. Their media impact was primarily in the science section of the newspapers, or by science correspondences, whereas repatriation activists dominated the sector publication, the *Museums Journal*, and also made inroads into the comment section of the *Guardian* newspaper, which gave them a broader reach. Both sides of the debate successfully targeted the journal for archaeology: *Antiquity*.

Future Potential

Those contesting the calls for repatriation tried to frame their counter-claims through an appeal to the future potential for research and knowledge. It was argued that by asking new and different questions of the material, or because of the development of new techniques and technology, more information could be retrieved from human remains at some point, especially with advances in DNA. As Chris Stringer wrote in the *Telegraph*:

> [W]ith future techniques, who knows what other secrets of our past could be unlocked? We don't yet know what answers to the big questions facing future generations may lie within the bones held in our collections [. . .] As new DNA techniques are developed, much more will be possible. (Stringer 2003a)

'Science is always throwing up new questions, and we may find we can no longer answer them,' Robert Foley warned, giving examples of genetic analysis techniques that have developed over the past fifteen years, and the potential of DNA in constructing the story of human history (Foley, cited in McKie 2003). Professor Simon Hillson of the Institute of Archaeology at University College London stated, in his submission to the Working Group on Human Remains (WGHR), that human remains were part of the archaeological record and important for future publics:

> [A]rchaeologists and museums have a responsibility to conserve and preserve archaeological remains and records for future generations. It is only in this way that our knowledge of the past can be reconsidered in the light of new techniques and new questions which arise. (Hillson 2001: 1)

These appeals to the value and future potential of science were quickly dismissed. Firstly, it was suggested that they were over-stated and that the contested material was rarely researched by scientists. According to the museum director and activist Tristram Besterman: 'The Manchester Museum has no record of having received from a bio- anthropologist any request for information about, or access to, human remains which it held' (Besterman 2004: 10). Secondly, science, activists contended, was just one value system and should not be elevated over other outlooks. The benefits to science were characterized as holding less value compared to the benefits of the transfer of the material to communities.

Mary Brookes and Claire Rumsey from the Winchester School of Art encapsulate this opposition between future benefits, viewed as uncertain and questionable and in which, they imply, only a small group of people are interested, and the immediate needs of larger communities. In a guidebook for the profession on how to treat human remains, they state:

> Published scientific research on human remains [. . .] tends on the whole to focus on research questions that are of interest to other specialists, but rarely can it be said to be a clear 'benefit' to a wider community. Against that we must set the groups for whom the ancient dead are experienced as still part of their communities: those communities have interests and needs now, in the present—not some uncertain future potential. (Brookes and Rumsey 2006: 266)

Note their reference to the 'uncertain future potential', which suggests that future research holds no tangible value compared to the needs of communities. Similarly, activist Paul Turnbull complained that while institutions such as the Natural History Museum and the Royal College of Surgeons tended to tell indigenous peoples that they would benefit from the research on remains:

> Rarely if ever have these arguments been tempered by consideration of the benefits to health and well-being arising from the expression and enjoyment of cultural heritage. (Turnbull 2002: 64–65)

It is clear that according to these campaigners, the value to science from research on human remains is negligible, compared to the benefits to the communities achieved by the transfer of human remains.

A significant development in the construction of this issue was that those resistant to the transfer of human remains out of collections came to cite the law as a reason why they could not do this. The legislation was the British Museum Act of 1963, which generally restrains museum trustees from the disposal of any object in the collection. Critics of repatriation, in particular those at the British Museum and the Natural History Museum, came to focus on the legal barriers. As the Natural History Museum stated in a memorandum to the House of Commons Enquiry into Cultural Property in 2000: 'The Museums policy has two strands: There are specific legal constraints on disposal of objects from the collection, coupled with a strong presumption by the Museum against disposal' (NHM 2000 cited in TAC 2001: 13). Giving evidence to the Select Committee on Culture, Media and Sport in 2003, Neil Chalmers defended the research potential of human remains, but also made the point that legally it was not possible for the museum to de-accession such material, suggesting that museum professionals would welcome this power: 'We are not permitted to return, as you know, at the moment, by the British Museum Act 1963, and we actually would favour some limited ability to return in very specific cases'. He continued: 'At the moment we have our hands tied' (Select Committee on Culture Media and Sport 2003, October 28: questions 54–59). Historian Jeanette Greenfield (2007) makes the distinction that in the 1990s, Scottish museums tended to respond negatively to requests, citing scientific value as the reason, while the English responded with legalistic claims. It should be noted that despite this law, as we have seen, a number of museums repatriated human remains. And, as the WGHR points out, the legal position was unclear: the museums could have disposed of the items if they deemed them 'unfit to be retained' (DCMS 2003b: 94). But as a consequence of citing the law as the reason why repatriation was prevented, changing the law became a focal point for activists. In turn, by using the law as a reason not to repatriate, when a new law was passed, critics had little to fall back on.

THE PROBLEM WITH LEGITIMIZING CLAIMS

We have seen that campaigners used rhetorical idioms of reparations, making amends, suffering and harm, which gave their claims authority, due to the rise of reparations thinking and a therapeutic sensibility. Why then did the claims made by scientists not have a broader resonance? After all, science is a major and powerful social institution and cultural phenomenon in modern society, held in high esteem and often used to legitimate claims-making (Woolgar 1988). Instead of being able to rely on the justification of the important value of science, fluctuations in the social value credited to science contributed to the claims made by those resisting repatriation as having a more limited purchase.

The science writer, Kenan Malik, outlines that while the Enlightenment view of civilization began to corrode from the late eighteenth century, the Enlightenment view of science had remained relatively intact. This changed in the twentieth century, when positivism crumbled and progress was no longer considered a straightforward good. In particular, perceptions of science changed after the Second World War, partly as a result of the atomic bomb. Science came to be viewed less as a method from which advances in medicine and society could be furthered, and more as a source of potential hazard (Malik 2008). Scientists were attacked for being dangerous, and producing racist and sexist research. Their claims to objectivity were criticized (Gross and Levitt 1994, Gross and Levitt 1997). The close relationship between scientific and military projects during the Cold War, and the relationship between science and big business that strengthened after it, has further contributed to a highly critical engagement with science (Moore 2008).

With the rise of postcolonial and postmodern theories, science has come to be viewed as a reflection of the local prejudices of European cultures, rather than as universal and objective (Cove 1995). Postcolonial theories, in particular, view scientific knowledge as largely determined by historical and cultural context, making a link between the physical subjugation of the developing world through colonialism and the intellectual subordination of non-Western ideas and ways of living. According to this view, Western scientists and intellectuals have imposed their Eurocentric knowledge upon the rest of the world to the detriment of many. For example, writing in the volume *Is Science Multicultural? Postcolonialisms, feminisms, and epistemologies,* the philosopher Sandra Harding claimed, 'All knowledge systems including those of modern science are local ones' (1998: x), and that Western science came to dominate due to the military, economic and political power of European cultures, rather than because of the purported commitment of the West to the pursuit of disinterested truth. Science, Harding argued, is politics by other means (Harding 1991). There has been a reaction against this body of work of postcolonial thinking that led to the 'Science Wars' of the 1990s, in which critics tried to reassert the value-free nature of science and debates ensued about the nature of scientific theory (Ross 1996), but nonetheless it has had an important impact.

The postcolonial outlook is reflected in the writings of the Native American scholar and activist Vine Deloria Jr. in his work *Red Earth, White Lies: Native Americans and the myths of scientific fact* (1995). Science is only a 'myth' (p. 9) that has ignored and dismissed the theories of Native Americans. As he wrote:

> Regardless of what Indians have said concerning their origins, their migrations, their experiences with birds, animals, lands, water, mountains and other peoples, the scientists have maintained a stranglehold

on the definitions of what respectable and reliable human experiences are. (Deloria Jr. 1995: 19)

Deloria Jr. argued that science is responsible for the exclusion of Native American views in mainstream culture and their treatment as 'subhuman' (p. 20). Furthermore, Western science legitimized and encouraged the slaughter of Native Americans for experiments. He explained: 'Some Eskimos staying at a New York museum to help the scientists were boiled down for further skeletal use instead of receiving a decent burial' (p. 19). He wrote of the 'robbing of graves' (p. 19) for scientific purposes, language that is echoed by Cressida Fforde and Jane Hubert, as we saw in Chapter 1.

INSTITUTIONALIZING ARGUMENTS FOR REPATRIATION

Claims-makers succeed when others validate the claims, either through expressing concern about them, or establishing policies to deal with them. Campaigners required support outside the sector to shift resistance, especially at the Natural History Museum and the British Museum. As these critics cited the British Museum Act of 1963 as a reason that they could not repatriate, government involvement in the form of changing the law was essential to institutionalizing claims. Support was not only essential in relation to the legislative change, but also in endorsing the problem. As Berger and Luckmann (1966) explain, the ideas that humans develop collectively, if incoherently, to rationalize the world become externalized and institutionalized through specific entities, such as the state, its laws and government. It is then that these ideas acquire a degree of legitimacy and durability and act back upon individuals through knowledge. The role of government and law, then, is important as a legitimizing function, giving significant weight to certain rationales and ideas.

Campaigners rapidly received policy makers' support. In 1999, the Labour Government established a House of Commons Select Committee to consider issues relating to cultural property, which recommended that Department of Culture Media and Sport (DCMS) focus separately on human remains (Culture Media and Sport Select Committee 2000: § 164). Giving evidence to the Committee, Alan Howarth MP, then Arts Minister, stated: 'I think we should be willing to look sympathetically and constructively at whether it is possible to ease the law so that if the trustees so wish they can make amends and they can return human remains.' (§ 686) In this comment from the Arts Minister, we can see the discourse of making amends to endorse the act of repatriation and the suggestion of legislative change. Soon afterwards the Prime Minister, Tony Blair, also became involved. A joint UK/Australia Prime Ministerial statement on Aboriginal remains was issued in July 2000, proclaiming: 'The Australian and British governments agree to increase efforts to repatriate human remains to

Australian indigenous communities.' (Blair and Howard 2000) The influence on the development of the issue by this intervention by Blair, the most senior political figure in the country, cannot be underestimated. It sent a clear message to those contesting repatriation informing them that they were not supported by the government.

The Working Group on Human Remains

Alan Howarth, the Minister for the Arts, set up the Working Group on Human Remains (WGHR). From its initial establishment the committee was instructed to look at the practicalities of legislative change, assuming a degree of desirability. The committee, appointed in consultation with deputy director of the MA, Maurice Davies, was overall, though not exclusively, sympathetic to repatriation.[3] Significantly, there was only one scientist on the committee (Neil Chalmers, from the Natural History Museum) and, although he was the director of a major research institution, he was a biologist and did not directly research human remains. The lack of an appointment of such a scientist was criticized by Margaret Cox, on behalf of the British Association for Biological Anthropology and Osteoarchaeology:

> It continues to be unfortunate that the WGHR contains no member who is directly involved in the archaeology and analysis of human remains. This situation is extremely unfortunate as such practitioners and researchers have a legitimate interest in the outcome of the deliberations of the Group, and much relevant expertise and knowledge that would serve to enhance the ability of the Group to arrive at findings that represent a balance of opinion and interest of those directly involved in the outcome. (Cox 2003: 21)

It was clear that, without the appointment of a scientist who worked on the remains and the high proportion of individuals in favor of changing the law, the intention of setting up the WGHR was to endorse legislative change to facilitate repatriation.

The WGHR was linked with the controversy over the retention of body parts at Alder Hey, reinforcing the intertwining of these two problems. The Department of Health set up the Retained Organs Commission (ROC) to investigate medical collections after the controversies. The ROC and the WGHR agreed to exchange legal information, meet, and work on common policy, meeting on various occasions between 2001–2003, when the Chair of the WGHR Norman Palmer met the Chair of the ROC and officials of the Department of Health to discuss matters of 'common interest' (DCMS 2003b: 7). As the report of the working group stated:

> The Working Group feels that there is much merit in including museum collections of human remains within the regulatory structure proposed

by the DH for health authorities and hospitals. Such a structure has the potential to bring about better standards of care and treatment of human remains nationally. (DCMS 2003b: 83)

From the inception of the WGHR and the ROC, the idea that human remains require special consideration is advanced and further formalized in the process of deliberation by both groups. That the treatment of human remains was coming to be seen as a problem is further demonstrated by the establishment in 2001 of a joint working group by English Heritage and the Church of England to address the issues concerning burials from a Christian context in England from the seventh to nineteenth century (Church of England and English Heritage 2005). Maurice Davies sat on this working group, reinforcing the links between them.

The Human Remains Working Group Report

The WGHR published its report in November 2003 (DCMS 2003b). The opinion of the committee was split, as Neil Chalmers issued a 'Statement of dissent' (DCMS 2003b: 220–229) arguing that the Human Remains Working Group Report does:

[N]ot provide a proper balance between the public benefits deriving from medical, scientific and other research on the one hand and the wishes of claimant communities on the other. The Report is slanted heavily, both in tone and in substance, in favour of the latter. (p. 220)

Amongst the recommendations of the HRWGR was that the law affecting human remains should be changed. It further associated the problem of human remains in collections with the body parts controversies, by devoting a chapter to the concept of consent, arguing that the concept is of 'paramount importance' (DCMS 2003b: 282). The report posited that the concept of consent is relevant in relation to historic human remains (those deriving from the period between 1500 and 1907), proposing that institutions would have to research the provenance of all remains and proactively contact related community groups to consult with them. As it is expansive and retrospective, this broadens the definition of consent from that applied in the debate at Alder Hey. Furthermore, it creates a definition where it would be difficult to ascertain whether consent was granted. The HRWGR implied that where there is no evidence of protest, or lack of consent for the removal of material, this should not be taken as consensual: 'Museums might wish to look critically at the political, economic and other reasons for any silence or absence of protest, in order to test its authenticity as a potential source of consent.' (DCMS 2003b: 150). The report continued: 'A formal or apparent consent should be evaluated in terms of the ascertainable conditions prevailing at the time possession was vacated. Such

evaluation might suggest that an apparent consent was vitiated by colonial dynamics of power or equivalent factors.' (DCMS 2003b: 151)

Two more recommendations in the report implied that all human remains require different treatment. The report stated that all human have a unique status and that they should be treated with 'Respect and reverence. Human remains must always be treated with respect. Responsibility for them should be regarded as a privilege' (DCMS 2003b: 135). This is regardless of claims, as the HRWGR stated:

> Most human material in English museums is of UK origin, and its retention and treatment has hitherto been non-contentious. [. . .] Claims are in fact very uneven in their incidence: requests for return mostly originate from North American, Australasia and the Pacific, despite the fact that many remains in English collections are from other regions. For instance we received no submission on the return of Egyptian remains, despite the large holdings of such remains in some museums. We believe nevertheless that many of the principles we have formulated and the recommendations we make apply with equal force to the care of all human remains, whether claimed or not. (DCMS 2003b: 10–11)

The HRWGR proposed that all institutions holding remains must be licensed by the Human Tissue Authority (previously they needed no licence), and that a panel of 'independent experts' should be appointed to oversee claims, as well as other issues relating to the remains, including storage, handling, treatment and use.

Repatriation critics challenged this report, for a number of reasons. None however opposed the changing of the law; indicating that that argument had been won by activists and accepted by those contesting it. Nor did they especially question the idea that human remains require special care, or refute the association with the body parts controversies. In his Minority Report, Neil Chalmers took issue with some aspects of the HRWGR, but he agreed that the law needs to be changed so those museums 'prevented from returning human remains' were given the 'discretion' to do so (DCMS 2003b: 222). Critics questioned the proposal for the proactive obtaining of consent and mandatory return, primarily because it was impractical or costly, rather than querying the expanded concept of consent. Robert Foley argued, on the Radio Four programme *Analysis*, 'That would be a vast undertaking which I think would absolutely devastate the resources that most collections have available to them' (Foley, cited in Malik 2004). Professor Paul Harvey, a Fellow of the Royal Society, commented in a press release from the Royal Society: 'The suggestions that institutions proactively obtain consent for the retention of human remains is problematic. Such a requirement would place a huge and financial burden on such institutions.' (Harvey, cited in Royal Society 2004) The Minority Report endorsed the idea that human remains require a special licence. While Chalmers rejected

the need for a human remains panel, he agreed that 'There needs to be a Licensing Authority with the power to enforce high standards of care for human remains that are held in museum collections, and there need to be transparent and publicly acceptable procedures for responding to claims for their return.' (DCMS 2003b: 220) Chalmers may have argued against certain aspects of the HRWGR, as did others who contested the practical implications of proactively obtaining retrospective consent, but ultimately the case for repatriation was accepted, and in the endorsement of the Licensing Authority so was the idea that human remains require codes of practice.

Legislation, Guidance and Policy

Legislation was passed to permit the de-accessioning of human remains in the form of the Human Tissue Act 2004 (HTA 2004) which came into force in England, Wales and Northern Ireland in April 2006. This Act replaced the Anatomy Act 1984. It regulates the removal, storage and use of human tissue and introduced an expanded definition of consent. It also amended the British Museum Act and removed the barrier to repatriation cited by professionals. They could no longer claim that they were prevented by law from repatriating remains.

The HTA 2004 established the Human Tissue Authority (HTA) as the regulatory body in England, Wales and Northern Ireland for all matters concerning the removal, retention, use and disposal of human tissue (excluding gametes and embryos) for specified purposes. While aimed at medical collections, it included a responsibility for licensing the public display of whole bodies, body parts and human tissue from the deceased, if they died after September 1, 1906. All museums holding human remains less than 100 years old have to purchase a licence from the Human Tissue Authority (HTA). For museums considering claims, a Human Remains Advisory Service (HRAS) was established to assist museums in negotiating claims, although it has since been informally disbanded.

Guidance for the Care of Human Remains in Museums (DCMS 2005) was issued by the DCMS and the Museums Association (MA), and supported by organizations from the sector: the National Museums Directors' Conference, the Museums Libraries and Archives Council, and the Welsh Assembly Government. While this guidance is not statutory, it is a novel development. Previously there was no such code for how museums dealt with human remains in their collections. The policy endorses the repatriation of remains from overseas communities. While it was drawn up to advise institutions on how to deal with claims, there are a number of small shifts in the policy that broaden it out to begin to consider the treatment of all human remains. Firstly, it is concerned with the treatment of human remains of all ages and all countries, whereas the HRWGR was confined to historic remains (deriving from the period between 1500 and 1907).

Secondly, while the policy has three sections, only part three deals with claims for repatriation. The other two sections address the curation, care and use of human remains.

Overall, the guidance presents a confused message about how to treat human remains, reflecting an uncertainty over whether they are uniquely difficult objects and how they should be held. For example, on the one hand it suggests that the holding of human remains is not a problem: 'The vast majority of human remains in UK museums are of UK origin, excavated under uncontentious conditions within a clearly defined legal framework' (DCMS 2005: 7) It also suggests that one ethical principle that should be taken into account when making decisions is: 'Respect for the value of science' (p. 14). On the other hand, the guidance also suggests that all human remains could be subject to careful consideration. In the section on public display it states:

> There are many valid reasons for using them in displays: to educate medical practitioners, to educate people in science and history, to explain burial practices, to bring people into physical contact with past people, and to encourage reflection.
>
> Nevertheless, careful thought should be put into the reasons for, and circumstances of, the display of human remains. (DCMS 2005: 20)

This 'careful thought' is advocated regardless of public opinion: 'Some museums have taken the decision not to display human remains, or images of them, to the public. However, visitor surveys show that the vast majority of museum visitors are comfortable with and often expect to see human remains' (p. 20). The guidance continues:

> Those planning displays should consider how best to prepare visitors to view them respectfully, or to warn those who may not want to see them at all. As a general principle, human remains should be displayed in such a way as to avoid people coming across them unawares. (DCMS 2005: 20)

The suggestion that people should be warned, and that they should not come across human remains unprepared, gives the impression that display of such material is difficult. It may also express an anticipatory concern that people may be offended, even if they have not been. The policy is similarly confused in the section on 'Use, access and education', where it states:

> Handling sessions at museums or at special events are a good way in which the general public may learn about archaeological remains. However, the use of human remains poses special problems. Direct contact by the general public may entail a greater risk of offending religious and other sensitivities than is the case in a more controlled environment.

Those contemplating handling sessions should weigh carefully the po-
tential benefits against the risks involved. (DCMS 2005: 20)

So, the guidance states that handling this material can be positively edu-
cational. But it also warns that doing so may offend people, which, it sug-
gests, is a 'risk' that should be weighed carefully. Overall, while there is
a recognition in the policy of the interests of science, and the interests by
the public in viewing human remains, it errs on the side of suggesting that
human remains are a problem.

Sixteen museums subsequently drafted individual policy on human
remains, which I return to in later chapters, contributing to the idea that
human remains require specific guidance or care.[4] Manchester University
Museum, Glasgow Museums and the Natural History Museum (NHM)
have specific 'Human Remains Panels' for their institutions, which indi-
cates the importance of the issue for those institutions. One panel member
for the NHM is Ian Kennedy, the professor of Health Law, Ethics and Pol-
icy at UCL who chaired the Bristol Royal Infirmary Inquiry, thus further
reinforcing the links between the problem of overseas indigenous remains
and the body part controversies.

Contested Claims Resolved

Once the Human Tissue Act 2004 was passed, two decisions to transfer
human remains out of collections were made, which signaled a shift in prac-
tice and compliance in previously resistant institutions. In 2006 the British
Museum and the Natural History Museum agreed to transfer Aboriginal
human remains following years of refusal, citing the change in law as per-
mitting their change of policy (BM 2006a; NHM 2006a). Both institutions
framed their decision through the discourse of harm caused by coloniza-
tion and the need for therapeutic reparations. This framing by these institu-
tions signals the acceptance of claims-makers' reparations and therapeutic
discourse, which they found difficult to challenge. The high profile barrister
and British Museum trustee, Helena Kennedy, fronted their decision, writing
an opinion piece in the *Guardian* newspaper that rationalized the decision in
terms of the wrongs of colonization, using the term 'genocide'. Kennedy also
stressed the uniqueness of human remains as opposed to objects:

The law prohibits trustees from disposing of any part of the museum's
collection—a sensible measure to protect against short-term financial
or political pressures. But it has long been obvious that human remains
are not like other objects held by museums. Descendants are distressed
that the remains of ancestors have not reached their final resting place,
in accordance with indigenous customs. And when, as in the case of
the Tasmanian Aboriginals, those ancestors suffered such an egregious
wrong, that distress is likely to be very intense. (Kennedy, H. 2006)

This framing is important in terms of signaling the acceptance, by a resistant institution, of the activist arguments in relation to historical suffering, and because it endorses the idea that human remains are unique and different to other objects held in collections. Indeed, this national institution, previously resistant to repatriation, subsequently promoted human remains as different to objects, as a strategy to curtail ramifications of claims on artefacts. A senior professional at the British Museum explained to me in an interview that took place after the decision was taken, in March 2006:

> We also talk about these things as recent human remains, which is different to objects so it doesn't set precedents. You know . . . we are not about sending things back to where they came from, we are about responding to claims on these particular human items in the collection, which are unlike anything else because they are bits of people.

In order to defend the institution from claims on objects, this professional elevated the specific problem of human remains. In this instance, once the law had been changed, an institution previously critical of the problematization of human remains tried to avoid any implication that the move towards repatriation might apply to artefacts, by reinforcing the idea that the holding of human remains is itself problematic.

The decision taken to repatriate the remains of 17 Tasmanian Aboriginals from the Natural History Museum was similarly framed. The written advice from the NHM's Human Remains Advisory Panel to the Trustees stated that while the remains are of scientific value, this is not reason alone to retain them when there are other ethical considerations:

> The remains have been the subject of extensive research in the past and continue to be of interest to scientists. They represent an important part of the spectrum of human diversity, current understanding of which is based in part on research that generated data from these remains [. . .] We do not consider unique or very limited research access to be sufficient reason alone for retention if other ethical considerations weigh in favour of return.(NHM 2006b: 1)

The advice stated that although the remains were legally taken at the time, to hold on to them today would be considered immoral by contemporary standards. The panel concluded that return should occur because of what it could achieve for the community:

> We are moved by the situation of the community in terms of its history and modern position. The significance of the remains to the modern community is beyond doubt and a strong sense of connection and responsibility has been described. There is a clear sense that the return of human remains can have an important role for

the living community in moving forward from a negative historical experience. (NHM 2006a: 2).

In these two decisions, the scientific benefit of the remains is considered of lesser value that the therapeutic impact of the transfer of human remains, removed under colonization, to communities. In these two decisions, by previously resistant and highly symbolic institutions, we can identify the success of claims-makers activity regarding the problem of human remains.

3 The Crisis of Cultural Authority

In campaigning for repatriation, senior professionals participate in activities that result in the removal of, at times, highly valued material from research collections. They appear keen to highlight the negative historical legacy of colonialism, the deleterious impact on communities, and the role that museums have played in this. But until recently, members of the sector would not advocate the removal of valued material from museum collections, nor would they critically question the role of the institution. They were the gatekeepers of such institutions, guarding the collections. Now, some members appear to be opening the gates. What, then, do these activists achieve by questioning the role of the museum, promoting acts that appear to alter, even undermine, their own role and status? Why do they participate in these activities?

Those examining the construction of problems identify and explore the claims-makers' interests in promoting an issue. Joel Best (1990) observes that activists may stand to acquire more influence, or that there may be indirect symbolic benefits which contribute to explaining their activities. In what follows, we see that the campaigners for repatriation are responding to a crisis of authority, and attempting to secure new legitimacy by distancing themselves from a discredited foundational remit. In the past 40 years, the cultural authority of the museum has undergone considerable scrutiny and a number of criticisms, which have resulted in the destabilization of its legitimacy. A number of overlapping social and intellectual shifts have resulted in significant and widespread questioning of the purpose of the museum, which has weakened its traditional sources of justification. Museum theorist Steven Conn (1998) suggests that museums have always perceived themselves to be in crisis. While the crisis discourse may have been present for some time, and there have been fluctuations in the purpose and credibility of these institutions, my central argument is that the foundational principles of the institution have been consistently and profoundly questioned in the past four decades, and that the extent of this legitimation crisis has not been fully recognized.

CULTURAL AUTHORITY

Max Weber's (1968) conceptualization of legitimacy in relation to state authority has provided the analytical framework for most analyses of authority. Weber was interested in legitimate forms of domination. Broadly, he argued that society evolved historically from political orders based on charismatic and traditional types of legitimation, to a modern state legitimated primarily on legal grounds. Authority demonstrates possession of status or a social position that compels trust or obedience. As part of this ability to demand trust or obedience, authority suggests the potential to use force or to penalize people in some fashion. For example, political authority can threaten imprisonment, which makes people reliant upon such authorities for their freedom. However political authority requires respect and consent, rather than domination. Authority therefore incorporates two sources of control: dependence and legitimacy. Political philosopher Hannah Arendt (1977) is careful to stress these two foundations of authority, identified as crucial by Weber, both of which are equally, concomitantly required. Where and when force is used, Arendt suggests, authority has failed. It has also failed when only argument and persuasion are used, for this presumes equality rather than superiority.

Social theorist Richard Sennett (1980) echoes these observations about the importance of legitimacy, in his discussion of authority in the domain of professional and personal relationships. He asks, what makes an authority? Sennett illustrates his answer with an example of the conductors Toscanini and Pierre Monteux. Both were able to discipline the orchestra, but through very different methods. He concludes: 'Assurance, superior judgment, the ability to impose discipline, the capacity to inspire fear: these are the qualities of an authority' (Sennett 1980: 17–18). Authority, then, can involve more than laws or rules. It can also refer to the imposition of definitions of reality or judgments of value and meaning, where the legitimacy of that or those defining reality or making judgments is crucial. Sociologist Paul Starr (1982) terms the authority that defines and affirms judgments of meaning and reality 'cultural authority'. Social and cultural authority differs in several ways, Starr explains. Social authority controls actions and behavior through law, rules and instructions. Cultural authority involves the construction of reality through definitions of fact and value. Institutions such as the church and the academy make authoritative judgments about the nature of the world, as do museums.

THE EMERGENCE OF THE MODERN MUSEUM

Museums hold a cultural authority that frames and affirms the pursuit of truth and defines what is historically and culturally significant. These institutions, which can have varying specialisms; including science, natural

history, art and anthropology, play a role in affirming ideas about the pursuit of knowledge and how it is organized, reinforcing ideas about what is considered important and valuable from human civilizations, for reasons that are historically constituted. While aspects of the museum can be traced back to the medieval Schatz, a treasury of goods collected by the Habsburg Monarchy, or private collecting in the Renaissance, it was the development of public collections in the eighteen and nineteenth century that, arguably, rationalized private collections into a specific meaningful public context (Abt 2006). The museum in this period is generally understood as forming in overlapping stages. The first is the move, in the eighteenth century, of the Royal Collections in France into a semi-public context, reconceptualizing the space and the collection from artefacts chosen randomly by private individuals, into a rational organization of artefacts based on ideas of progress (Prior 2002). As museologist Eileen Hooper-Greenhill writes of this period, the French Revolution created 'the conditions of emergence for a new "truth", a new rationality, out of which came a new functionality for a new institution, the public museum' (Hooper-Greenhill 1989: 63). With the Enlightenment, ideas developed about the absolute character of knowledge, discoverable by the methods of rationalism and its universal applicability, which informed the purpose of the museum and the display of artefacts.

Museum theorist Tony Bennett explains that the emergence of the museum coincided with, and presented, new sets of disciplinary knowledge:

> The birth of the museum is coincident with, and supplied a primary institutional condition for, the emergence of a new set of knowledges— geology, biology, archaeology, anthropology, history and art history— each of which, in its museological deployment, arranged objects as parts of evolutionary sequences (the history of the earth, of life, of man, and of civilization) which, in their interrelations, formed a totalizing order of things and peoples that was historicized through and through. (Bennett 1995: 96)

The assemblage of private objects, once categorized as unique artefacts, was transformed into a collection that demonstrated scientific themes and rational principles of classification. This was a significant shift, where museums holding objects became more than displays of eclectic treasures and developed into institutions concerned with the pursuit and display of knowledge within a rational framework.

Tony Bennett posits that during the nineteenth century the museum was informed by the symbolic use of such institutions to the emerging modern state (Bennett 1995). Pointen (1994) describes how the promotion of the European state in the late eighteenth and early nineteenth century developed with the modern national museum, in his analysis of the Louvre in France. The Louvre had been a palace for the King. When the French revolutionary government nationalized the King's art

collection it became a symbol of the fall of the old regime and the rise of the new order. For Carol Duncan (1995) too, in her exploration of the development of the discipline of art history, the transformation of this palace into a public space accessible to everyone made the museum a demonstration of the state's commitment to the principle of equality and the idea of national identity. Benedict Anderson's (1983) discussion of nation states as imagined political communities shows that museums were used as repositories and narrators of official nationalism and were symbols of those imagined communities.

While Britain did not have a royal art collection to take over as a national symbol, it is argued that museums did become places of Britishness (Bennett 1988). In his study of museums and modernity in Britain, sociologist Nick Prior (2002) explains that museums in the eighteenth century were not usually owned by the state, but in the nineteenth century, following the emergence of citizenship, governance and democracy, they gradually came to be held by the state on behalf of the people. During this period the state began to 'construct a nineteenth-century state art apparatus.'(Prior 2002: 79) This period, according to Nick Prior, gave clarity and concrete form to the museum project, which was then taken up across Europe.

The organization of the social space of the museum occurred alongside the formation of the bourgeois public sphere. Tony Bennett (1995) suggests that the opening of museum to a wider public in the nineteenth century should be read as a regulating mechanism that aimed to expose the working class to the pedagogic mores of middle class culture, in order to civilize them. Bennett, drawing on theorists Foucault and Gramsci, highlights the ways in which the development of the museum was involved in attempts to transform a populace into a citizenry. Bennett discusses what he terms the 'exhibitionary complex', where the exhibition space was a response to public order and which won heart and minds, while the prison institution disciplined and controlled bodies (p. 335). He concludes that the public museum is a product of an outlook that seeks to civilize and educate the masses to produce a 'self-regulating citizenry' (p. 63).

Theorists have thus argued that museums are institutions of 'overpowering cultural authority [. . .] [expressing] ambitious and encyclopaedic claims to knowledge' (Karp and Kratz 1991, cited in Corsane 2005: 39). Crane argues that the authority vested in museums remains 'a fixed aspect of the cultural landscape, so certain does their purpose seem to be' (1997: 46). In line with this analysis, the common sociological understanding of the gallery or museum, as encapsulated by Bourdieu (1984), can be referred to as a dominant ideology approach to state-sponsored cultural institutions, where they are seen to function for the cohesion and reproduction of capitalist society. Museums are taken to contribute to civic ritual, ideals of nationhood, and the promotion of structural inequalities (Fyfe 2006).

A CRISIS OF CULTURAL AUTHORITY

It is widely recognized that the state and associated institutions, including educational, medical and cultural organizations, are in a condition of a legitimation crisis (Arendt 1977; Gabe, Kelleher and Williams 1994; Owens 1985; Eagleton 1993), although there is considerable debate over the causes, periodization, and institutions affected by this crisis. Broadly, a legitimation deficit arises when older sources of justification for institutions have been undermined and eroded (Habermas 1987). I suggest that a number of overlapping social and intellectual shifts have resulted in significant and widespread questioning of the purpose of the museum. These have weakened its traditional sources of justification and contributed to a crisis of cultural authority. It is this that helps to explain the broader context in which professionals have become key advocates in elevating the problem of human remains.

The social theorist Zygmunt Bauman explains that the late eighteenth and early nineteenth century, the time of the emergence of the modern museum, was a time when men of knowledge—the intellectuals—had authority that could be described as legislative (Bauman 1987; 1992). This intellectual climate underpinned the formation of the modern state and official institutions of culture, including education and the early public museums. In the present period, however, Bauman argues that the role for intellectuals as legislators of meaning has weakened. They no longer securely hold legislative authority or the ability to define meaning and outline judgments. Instead, men of knowledge play a role more akin to that of an interpreter. Bauman traces the changing role of intellectuals, the 'legislators of meaning', in relation to the development of the state and the market over the past 200 years. The state's dependence upon intellectuals for legitimation was superseded in the nineteenth century, Bauman writes, by political technologies of panoptical power, fields within which ranks of experts, and expertise, proliferated. Expertise developed with the creation of techniques of surveillance, medicalization and education. As the state's reliance on culture for the reproduction of its power diminished, market forces rose to challenge the autonomy of intellectuals. Bauman describes a clash of interests between philosophers and aestheticians, and emerging market-orientated intellectuals where the production of culture serves the market:

> It is therefore the mechanism of the market which now takes upon itself the role of the judge, the opinion-maker, the verifier of values. Intellectuals have been expropriated again. They have been displaced even in the area which for several centuries seemed to remain uncontestably their own monopolistic domain of authority—the area of culture in general, 'high culture' in particular. (Bauman 1987: 124)

A role in social reproduction remains for intellectuals, Bauman notes, but it is a weaker role of bureaucratic usefulness rather than of legislative power.

The rise of the market has had a significant impact on the role of the museum. In particular, in relation to this study, British cultural policy underwent a significant change in direction in the 1980s (Sinclair 1995; Selwood 2001). Theorists argue that the impact of the fiscal crisis of the welfare state led to cuts in public spending including arts subsidy (Quinn 1988; Gray 2000). During this period arts institutions could not rely on the idea of 'art for its own sake' to justify funding and support, but had to find other utilitarian values with which to promote their work. In the context of decreasing state support, and the introduction of admission charges for most nationals, institutions began to conceptualize and promote exhibitions as products to be marketed with the aim of encouraging larger numbers of paying visitors (Macdonald 1998a). Cultural historian Robert Hewison (1991) argues that the influence of the market during this period shifted the values of the institution away from serious scholarship, which has triggered a crisis of purpose. He suggests that scholarship and stewardship have been abandoned due to market forces.

Postmodern Thinking

In addition to the constraints and pressures arising from the operations of the market, the central tenets of the Enlightenment, which informed the remit of the museum in the eighteenth and nineteenth centuries, have been called into question (Foster 1985; Bennett, O. 1996; 2001). While the principles of the Enlightenment have always evoked some hostility, a number of intellectual trends since the late 1960s have furthered this stance, thus profoundly challenging claims about truth, and the idea of the museum as a distinct realm removed from social and political forces. In particular, these trends are: postmodernism, cultural theory, and postcolonial theory. These trends are complicated, specific and overlapping, and to give a precise account of them and the relationship of each to the other in a few paragraphs will necessarily truncate and reduce their complexity. However, I will attempt to provide a summary of this process.

Postmodernism is a periodizing concept that describes a break with the aesthetic field of modernism. It has come to be used as a term to describe a rupture, in the last few decades of the twentieth century, from the modern period and modernity (Docherty 1993; Jameson 1993). The aspect of postmodernism thinking that has had a major impact on the role of the museum is a scepticism about modernist ideas. This is a way of thinking that developed out of poststructuralist theory in the 1960s and 1970s, as proposed by theorist Jean François Lyotard (1984). Scholar Terry Eagleton (2003) describes the outlook of postmodern thinking as rejecting

concepts of totality, grand historical narratives, universal values, and the very possibility of objective knowledge. Postmodernism is sceptical of truth and progress, and tries to tear down hierarchy, celebrating pluralism and relativism.

> [T]he contemporary movement of thought which rejects totalities, universal values, grand historical narratives, solid foundations to human existence and the possibility of objective knowledge. Postmodernism is sceptical of truth, unity and progress, opposes what it sees as elitism in culture, tends towards cultural relativism, and celebrates pluralism, discontinuity and heterogeneity. (Eagleton 2003: 13)

In relation to intellectual practices, the terms 'modernism' and 'postmodernism' indicate differences in understanding the nature of the social world and the purpose of intellectual work. With the modernist outlook, relativism was to be struggled against and overcome. The postmodern outlook instead holds the view that knowledge is relative. Bauman (1987) makes a helpful distinction between the two, commenting that while it is debatable whether philosophers of the modern era ever established the foundations of objective knowledge, the point is that they pursued it with 'conviction' (Bauman 1987: 120). Under Postmodernity, he argues, the search for truth was deemed pointless and abandoned.

Cultural relativism, the principle that an individual beliefs and activities should be understood in terms of his or her own culture, was originally developed in anthropological research by Franz Boas, influenced by the thinkers Kant, Herder, and von Humboldt, in the first few decades of the twentieth century (Marcus and Fischer 1986). Frank Furedi (2004) maintains that while these ideas were initially held by the right-wing thinkers, then amongst a small group of artists and intellectuals, they became increasingly influential from the 1960s when they were adopted by left-wing thinkers: the 'New Left'. This is a development described by the American cultural critic Alan Bloom as the 'Nietzscheanisation of the left' (1987: 217), when left-wing thinkers became disillusioned by modernism and embraced particularism and heterogeneity. Cultural relativism has subsequently become a prevailing intellectual force.

Cultural Theory

Cultural relativism influenced the development of cultural theory. Its central idea is that culture is a signifying practice that is bound up with value judgments (Hall 1992). Milner and Browitt (2002) identify that cultural theory developed within the academy in the late 1960s, although they trace the origins to the ideas of nineteenth-century thinkers. Cultural theory advanced a broad definition of culture beyond the fine arts, to a more anthropological understanding of common meanings and material practices in a whole society. Culture did not exist in reified spheres but

was a product of social and material relationships and therefore could be 'ordinary', wrote Raymond Williams in the late 1950s (Williams 2001). The emergence of cultural studies and the work of academics such as Raymond Williams, Richard Hoggart, Tony Bennett and Stuart Hall, popularized a political role for culture in society. These theorists were part of a new institution established to address questions of 'cultural apparatus': the Birmingham Centre for Contemporary Cultural Studies, founded in 1964 (Hewison 1995). Their contribution to academic debate was also reflected in the roles they undertook in the arts world. Williams sat on the board of the Arts Council in the 1970s, and Hall has played a prominent role in artistic networks and cultural institutions.

Broadly there are two strands to cultural studies. One involves theorists who argue that cultural studies are a critique that impartially analyzes cultural products and representations, better to understand structuralist dynamics. This approach is predominant in early cultural studies (see for example Jameson 1998; McGuigan 1996; 1999). It draws on a Gramscian analysis of the hegemony of the state in shaping ideology, and sets out to create strategies of resistance to this through critique. The second strand comes from those who argued that it was impossible to think that cultural studies could be separated into a transcendent space for abstract analysis. Theorists argued that cultural studies could never be free from the agenda of state power. Tony Bennett was an influential advocate of this position, arguing that cultural studies was problematic if it saw itself as a critique, for culture would always be used politically (Bennett 1992; 1998). Reformation rather than revolution was seen as the solution.

Museums, for these theorists, are not able to abstract rational thinking for the public, but instead reinforce the values and position of the elites. Theorists developed a highly critical analysis of culture, and advocated that it should be subject to critical engagement, or consciously used to tackle contemporary political problems. Stuart Hall (2001) argued that the history of modernity in the Western canon needed to be reconsidered—although this would be difficult, because 'museums are still deeply enmeshed in systems of power and privilege' (p. 23). The museum, suggested Hall:

> [H]as to be aware that it is a narrative, a selection, whose purpose is not just to disturb the viewer but to itself be disturbed by what it cannot be, by its necessary exclusions. It must make its own disturbance evident so that the viewer is not trapped into the universalized logic of thinking whereby because something has been there for a long period of time and is well funded, it must be 'true' and of value in some aesthetic sense. Its purpose is to destabilize its own stabilities. (Hall 2001: 22)

For Hall, then, the museum should no longer claim to be the legislator of truth, or to consider itself as benign, as this is not possible. Instead it should constantly question these ideas and to disturb them, constantly to

draw attention to the museum's unreliability. With this approach, permanent and continued questioning is advocated in relation to any idea of truth and value. The authority of the institution, for Hall, must constantly be in doubt.

Tony Bennett (1998) argues that museums should discard the old universalist outlook and become a space to discuss diverse narratives and values. Instead of trying to separate culture from the interests of the powerful, Bennett advises that society should use culture as a positive political tool. The curator, he suggests, should discard their traditional position of the legitimate authority and instead become more of a catalyst for debate. Museums should not aim to establish a singular truth claim or narrative, or universal standards of 'the best', but to show the inherent instabilities of truth claims, and give different individuals and ethnic or social groups the opportunity to present their own versions of the past and of cultural value (Bennett 1998).

The development of cultural theory, and the identification of the political role of culture, coincided with and reflected growing disillusionment with the conventional framework of class politics. Terry Eagleton (2003) explains that this interest in cultural politics replaced declining and failed traditional political concerns. Eagleton (2000) argues that the turn to culture in this way is utopian and that it is a desire to achieve in the realm of the imagination a resolution of the fundamental structural contradictions of capital. For him, the poststructuralist turn to culture attributes historical agency to individuated, culturized strategies of representation in the realm of consumption.

The Politics of Recognition

The cultural turn was reinforced by ideas generated by the politics of recognition, which became influential in the social sciences in the late 1980s and 1990s, lending the discipline a therapeutic sensibility. Advocates of the politics of recognition argue that culture should be attributed as much weight as political representation because it deals with the psychological aspect of the individual's relationship to society (Honneth 1995). This view suggests that individuals require not just material wealth but the positive affirmation or 'recognition' of their identities by state and institutional bodies (Taylor 1992; Young 1990). Even the political theorist Nancy Fraser (1995), who has criticisms of this approach, suggests that the redistribution of material wealth is not enough and that attention must be paid to cultural exclusion. The therapeutic ethos, that is the need for institutions to recognize and support the emotional needs of citizens, is increasingly a central function of governments today (Nolan 1998), and, it is argued, cultural policy (Silverman 2002; Furedi 2004; Mirza 2005). These trends have contributed to the shift in the purpose of the museum, away from the pursuit of empirical truth to that of playing a role in therapeutic identity work.

The growth of postmodern thinking and cultural studies stimulated post-colonial studies, which is discussed in Chapter 2. With the rise of postmodern and postcolonial theories, culture and science came to be viewed, not as universal or objective, but as a damaging reflection of the prejudices of European cultures. The impact of these ideas stimulated the 'culture wars', 'history wars' and 'science wars' in the 1980s in North America, in which Enlightenment ideas of truth, universalism, judgment, and progress were criticized, defended and debated (Hunter 1991; Gitlin 1994; 1995; Gross and Levitt 1994; Ross 1996). As a consequence of these intellectual shifts, the outlook of the earlier period that informed the role of the museum—to validate the superiority of modern reason, to make judgments, to pursue the truth and to claim to pursue the truth—have been severely attenuated. The previously overriding cultural authority of the institution has been questioned to the point of crisis.

The Impact on Museology

Until the 1980s, most literature on museums was devoted to reports of exhibitions, discussion about equipment and histories. While there was some examination of the social and educational role of museums, this was marginal (Merriman 1991). This changed dramatically in the 1980s, when a body of work developed criticizing the idea that museums were value-free and arguing that they are inherently and unavoidably political. The debates over objective truth, relativism and the political role for culture, that were present in postmodernism, cultural and postcolonial theory, were rapidly assimilated into museology by theorists and practitioners.

The work of French sociologist Pierre Bourdieu was a catalyst for this approach. In *Distinction: a social critique of the judgement of taste* (1984), Bourdieu explored the social roots and organization of judgment and taste. In this work, and in *The Rules of Art* (1996), Bourdieu developed the idea that cultural discernment was a marker of class position and that visiting galleries was a way to indicate taste and class. Cultural tastes were influenced by primary and secondary socialization processes rather than a response to universal values of truth or beauty. While Bourdieu focused on art galleries in France, his work encouraged a similar analysis of museums. A broad group of museologists and practitioners came to argue that the development of museums in Western societies occurred in specific historical circumstances and actively supported the dominant classes, maintaining the status quo as natural (see for example Duncan and Wallach 1980; Sherman and Rogoff 1994).

Towards the end of the 1980s, a group of British museum professionals and scholars published *The New Museology* (Vergo 1989), a collection of essays that aimed to develop new critical theory on museums and to reconsider the social role of museums. *The New Museology* recommended that

the study of museums and professional work should adopt a greater degree of self-awareness and questioning of the methods employed, as well as the purpose and context of the institutions. The stimulus, wrote the book's editor and Art History professor Peter Vergo, was 'widespread dissatisfaction with the "old museology", both within and outside the museum profession [. . .] [I]t is too much about museum methods and too little about the purposes of museums' (Vergo 1989: 3). There were a number of interventions made into the debate by this volume. Firstly the idea was developed that the meanings of objects are contextual rather than inherent, suggesting that the current social and political conditions and context frame the meanings of the object, rather than that they are given by the object itself. Secondly, the argument was advanced that museums were not as isolated from society as had previously been thought, but were far more influenced by the social circumstances. Thirdly, it was advocated that greater attention should be paid to the perceptions of the visitor or others outside of the profession, counterpoised to concentrating on the needs of the elite. This stimulated a series of studies on audiences and the museum visitor. Overall, this approach postulated that the meanings of museums and their contents were more contingent than had been previously considered. While Vergo referred to the new museology as the emergence of theory in the study of museums, it has come to signify a wider change in thinking and practice in the museum world that has been triggered by this critical approach (Ross 2004). The new museology has been interpreted in different ways in the US, Britain and France, but nonetheless, argues Peter Davies (1999), it can be seen as shorthand for a reassessment of the role of museums in society.

Subsequent to the emergence of the new museology there was, as described by historian Ralph Starn, a 'tidal wave of museum studies' (Starn 2005: 68). The ideological mission, the apparent elitism, and the divisiveness of museum institutions, were critiqued extensively in collections such as that edited by museum theorist Robert Lumley's *The Museum Time Machine: putting cultures on display* (1988) and Sherman and Rogoff's *Museum Culture: histories, discourses, spectacles* (1994), where analysis was focused on the constructions museums have placed on history, difference, class and gender. These edited anthologies developed ideas concerned with and critical of the representation of the past, and assessed how museums reinforce the social divisions in society. There was a developing identification of the role of museums in colonialism and the damaging representation of minorities, influenced by postcolonial theory (see Ames 1992; Barringer and Flynn 1998; Harth 1999; Henare 2005). An example is given by Moira Simpson, theorist and campaigner for the repatriation of human remains, who argues that museums' origins were implicated in colonialism and are still 'inextricably enmeshed' (Simpson 1996: 1). Overall, as the historian Daniel Sherman and the art historian Irit Rogoff describe, 'a broad range of critical analyses have converged on the museum, unmasking the structures, rituals, and procedures by which the relations between

objectives, bodies of knowledge and processes of ideological persuasion are enacted' (1994: ix–v).

Sherman and Rogoff also argue that museums have the potential to become a positive force in society. They draw on the work of Tony Bennett and cultural studies scholars, who argue that museums should drop their traditional claims to knowledge and truth and instead become spaces in which diverse values and narratives can be debated. Theorists and practitioners suggest that museums should distance themselves from the traditional justifications of the museum. The institution should embrace pluralism and include the diverse groups traditionally excluded from the museum (Duncan and Wallach 1980; Hooper-Greenhill 1989; Sherman and Rogoff 1994). In Karp and Lavine's *Exhibiting Cultures: the poetics and politics of museum display* (1991) and Karp, Kreamer and Lavine's *Museums and Communities: the politics of public culture* (1992), papers were published from two conferences on the presentation and interpretation of cultural diversity in museums, which took place at the prestigious Smithsonian Institution in Washington. In *Exhibiting Cultures*, contributors argued for museums as political arenas where definitions of identity and culture are asserted and contested. Museums, they suggested, have the power to represent communities more positively. In *Museums and Communities*, contributors explored the changing ways in which museums should manage relations with communities.

For anthropologist James Clifford (1997), historical claims to universalism are, in fact, partial, related to concrete social locations, and contextually located. Clifford proposes that the hierarchy of value should be contested. He suggests that museums should decenter the collection and include more diverse arts, cultures and traditions. Museums should operate instead as a 'contact zone' and be orientated towards cultivating and sustaining relationships with communities and becoming places for dialogue. Clifford argues that this shifts the location of authority away from the traditional sources and positively changes both the role of the object and the institution.

Academics and professionals are enthusiastic about the significance of culture and museums for identity formation (for example, Appadurai and Breckenridge 1992). Here museums are instructed to play a role in the politics of recognition instead of pursuing discredited notions of truth and knowledge. Nancy Fuller (1992), research programme officer of the Office of Museum Programmes at the Smithsonian, argues that the museum can be a vehicle for community empowerment. Barry Gaither (1992), director of the Museum of the National Centre of Afro-American Artists, suggests that museums can play a role in the reconstruction of society. Laura Peers and Alison Brown (2003) celebrate the way that the relationship between museums and their source communities—the term for those communities considered culturally connected to the artefacts—has changed over the past few decades. As they write: 'No longer able to lay claim to a role as the

custodian of a post-Enlightenment "science" or "knowledge", museums nowadays often promote themselves as field sites or "contact zones"' (Peers and Brown 2003: 2). It is worthy of note that Laura Peers, the co-author of this collection on how to work with source communities, is a curator of the Pitt Rivers Museum in Oxford and was a member of the Working Group on Human Remains, and a campaigner for repatriation who advocated an internal review for the removal from display of uncontested shrunken heads at the museum for which she worked.[1] The problem of human remains, for this professional and anthropologist, is one where the impact of colonization can be reworked and the possibility of equality created (Peers 2007). Similarly, Moira Simpson (1996) argued that by reconfiguring relationships with communities, museums can stimulate profound changes in their lives.

The important observation to be made about these many volumes within the new museology and museum studies, often written by practitioners, is that they have incorporated the intellectual challenges to museum institutions that came from postmodernism, cultural theory and postcolonialism. They are contesting the remit of the institution from the inside. However, what is remarkable about the incorporation and internalization of these challenges is that the process has gone relatively unnoticed. Theorists continue to present museums as monolithic and resistant to change. Most challenges and changes are analyzed as a result of external factors, neglecting an appreciation and analysis of internal influences.

Museums as Sites of Contestation

During the 1990s, museums in America displaying particular histories became a focus for debates about the construction of national histories, representation and remembrance (Zolberg 1996). The most prominent exhibition sparking controversy was the 1994 exhibit of the Enola Gay. The proposed exhibit, marking the fiftieth anniversary of the end of the Second World War, featured the B-29 bomber airplane Enola Gay in the Smithsonian's National Air and Space Museum. The exhibition aimed to raise critical questions about its use. The exhibition stimulated high-profile debate over how the institution should represent the atomic bombing of Japan. Strong criticism of the planned display was mounted by the American Legion and conservative members of Congress, who argued that curators had '"hijacked history"; they were "anti-American"' (Engelhardt and Linenthal 1996: 2).

Theorists have subsequently examined museums as 'sites of contestation' and as influenced by a number of social changes. In *Displays of Power*, Steven Dubin (1999) analyzes a number of controversial exhibitions in American museums, primarily in 1990s but including one that took place in the late 1960s. Museums, Dubin suggests, have become sites of controversy due to three influences: firstly, the legacy of community empowerment that

developed in the 1960s; secondly, the emergence of social history, which has destabilized the traditional history once depicted, thus creating problems as groups compete for representation; and thirdly, because cultural issues more generally became controversial in the 1980s and 1990s, displacing the political sphere as a site of debate. As a result, he ventures, museums have become politicized spaces.

Social anthropologist Sharon Macdonald (1998b) tackles the political and contested nature of exhibitions of science and technology in the edited collection *The Politics of Display*. Like Dubin, Macdonald concentrates on external challenges as crucial, focusing on developments since the 1960s that have contributed to the displacement of the museum's original remit and its emergence as a site of contestation. This, she suggests, has been met with resistance:

> While there has undoubtedly been a proliferation of different, particularly minority, 'voices' speaking in the public arena, the old political and cultural high ground has not simply been relinquished. On the contrary, what we have seen is an escalation of intellectual battles over the legitimacy of different kinds of representation. (Macdonald 1998b: 14)

The controversies over representations of the past are predominantly understood as the results of tension arising from challenges brought by social movements, which make demands regarding the representation of 'their culture'. The institution and profession are characterized as resistant to those challenges (see also Macdonald and Fyfe 1996: 9). In this vein, commenting on controversies over the holding and display of sacred artefacts in museum collections, the sociologist Jan Marontate states: 'Tensions also arise in relations between museums and their "subjects" about ethics and ownership of cultural information or things.' (Marontate 2005: 289) Marontate ventures that museum professionals resist these challenges from their subjects because they still hold on to ideas of truth and objectivity: 'Museum professionals, many of them trained historians, often resist that knowledge is socially constructed [. . .] This has concrete implications for museum practices. Demands for parity of representation or affirmative action for under-represented cultural groups is a common source of friction.' (Marontate 2005: 289). For Marontate, contestations are created when audiences challenge the representation or ownership of their culture, and professionals withstand these challenges as they still feel their way of understanding the world holds firm: that it has an objective reality discoverable by rational investigation, and that is retains its legitimacy. She remarks in passing that conflict does occur between museum professionals within institutions (p. 288), but overall she sees challenges to representation, and the controversial exhibitions that result from this, as a process that is resisted by professionals: 'Museum professionals may be increasingly aware of the importance of public interaction for meaning-making but they

have not necessarily embraced a sense of relativism. Nor have they all relinquished their claims to position of authority' (Marontate 2005: 293).

Although the museum as a site of controversy is commonly interpreted as stimulated by pressure from external groups challenging resisting institutions, in Macdonald's afterward to *The Politics of Display* (1998b), she is careful not to be inflexible in delineating these two sides, explaining that caricatured polarizations do 'symbolic violence' to more complicated positions (Macdonald 1998b: 290). Similarly, her study *Behind the Scenes at the Science Museum* (2002) also acknowledges a more complex interaction. Here Macdonald critiques the frequent assumption within academia that professionals hold strict positivist and celebratory attitudes about science. She explains that this differs from the findings of her ethnographic study of the Science Museum in London, where she observes that staff were involved in debates about social and cultural perspectives on science (Macdonald 2002: 60).

In his analysis of narratives of decline, Oliver Bennett (2001), like Macdonald, points to a more complicated picture than that posited by the common analysis of a bipolar contest between a resistant profession and external challenges. Bennett notes that the relativism that had eroded the defence of high culture was in part felt by those responsible: the directors of cultural institutions and broadcasters who could no longer uphold a status for the arts as value free (Bennett 2001: 132). This departs from Maronate's (2005) assertion that the cultural elite has not taken cultural relativism on board. Similarly, Nick Prior (2006) notes that museums have changed since the 1960s, and that they have engaged with the critique that they are institutions of dominant ideology. Also acknowledging the role of the profession in these contestations, Dubin (2005) observes that change can come from within due to new curators from diverse backgrounds. And the theorist Max Ross (2004) ventures that influences on the institution, including that from the new museology, have shifted priorities, but concludes that museum professionals are highly resistant to change. In particular, Ross argues that the internal culture of the institution and the traditional subject divisions define and defend professional and social identity. He ultimately maintains the characterization of the changes to museum institutions as one in which social groups challenge and demand representation, against the dominance of an elite that still considers the museum to be orientated towards a legislative project.

However, the issue is not simply that the two positions discussed previously—the challenges from the public and community groups regarding the representation of 'their culture' and resistant professionals—represent a too-simplified analysis of the situation. Rather, this characterization of museums as sites of contestation has not adequately considered the role of the profession in advocating some of the challenges they have been facing. While Macdonald, Dubin, Prior, Ross and Bennett all acknowledge debate and shifting values within the profession, they only acknowledge

these trends. What is missing is a substantial exploration of the internal element to these contests; of contestation from and within the profession over the role of the institution. While these theorists refer to the sector becoming more self-reflexive, and integrating critical theories including feminism and postcolonial theory, my central point is that this contribution is more influential than has been previously considered. To date, the literature on contestation in collections has not sufficiently recognized the significance of the extensive internal aspect of the contestation over the role of museum institutions and is prone to interpreting it primarily as a profession still committed to objectivity, reacting to and defying external challenges to its authority.

RECONSTITUTING LEGITIMACY: A TEMPORARY RESOLUTION

We have seen that professionals are involved in an internal challenge to the role of the institution. This has come about because the foundational purpose of the museum—the pursuit of truth and knowledge—has come under unremitting questioning. In actively questioning this traditional role, campaigners are trying to distance themselves from the museum's discredited foundational purpose. The reorientation of the museum away from the weakened objectives of the pursuit of truth and knowledge is part of an attempt to gain authority via establishing a new purpose for the museum in defining and affirming identities. Professionals' engagement with this process can be seen as an attempt to establish a new basis of legitimacy for the institution as an authoritative voice of therapeutic recognition.

Theorists examining the American and British state have identified the introduction of the therapeutic ethos as an opportunity for the state to develop a role as the authoritative voice of recognition (Rieff 1966; Nolan 1998; Furedi 2003). Sociologist James Nolan interprets this shift towards a therapeutic ethos as an opportunity for the state to address its legitimation crisis, because it offers a 'replacement to traditional moral codes and symbols, worn by the effects of modernization' (Nolan 1998: 17). Refashioning a role for the museum as a place of political struggle and the recognition of identity, then, is a way of establishing the role of the institution as one which affirms and valorizes identities, rather than one that plays a legislative role in the construction and affirmation of knowledge. The former is an important role that currently holds legitimacy. The latter is not. As James Nolan argues in relation to the therapeutic ethos in the American state: 'In Bourdieuian terms, it is a form of "cultural capital" that has, in the contemporary cultural context, a high exchange rate' (Nolan 1998: 17).

Such an attempt to re-legitimize the role of the legislator is anticipated in Bauman's work. While Bauman (1987) argues that legislative authority has shifted away from intellectuals, he suggests that they still aim to retain or

refashion their authority. They reposition themselves, he posits, in response to these challenges with the aim of sustaining some form of legitimacy:

> While the postmodern strategy entails the abandonment of the universalistic ambitions of the intellectuals' own tradition, it does not abandon the universalistic ambitions of the intellectuals towards their own tradition; here, they retain their meta-professional authority, legislating about the procedural rules which allow them to arbitrate controversies of opinion and make statements intended as binding (Bauman 1987: 5).

For Bauman, intellectuals aim to retain professional authority by putting themselves in the position of an arbitrator of procedure and opinion. The central question raised is whether the attempt to re-legitimize the museum in this way succeeds. Analyzing the continued unfolding of the problem of human remains would suggest that it does not. As we will see, despite attempts to resolve this contestation by defining the institution as moving away from the traditional role and engaging in identity work, professionals have continued to question their own authority. This continued questioning is of particular importance, because it suggests that solutions to the problem of legitimacy are provisional.

An Internal Battle

Besides studying the claims-makers as a method of examining the diffusion of the problem, Philip Jenkins (1992) outlines that social problems should be understood in terms of those attempting to define them. While any document or policy analysis is a useful method to assess ideas, to explore how they are framed and their institutionalization, this focus has certain limits because texts usually serve a function of rationalising policies. I needed to know how professionals interpreted and understood this problem. Therefore it was important that I analysed how professionals understood the issue. Interviews were particularly helpful to do this, because they explore the world of beliefs and meanings (Arksey and Knight 1999). Through interviewing the actors, I was able to examine why they were involved in different aspects of this debate and assess how they interpreted their involvement in this issue.

The majority of the comments made by interviewees regarding the holding of human remains were situated in a broader discussion about changes within the museum remit, concerning the role and purpose of the institution. Thirty-three interviewees commented, without prompting, that museums are in the process of a number of changes in relation to the role that they play. The prime concern about these changes was that they didn't go far enough, due to fellow professionals who were framed as acting in 'traditional' or 'old fashioned' ways. The word 'traditional' or 'traditionally'

was often used by actors, to characterize practice and behavior deemed problematic, which needed to be addressed and changed. One curator from a regional museum explained:

> Traditionally the museum community is obsessed with ownership, control and authority . . . We know now ourselves that it won't do, you know, but it's so ingrained in us we cannot quite kick it, so you know, we are wavering between the two.

This individual welcomed the general changes in museums. He felt the process was positive. Indeed he explained that while change was difficult it was necessary to continue to press for change in other professionals, commenting that there were individuals who were still too controlling.

> We know we should be better at sharing and not controlling but we can't quite kick it. And that is a little bit . . . a bit about the type of people who work in museums, without being too crude, um . . . there is still a generation of people who work in museums, you know who are . . . still in the past, their whole psyche is about control, ownership and authority and not talking and not sharing.

The concern expressed by this curator describes how there are still people in the sector who retain the idea that they are an authority and feel that they control and own the objects. This focus of concern—professionals was held by another interviewee. This senior curator of a regional museum positioned his own advocacy work around human remains in a context of a long-term campaign to change the remit of the museum and those individuals formally termed keepers:

> I've had to battle all my life with people in museums who are, to put it crudely, carers and sharers . . . you know keepers is the right name for some of them. Carers are anally retentive . . . sharers tend to be the opposite but tend not to have, you know, the scholarly background but are really excited by the museum as a social enterprise . . . and that I think what you are seeing in British museums is an agenda which have moved away from the carer to the sharer.

His reference to a 'battle' suggests that the debate about the remit of the museum is significant for him, reinforced by the dramatic use of 'all my life'. That he identifies the 'battle' with 'people in museums' reveals the internal objective of changing the behaviour of professionals, through this issue. His account of the changes in museums echoes Bauman's (1987) articulation of the move from a legislative role, to one of facilitator, when he describes the agenda moving from the carer to the sharer. While this interviewee was 'excited' about changes in museums and a more social role,

he was highly critical of those in the sector who tried to 'hang on' both to objects and authority. His reference to carers as 'anally retentive' leaves us in no doubt that he disapproves of this stance.

Another interviewee, a senior archaeologist at a university museum and campaigner also argued that the institution needs to change, suggesting that it should play a different role today which makes a contribution to society.

> Museums have to grow up, which is to be less concerned with where things are, and less concerned with . . . maybe issues around control and authority, but just to make sure that . . . um . . . artefacts or other material over which the museum has responsibility for . . . be in a position where they can do most good.

This interviewee opines that the role of the collection should not be object, research or aesthetics orientated. Instead he ventures it should devote itself to a social role and where they can do good. Controlling objects, holding on to them, represents the wrongful assertion of authority to him.

Others were enthusiastic about the contestation over human remains because it suggested museums could change. One archaeologist in a regional museum expressed regret that the repatriation debate had been resolved before she got the job as she would have liked to be involved, even though there were no human remains from overseas communities in the collection. She commented: 'It's a shame as it was so exciting, you know, people were really doing some good and getting things changed.' The issue had symbolic resonance with this individual, despite not being involved in a particular case and even though the museum she worked for held no remains from overseas communities. This curator aged in her twenties had been commissioned to write the museum's general policy on human remains. She was of the view that she was instructed to do so, specifically she was in tune with the wider inclusion agenda in the institution, as indicated when she got the job for this reason. She commented:

> One the reasons I got this job, I've been told, is because of my access experience from the course in Leicester.[2] I was up against two curators with 30 years experience, but they wanted me because they are too collections focused . . . too much in the backroom.

A recurring motif is the problem of 'control' or 'controlling' professionals and their holding on to collections, which is contrasted to sharing objects and authority with communities. She continued: 'All museum curators today are trying to look at collections differently. You know in the past, it was collect it for yourself, or for collection' sake, not, you know, never for the visitor. Not for the visitor.'

For another curator, at a national museum, the purpose of the collection in contemporary society is to create relationships:

> [W]e certainly feel that the central role of museums in modern so-ciety is to broker relationships, relationships between collections and communities, or sometimes between different communities, using the collections in an active way. And you can use the collections in, you can either acquire new collections in order to create relationships, or sometimes you can give back collections to broker relationships. And what we are interested in is in sustainable, respectful and reciprocal relations.

His use of the description 'active' implies that other ways of engaging with the collection, that is using it without communities, is passive and thus negative. For him the collection has a positive purpose when it is orientated towards forging or sustaining a relationship with communities outside the museum. Putting collections to a social use with communities is considered their proper value, for this professional.

Involvement in the campaign to either transfer human remains, or to encourage respectful treatment, was an issue that activists took very seri-ously and identified with strongly. For one archaeologist and campaigner from a university museum, being involved in the debate was highly impor-tant to them; more so than their trained area of expertise:

> I am an archaeologist. My specialism is the Persian period . . . a big find has just happened and I should go, I am the expert of . . . in this area, but I would much rather stay and do this, this is more pressing and important for me now.

The intensely personal identification of some individuals around this problem speaks to its symbolic nature. For this individual, being involved in campaigning for, in his case, greater 'respect' for human remains gener-ally, was considered more important than work which involved his trained expertise. It gave him a positive sense of purpose.

Imposing Divisions between the Past and the Present

The dominant theme in my interviews was the problem with traditional museum, and professionals who wanted to retain objects and authority, which interviewees constantly contrasted to their aims and actions. Inter-viewees repeatedly spoke of 'the traditional museum' in 'the past' as act-ing in a certain, problematic, fashion, including: keeping or controlling of objects, the pursuit of knowledge, thinking solely about the collection instead of the audience, or only thinking about an elite audience. For exam-ple in one interview, a curator at a local museum, explained:

[. . .] in the old days museums displayed things associated with faith and belief, but from the point of view of anthropology, archaeology, sociology, fine or decorative art, you know. Traditionally, the objective was appreciation not participation.

Displaying material organized through subject division is seen as promoting 'appreciation' which this interviewee suggests is different to the preferred aim of 'participation.'

There was less detail about current practice than an emphasis on the point that the present practice is unlike the past. For example, when talking about the need to consult with different groups, the emphasis in the following extract is less on the specifics of the groups, their needs or particular concerns, than the actions of the museum and the shifts in what it is to be a curator:

> Generally we are consulting more and more. We will consult on everything in future. It's so completely different to how it used to be done, you know. About a year ago we set up the community consultation panel with different faith groups and other groups. It's about not being so arrogant. Not like, I'm a curator and I know best.

Here we can see the idea that the curator in the past was arrogant and assumed they knew best.

One curator commented that they were not especially concerned about particular treatment of human remains, but that their treatment should be rethought, primarily it would seem because contemporary practice relied on the old way of doing things:

> I do think that there is a need for serious ethical debate about the issue of how all human remains are treated in museums. I don't think they should be just taken off display . . . really . . . I'm not quite sure, I don't think so. But a lot of what we do just relies on what we used to do, and maybe that needs rethinking.

The talk about the past to justify, even define, contemporary action pervades the discourse. The constant rhetoric that the traditional museum needs to change, or that this is not how it was done in the past, raises the question of how important it is to impose this division position between the old and the new, the traditional and the contemporary. It suggests that present day actions are a strategy to distance professionals from the past.

While most interviewees framed their views regarding human remains and museums in terms of the need for historical changes in institutions, there were 10 individuals who tried to do the opposite. These professionals aimed to contain or avoid any implied wider ramifications to the remit of the institution. These ten had been, or still were, critical of changes to

the holding of human remains, and had been critical of the transfer of this material out of collections. One curator who had criticized the transfer of human remains and described it as a serious threat to science, claimed the same material that he had said was valuable, was not, once the law had been passed and remains transferred from the collection. He commented after these developments: 'I see it as a political issue and you know, we weren't working on those skulls. I don't think anyone really wanted to, because they were not useful, and they wanted them.' This professional, over time, down-played the significance of the transfer of this set of remains which he had once identified as important. His use of the term 'political' is a way of diminishing the action and distancing it from general practice. He tried to smooth out divisions in the conception of these changes on the impact of the museum, rather than impose them. Another tried to play down any implication of changes to the institution, suggesting that the transfer of human remains was an act in continuity with the historical remit of the institution, instead of the more frequent presentation of it as a dramatic shift. Firstly, he framed the transfer of human remains as contributing to an idea of public benefit because of the gains to knowledge from Australian aboriginal communities, rather than as a loss to knowledge:

> If we want to expand the work we do across Australia we want to work with representatives of those communities . . . it's a good thing . . . and they know stuff we don't, so there is an important public benefit in the return. We will learn from them, so it's to the benefit of the museum. And so then the removal doesn't really entail a loss . . . In fact, we've always been, museums have always been about public benefit.

The implication is that museums will learn from communities, rather than loose research material. The comment that 'museums have always been about public benefit' suggests that this act is not a significant change in practice, but holds a historical continuity with past practice.

Problematizing the Government Guidance

By the end of 2005, the major legal change that campaigners were advocating—an amendment to the British Museum Act to permit de-accessioning—was passed in the Human Tissue Act (2004). Significant agreements were reached to transfer Aboriginal human remains out of the British Museum and the Natural History Museum: two important, and previously resistant, national institutions. Furthermore, the *Guidance for the Care of Human Remains in Museums* (DCMS 2005) was published by the Department for Culture, Media and Sport (DCMS), designed to advise institutions on dealing with repatriation requests, and place parameters on actions and treatment concerning human remains. In so doing, the guidance intended to draw the controversy to a close. However, instead of resolving the debate, it

was to continue. There was a highly critical response to the document from two groups. One was the newly-formed Pagan organization, Honouring the Ancient Dead, which was formed to make claims on human remains and is discussed in detail in Chapter 4. The other group was formed of members of the museum sector, discussed subsequently. Both groups demonstrate the continued problem of challenges to authority from within the profession.

The main concern expressed by critics of the DCMS guidance was that museum professionals continue to impose their authority, because it is they who are charged with deciding the future of human remains, even if they repatriate them. Indeed, this is explicitly acknowledged by the policy as a problem that should be alleviated over time:

> However, as the current guardians of the remains, the museum will have the responsibility of making the decision over their future and this will make the process one-sided. It is hoped that, through time and a continuing open and constructive dialogue between museums and claimant groups, the process will become equal. (DCMS 2005: 24)

One member of the committee that drafted the guidance explained to me, in an interview in early 2006, that the committee was concerned about the museum sector continuing as the decision-maker in human remains cases. Hopefully, he said, the one-sided nature of the relationship would change:

> [W]e went through that whole thing of . . . we went on and on about how this has to be an equitable equal relationship . . . then someone said . . . but they are in our collections and we'll be making the final decision. We went, 'oh God', without speaking for five minutes . . . but we have to accept it. They start off in our care, so we will be the ones that decide. At first . . . and then we'll see.

Commenting in the *Museums Journal* Tristram Besterman (cited in Heywood 2009: 35) stated: 'The DCMS criteria spring from a western museum mindset that only rubs salt into the wound of the original act of dispossession', arguing that the balance of power is still unequal: the western institution holds all the cards and makes all the rules. The response from the Museums Association was similar. While it welcomed the code of practice, it warned that museums retained too much power to decide the future of the human remains. In a formal response to the DCMS guidance the body stated it was 'disappointed' that there was no 'firm commitment' to the establishment of an advisory panel for museums to seek 'independent advice' in cases involving human remains requests (MA 2005: unpaginated). An advisory panel would have ensured that museums were not able to dominate the decision-making process, the MA argued.

Interviewees often raised this problem, which, in different respects, focused on the authority of the museum institution or professional and the problems of privileging scientific research, or traditional ways of working. Three interviewees cited this particular policy as problematically privileging scientific research. It is worth contrasting this complaint with what the policy says, as while it recognizes the value of science, it also recognizes other different views about the value of human remains. The *Guidance for the Care of Human Remains in Museums* states:

> Requests concerning the appropriate care or return of particular human remains should be resolved by individual museums on a case-by-case basis. This will involve the consideration of possession; the cultural and religious values of the interested individuals or communities and the strength of their relationship to the remains in question; cultural, spiritual and religious significance of the remains; the scientific, education and historical importance of the material. (DCMS 2005: 23)

Despite this recognition of cultural values, two curators and one director whom I interviewed complained that the guidance: 'privileges scientific values'. Similarly, five interviewees were concerned that the claims made on the basis of the document would be evaluated by a 'genealogical model' which, they said, was a problem. Again it is worth looking at what the document does say, as well as the criticism it attracted. The guidance states that claims will be considered both from genealogical descendents as well as those from the cultural community of origin (DCMS 2005: 26), which, it acknowledges, can be difficult to define. Of the cultural community of origin, the guidance states:

> [T]he assumption is that human society is characterized by the creation of communities that individuals feel a part of and which take on a collective set of values, often identified by particular cultural behaviour [. . .] For a community to be recognized and their claim considered it would generally be expected that continuity of belief, customs or language could be demonstrated between the claimants and the community from which the remains originate. (DCMS 2005: 26)

Despite this recognition of cultural community, rather than strict genealogy, for some members of the sector the guidance still problematically favored the genealogical model for assessing claims. One argued that 'the genealogical model is ultimately a colonial model', and that asking claimants to prove they were related at all 'could be seen as an abuse, a continued colonial relationship acted out as a result of this guidance'. For this interviewee, asking claimants to explain their relationship to the human remains they were claiming was repeating the 'abuse' of past colonial domination. Another curator expressed concern about the impact on potential

claimants of criteria that asked them to articulate their relationship to the human remains and their meaning to them: 'It's offensive to claimants to have to prove that the remains are significant to them'.

The major issue for 12 interviewees was that the decision about what would happen to the human remains resided with the museum. They expressed concern about the dominance of the museum in these decisions, arguing it was not their place to decide on lineage or affiliation. For example, according to a senior curator of a national museum: 'We are not the people who should decide what a legitimate connection or authority is. We should not be deciding what is a valid link or not'. For one curator, it was essential that professionals learn to remove their authority: 'It's about time we learnt that we do not know everything and there are other ways of understanding the world. We have to cede our authority.'

The continued problem of human remains in museum collections, despite the change in law and the transfer of significant remains out of collections to overseas communities, indicates that there is an underlying dynamic to this problem, which concerns internal questioning of the authority of the museum and the museum professional. The professional body of the sector, and individual professionals, voice the problem that they are retaining too much control in relation to the holding and collection of objects. Such criticism of the guidance indicates that the problem of human remains is partly driven by members of the sector who wish to devolve the authority of the profession and the institution. That some members of the profession appear uncomfortable with their position of decision-maker, and that they continue to try and outsource this role, suggests that despite attempts to resolve the contestation over human remains through legislation, codes of conduct and significant repatriation acts, possible solutions have a provisional and limited quality. The ongoing concern over 'who decides?' indicates that the problem of the authority of the profession and institution is not easily resolved. There is a continued problem of legitimacy.

4 The Rise and Impact of Pagan Claims-Makers

'We care about the bones of our ancestors.' So claimed Druid Princess Emma Restall Orr on the BBC's flagship news and discussion programme *Newsnight* in early 2010.[1] Reburial of the bones is necessary, she said, because: 'In Pagan terms it matters because of the cycle of life and death. When we return the bones to the soil, we're giving them back to the earth'.

Joel Best (1987) observes that newly constructed problems may encourage new claims-makers. This chapter examines such a process. The prevailing cultural climate in which human remains became objects of contestation cultivated the conditions for different Pagan groups to make claims on human remains, in order to lend weight to their existing demands for recognition and involvement in heritage issues. Pertinent to this study is the reaction to their campaigning by the museum sector. Despite considerable difficulties in the framing of the problem by Pagan activists, one group in particular, Honouring the Ancient Dead (HAD), has had a moderate influence.[2] Certain professionals have been highly positive towards this group's activism, because it fitted with their agenda in challenging professional authority. Although the response of the rest of the sector to HAD has been more ambivalent, an inability to draw the line regarding who should be involved in museum practice and why means that activism from Pagans has had an influence that professionals find difficult to resist.

PAGAN CLAIMS-MAKERS

Postmodernity has been described by theorist Michel Maffesoli as the 'time of the tribes' (1996), characterizing the fragmentary and fluid associations of individuals and groups in contemporary society. This description captures modern-day Paganism, cited as one of the fastest-growing spiritual orientations in the West (Hardman and Harvey 2000; York 2003). A study conducted by the historian Ronald Hutton (2001) estimated that there are 250,000 Neo-Pagan adherents in Britain, although these figures are highly variable, partly due to the fluid and private nature of the movement, which comprises a diverse group of people that orientate around shifting

and varying concerns. Scholars have theorized its dynamic nature (Clifton and Harvey 2004). Hutton describes the term 'Paganism' as inviting 'debate in itself, for the expression covers a multitude of faiths and practices, with only a limited (though important) amount in common' (Hutton 1995: 3). Nor does it necessarily denote an organized group. Theologian Amy Simes (1995) explains that while the growth of contemporary Pagan organizations may be rapid, many different groupings emerge and then disperse. They are often individualistic practitioners and their worship is frequently private.

Despite the fluidity, there are identifiable threads. As a generic term, Paganism is understood to encompass several recognized sets of beliefs. Hardman and Harvey (1995) explain that important shared ideas are the centrality of nature and the limits of one authority. Sociologist Jon Bloch echoes this observation about the perceived limits of authority and a critique of dualistic thinking, positing that the self is considered to have final authority as to what to believe in counter-cultural spirituality, which legitimates the 'pick and choose' attitude towards different beliefs and religions (Bloch 1998: 33). Hardman and Harvey (2000) identify contemporary cultural influences, explaining that while Paganism has always had an environmentalist philosophy and a romantic view of the land, this has become more coherent in the last decade, influenced by broader environmental thinking. Many describe themselves as polytheistic, worshipping a number of gods and goddesses. Pagan worldviews may include spirits, goddesses or gods, nature as an entity, or an animist outlook. The best-known paths are Wicca, Druidry, Heathenry and Goddess Spirituality, with individuals often identifying with more than one at a time. Contemporary Paganism, then, comprises a variety of paths, some of which overlap. It can be characterized as a coalescence of individuals around the view that a single authority has limitations, around nature-orientated traditions, and the rooting of authority in the self, rather than an organized belief system.

Emerging Pagan Claims on Human Remains

Social scientists Blain and Wallis (2007) propose the term 'new-indigenes' as an extension of Maffesoli's 'new tribes' for those Pagans whose practices involve ideas of re-enchantment of nature and human life, which they identify as inherent in the past and to be engaged with via prehistoric sites. While not all Pagans concern themselves with the past, many do; particularly Druids and Heathens (York 1995). Druidry, or Neo-Druidry as it is sometimes termed, is influenced by modern interpretations of Celtic religion and can be understood as orientated towards nature, with roots in pre-Christian times.

Over the past three decades, the prehistoric monument Stonehenge, in Wiltshire, England, has become an increasing focus of attention for Pagans interested in engaging with the past and the environment (Bender 1993; Hetherington 2000). There were high profile contests over access to the site

in the mid-1980s, between New Age Travellers, Pagans, and heritage organizations, the police and the government. These continued in the 1990s and early 2000s, when groups opposed the plans supported by English Heritage and the National Trust for the development of the A303 motorway around Stonehenge and the construction of a visitor center. Friction has continued as plans for Stonehenge evolved (Blain and Wallis 2007).

It is out of the struggles at Stonehenge that three well-known individuals, negotiating for access and influence, expanded their demands, also raising concerns about the treatment of human remains excavated on the site, and asking for burial, ritual or respect. They tried to link their campaigning over access to Stonehenge to the ongoing contestation over human remains, to give weight to their already-existing demands. The central protagonists are: Philip 'Greywolf' Shallcrass, joint-chief of the British Druid Order; the British Druid Order member, Paul Davies; and Emma Restall Orr, who is founder, head and treasurer of the Druid Network. The first two operate primarily as individuals. They do not seek to form any kind of organization but campaign alone, and have both supported and opposed Restall Orr. Restall Orr formed the campaign group Honouring the Ancient Dead (HAD) in 2004, to raise the issue of the treatment of human remains in archaeological excavation and in museum collections. HAD is described as an advocacy organization for Pagan groups concerned with the treatment of ancient British human remains.

The issue was first mentioned in the writing of these claims-makers in the late 1990s by Druid Paul Davies, during a time when the campaign to repatriate overseas human remains became prominent within the archaeological and museum sector. As Davies stated in the magazine *The Druids' Voice*, the journal for the council of British Druid Orders, in relation to the reburial issue: 'Aboriginal Americans and Australians have achieved this goal with their respective governments. Now it is our turn.' (Davies 1997: 13) Blain and Wallis posit that some Pagans deliberately align themselves with indigenous people elsewhere, as part of their identity construction (2003). Marion Bowman (1995) has examined those who identify themselves as Celts. Bowman notes that increasing numbers of people, particularly contemporary Pagans, 'feel' they are native to the British Isles. They may claim to be Celtic even if they have no Scots, Irish, Cornish or Manx parentage. Bowman terms this group 'Cardiac Celts' (1995: 246).

In interviews with Restall Orr and Pagans interested in this issue, and at conferences and meetings on human remains issues, there was frequent mention of overseas indigenous groups, primarily to support the Pagan's claim that they should receive similar treatment. In the first interview I conducted with Restall Orr, in November 2006, she explained:

> If I were called Susie Black Water and were seeking repatriation of
> my great grandmother's bones back to my own tribal lands in North

America, most museums would now deal with me courteously and with respect. However, because I am a Pagan, asking about the bones of my ancient ancestors, I am judged and dismissed as irrational.

Restall Orr complained that Pagans were often 'dismissed' by heritage organizations, because of their beliefs. The problem she identifies is the attitude of 'most museums' towards Paganism, pointing out that overseas indigenous groups, who also don't fit the rational framework, have been treated with respect. In the following interview, conducted in November 2006, a member of HAD explained that while there was a practical benefit to the claims from overseas indigenous groups, he felt that Pagans had not gained similar recognition:

Aboriginals and Native Americans have helped open up the debate, probably, I think, to a much wider stance . . . um . . . it's certainly allowed us to say if you are doing it for them, why can't you do the same thing for us. Um . . . you know, because, you know, it's that sort of thing, that what's good for the goose is good for the gander, um . . . you know, hang on a minute, we are here. This is actually, you know, they are thousands of miles away, why are they getting special treatment?

These remarks identify the central problem as that of the exclusion of Pagans by heritage organizations, in contrast to their treatment of overseas indigenous groups. The statement that this interviewee makes—'hang on a minute, we are here'—speaks to strong feelings of non-recognition. Frank Furedi (2003) suggests that the conceptualization of recognition as an individual right may encourage more recognition claims. He observes that the growth of compensation culture, stimulated by the growth of therapy culture, confers 'moral privilege' on those individuals who can establish their victim identity, which encourages people to see themselves as victims and to claim compensation. In Chapter 3, we saw that the remit of the museum has moved away from an empirical remit towards an inclusive, at times therapeutic, model in response to a crisis of legitimacy, and seeks to play a role in the recognition of community identities. The developing focus of HAD, in requesting affirmation by heritage organizations of their Pagan beliefs, suggests that this process invites communities to ask for recognition: a commitment that it is not clear that the museum can consistently honor. The recognition of certain identities by institutions grants a moral authority to selected groups that others also seek, and for which they therefore campaign. The moral privilege rhetorically bestowed on overseas indigenous groups has encouraged communities in Britain to demand equivalent treatment.

RESPECT, RITUAL OR REBURIAL? HOW MEMBERS OF HONOURING THE ANCIENT DEAD FRAME THEIR CLAIMS

The archaeological activists in North America seeking repatriation named their campaign to transfer human remains to indigenous groups the 'reburial issue'. British campaigners quickly ceased using this terminology, but it is nonetheless picked up by HAD in an attempt to piggyback on to this established problem. What is most notable, however, is that HAD's aims are inconsistent. At times, the organization asks for respect or ritual, as well as, or instead of, reburial. The framing of claims is usually a highly fluid process that depends upon the interaction with different groups and the purchase for their ideas. But it is especially changeable in this case. Honouring the Ancient Dead attempts to key into established frames and associate themselves with the problems that are established, but finds it difficult to sustain the motifs in interaction with others. As a consequence, unlike the coherent framing of claims made by the activists in Chapter 1, those made by HAD are more confused.

Demands for reburial and respect are used interchangeably in HAD's campaigning activity, as the following paragraph, taken from an article by Restall Orr in *British Archaeology*, illustrates:

> When Pagans speak of reburial, they are not demanding marked graves lauded over with occultism or magic. They seek simply the absolute as-surance of respect. In my opinion, reburial of every bone shard is not necessary: ritual is.
>
> At Stonehenge, should human remains or burial/sacrificial artefacts be found, priests will be called. Appropriate prayers and ritual will be made to honour the dead, their stories and gifts to the gods. Once finds are catalogued, reburial will be considered by all relevant parties. (Restall Orr 2004: 39)

This article states that when Pagans ask for reburial, this does not mean reburial. Instead, they 'seek assurances of respect'—which are not defined—and the requirement of ritual. Restall Orr refers to human remains and sacrificial artefacts as a focus, which further muddles the problem: is it human remains or is it burial of sacrificial artefacts, and what is it about any of these things that requires respect or ritual?

The use of the term 'reburial' is erratically employed in the writing and talks by HAD, and shifts to a call for 'respect'. The loosely-defined aim of respect is increasingly included in the group's writing and presentations, developing through a relationship with the museum professional Piotr Bienkowski, from Manchester University Museum. This is a discourse that operates, to use the term developed by Norman Fairclough (2003), on a logic of equivalence. By putting respect in relation to the already established

discourse of reburial, the two are associated. The term 'reburial' is used give the poorly-defined aims of respect rhetorical power. Take this extract from a conference paper delivered by Restall Orr to the 'Respect for Ancient British Human Remains' conference in 2006, a conference for museum professionals that she organized with Bienkowski:

> Although for many Pagans, the visceral need is to cry out for reburial of all human remains, this is neither the purpose of this conference, nor of HAD. Respect, however, must encompass the way in which human remains are exhumed, stored, displayed or reburied, with decisions and action based on sincere and informed debate. (Restall Orr 2006: 8)

The reference to reburial lends rhetorical force to HAD's claims for respect. But this dilution of demands, from reburial to respect, means that its claims lack a focus, which may limit their efficacy.

As well as borrowing the 'reburial' and 'respect' rhetoric from repatriation campaigners, HAD attempts to employ the frame that critiques science and archaeology and which establishes the necessary villains. To some extent this motif chimes with Paganism, in that one important shared belief is that secular rationality has created a false dichotomy between matter and spirit, which means that science and authority can be criticized as dualistic. In interviews, articles, conference papers and presentations, Restall Orr condemns science and archaeology. As she argues in *British Archaeology*, 'Attitudes towards the ancient dead are a significant part of the clash between Paganism and fact-searching archaeology. Within Paganism, the dead are revered. (2004: 39) Archaeology is characterized as 'fact searching' which, it is implied, is a problem, in contrast with Paganism, which, she suggests, cares for the dead. In HAD's formal response to the British government's *Guidance for the Care of Human Remains in Museums* (DCMS 2005), science is criticized as one view that is given undue privilege in the policy. This chimes with the Pagan concerns about monolithic authority:

> For archaeologists from outside the area to claim full authority to take away those ancient human remains, and to claim that the community has no involvement in deciding their future, is simply arrogance and abuse of power. It puts sole authority over ancient human remains into the hands of a small, unelected, distant, disciplinary-based group. (HAD, undated, circa 2007, unpaginated)

The common elevation of archaeologists as decision makers is problematic, in HAD's eyes, because it gives too much power to a discipline-based group. There is an attempt to contrast honoring the dead with scientific advancement. The dead are what will be harmed if science is allowed to continue unabated and the villains are the archaeologists and scientists.

Restall Orr finds it difficult to maintain the critique of science and archaeology in interaction with critics. In 2007, the BBC's *Heaven and Earth Show*[3] dedicated an item to Pagan claims on human remains. Restall Orr was joined in the studio by the Labour MP Chris Bryant, and the evolutionary psychologist Oliver Curry. Bryant and the programme's presenter challenged Restall Orr, who had said the scientific information to be gleaned from human remains was negligible. She responded defensively:

> [I]t's so seldom that this information comes through. And what most Pagans are looking at is, is not the last 1500 years where mostly, um, human remains are being excavated from Christian consecrated grounds, and are going through [. . .] a process of research, and most Pagans would say that's wonderful. The science is, is, most Pagans are not anti-science, we are not anti-science. It's not about stopping that research. It is about allowing the social and spiritual religious value of these to be a part of the consultation, in terms of what happens to those bones once they've been through the scientific, um, process. And a lot of these bones in museums have already been through that process of research. Um . . . are perhaps contaminated beyond use anyway because they've been dug up by the proto archaeologists; the antiquarians, they've been stuck in boxes.

In response to the assertion of the value of scientific research on human remains, Restall Orr stated that Pagans are not anti-science, revealing that this is often how they are characterized. This a much weaker criticism compared to the forceful critique of science put forward by campaigners discussed in previous chapters, where professionals condemned science as dangerous, and, while acknowledging the loss of important research material, argued that this was less important than helping the communities that would receive the repatriated human remains. Restall Orr tried to suggest that, instead of stopping research, Pagans are asking for different values to be included, which she defined relatively weakly as 'the social and spiritual religious value'. Furthermore she narrowed down the remains they are interested in claiming to those more than 1,500 years old, and implied that scientific research would be difficult because of the actions of particular archaeologists.

Further on in the conversation, when pressed about the claim that Pagans have over ancient human remains, Restall Orr backtracked again:

Oliver Curry: [T]here doesn't seem to be a direct link between Pagans and
 . . .
Restall Orr: And that's exactly what we're not, we're not, we don't have a special claim, and that's the big misunderstanding. We are not saying, we are not saying we have a special claim, we are saying we have a special interest which is completely different.

In this exchange, Restall Orr was unable to assert that Pagans do have a claim on these human remains, and tried instead to ask for a 'special interest'. This indicates an awareness of, and inability to challenge, the contested legitimacy of her claim.

We have seen how activists in the UK successfully linked their campaign to the contemporary body parts controversies, lending their arguments a powerful association with this high profile problem. This linking is only attempted by Pagan claims-makers on a few occasions and without success. HAD does not pursue a link, as other campaigners have done, to give its claims greater force. Furthermore, unlike the campaigners discussed in Chapter 1 who use words such as 'deflesh' and 'body parts', Pagan activists do not rhetorically use the body in an attempt to make the objects of contestation more person-like.

According to Joel Best (1987), the construction of a problem requires that grounds are made that consist of definitions, examples and numeric examples. On a number of occasions, Restall Orr's characterization of the problem is diluted and shifts in interaction with critics, asking for consultation instead of stopping scientific research, and stating a special interest instead of a special claim. She tries to redefine the scope of the problem as soon as she is questioned. There is no reference to numbers to give any sense of a widespread problem, nor the use of any other similar rhetorical device, which is one reason why the problem is not fully conveyed. Nor is there any reference to an example or case that can operate as an exemplar, associating the issue with an atrocity tale that can shape the perception of the problem: as in the cases of Truganini or William Lanney, which were effectively constructed by campaigners in the museum sector.

Claims for Legitimacy

A further analysis of their aims and activities reveals a number of legitimacy claims. One legitimacy claim is that the campaigners should be recognized due to their religious beliefs, and that it would be discriminatory not to do so. A second legitimacy claim is that HAD has the authority to speak on behalf of Pagans. The third legitimacy claim is that HAD has forged links with non-Pagan experts, which should add to its credibility. A fourth claim is that HAD represents a diversity of views. Here I examine each of these legitimacy claims in detail.

In Chapter 3, we saw that the internal confusion in relation to the foundational authority of the museum has created a situation where professionals continue to challenge and question their own authority, one manifestation of which is their reaction to the *Guidance for the Care of Human Remains in Museums* (DCMS 2005). This policy also came to be the focus of campaigning activities by HAD, which argued that the policy should be expanded to include Pagan claims. In the HAD document *Feedback*

on DCMS Guidance for the Care of Human Remains, the guidance is scrutinized to highlight the inconsistency of the discourse in recognizing different viewpoints. HAD argues that Pagan claims need to be recognized and included in such policy, or heritage bodies will be guilty of religious discrimination:

> The Pagan community's sensitivities towards British human remains must now be heard if bodies are to avoid charges of religious discrimination. While indigenous people's attitudes towards ancestry and heritage are now accepted (if seldom comprehended) by those dealing with human remains, British Pagan beliefs continue to be questioned or dismissed. This lack of acceptance is evidence in the *Guidance*, where there is no language sensitive to Pagan spiritual and religious concerns. Consultation is needed in order to address and amend this problem. (HAD, undated, circa 2007, unpaginated)

The problem identified is that Pagan sensitivities towards human remains are continually disregarded despite the inclusion of other similar communities. Another of the documents published by HAD is the *Policy on Consultation on Human Remains of British Provenance* (2007), which states that HAD should be consulted on all questions about human remains by museum professionals and archaeologists, and attempts to credit Paganism as a unique religious group. It elevates the importance of Pagans in this process over other faith groups, because Pagans honor everyone regardless of the possible attributable beliefs of the person whose remains are under question. This aims to validate the legitimacy of HAD on the basis of its inclusive feelings about the dead:

> Pagans honour all their ancestors, whenever they lived and whatever their faith or lack of it. Pagans should therefore be involved in consultation processes for recent remains and those of all Christian era, Jewish or other faiths, as well as pre-Christian remains. Although other faith communities may wish to exclude Pagans for religious reasons, this is not a reason for museums or other involved organizations to exclude them from consultations. (HAD 2007: 1–2)

In this document, HAD tries to advance a special claim to be included in consultation over all human remains on the basis that its exclusion would amount to religious discrimination. But it also emphasizes HAD's distinction from other religions, on the basis that Pagans' attitudes towards the dead are more inclusive.

The information made available on HAD's website[4] aims to establish the group's credibility. HAD initially claims legitimacy because it can speak on behalf of the Pagan community and for the diversity and expertise of Paganism:

HAD's Council is made up of Pagan theologians. At the time of writing, these are individuals who identify their spirituality or religion as Wicca, Witchcraft, Druidry, Eco-Paganism, Animism, Heathenism or Magick. The individuals were invited onto the Council as people who are recognized, through their teachings and writings, as well as respected members of those traditions. We are always awake to suggestions and requests to enlarge the Council.[5]

The website explains that HAD has a body of advisors that includes those with academic and professional expertise. This aims to associate the organization with recognized knowledge and status:

Beside the Council, HAD has a board of Advisors. These are a mixture of Pagans and non-Pagans, all of whom are professionals whose expertise is invaluable to HAD. Their fields of specialism range through museums, archaeology, history, anthropology, sociology, the academic side of religious studies, and law. Again, we are always looking for further skills to broaden our base.[6]

This presents a potential tension: that HAD questions the authority of established experts in making decisions over human remains, but also tries to associate with this authority to bolster its cause. A further tension is evident in the way that this same webpage explains the wide range of beliefs and interests represented about the issues:

When a query comes into the office and is sent out to the Council and Advisors, the range of answers that comes back is as diverse as Paganism can be. Sometimes we take the responses and simply collate them into lists. In other situations it is important to reach one decision; all the replies returned are brewed in the HAD pot, the resulting soup sent back out for confirmation.[7]

These claims send out potentially contradictory messages about the rationale for that inclusion. For example, the above statement which suggests that there is a range of diverse views about human remains, may dilute the claim that there is a problem.

The analysis of HAD's documents and its website, which present the case for inclusion, reveals that the group's primary aim is to establish the legitimacy of the organization and of Paganism. Overall, they indicate that the group's concern is less to do with the burial or particular treatment of human remains than with the recognition of Paganism by heritage organizations. These claims can be understood as warrants, statements that justify drawing conclusions from the grounds of the problem (Best 1987). In the construction of problems by claims-makers, it may be that despite disagreements over grounds or the definition of the problem, convincing conclusions are

presented. In this case, while there are limited grounds for HAD's claims for the problem of human remains, its conclusion is that these claims should be included in consultations and recognized in cultural policy papers.

Competing Claims

One constraint in framing the claims on human remains is the diverse belief system of Paganism. This is a problem because HAD aims to gather support from the Pagan community and develop a constituency. On a number of occasions, Restall Orr tried to promote the problem of human remains internally to cultivate support. The demands made by HAD regarding human remains, in particular the demand for reburial, though inconsistent and diffuse, is hotly contested within the Pagan community. It is actively resisted due the value some place on the importance of the past and knowing that past. This was well illustrated at the annual conference of the Association of Polytheist Traditions in May 2007,[8] a day long meeting for Pagans, which included four presentations related to the 'reburial issue'. Restall Orr made two presentations. There were about 22 individuals attending the conference, of whom four were highly receptive to the problem of human remains and three were strongly opposed. The rest were indifferent, and remained unconvinced either way.

The frames that Restall Orr employed to pose the problem of human remains were differentially contested throughout the day. Initially it was not clear to the audience that there was a problem with the treatment of human remains: one audience member asked: 'what is all the fuss about bones?' Restall Orr then shifted her emphasis in relation to why human remains should be considered as a particular problem, testing out what had purchase. Firstly she criticized the British Museum's loan of a bog body—Lindow Man—to Manchester University Museum: 'The British Museum is a last bastian of imperialism. We are only getting him because they are decorating. The British Museum is run by imperialists who are under twenty-five.'[9] Restall Orr's critique of the institution was refuted by another speaker, who felt that the British Museum is 'good to Pagan groups' and that 'they let us have ceremonies there.'

Other social problems were seen as more pressing by some of the audience. A number of participants argued that the environment should be a more immediate priority. The established social problem of the environment was seen to be of greater concern than the issue of human remains. In response Restall Orr tried to align the two problems as both being caused by a lack of respect:

Audience member: There is a whole environmental crisis out there so why are we talking about human remains?
Restall Orr: But we are, it matters. What is the connection? The lack of respect for land, space and time. So it is connected.

In this exchange, Restall Orr tried to link the two problems in terms of 'respect' for land, space and time, illustrating that the term 'respect' is employed in a number of different ways, to hide a confusion of purpose, but congruently to suggest the existence of a common problem.

In the following exchange between Restall Orr and the conference attendees, the lack of purchase of the problem of human remains is further exposed. Restall Orr spoke of the influence and success of HAD in the removal from display of the skull of Worsley Man, the head of a bog body from the Iron Age found in Greater Manchester. The head had previously been on display at Manchester University Museum:

Restall Orr: [T]he head of a bog body was on display here. We said we don't like that so they took it down. They may well put it up again, but they will consult us beforehand.

Audience member: But what is appropriate? If there is a severed head on display, why is that disrespectful?

Restall Orr: Because it wasn't found in a dry box. It was found in mud.

This individual was not interested in HAD's influence in the removal of the head and unsure of why its display might be considered a problem. Further discussion focused on what was wrong with human remains being excavated or displayed, with different arguments put across:

Audience member: What do gods think about us digging them up in the first place, putting them on shelves or in front of an audience? A lot of people dig them up for science, which tells us more about our past . . . everyone's got different views.

Audience member: But in the name of science, that doesn't actually happen. Excavation is often driven by road building.

Audience member: Personally, if you have a human being buried and dedicated to a specific space, I think it's insensitive to remove it, it's an insult to their deity. I hear lots of justification, but they were offerings to the deity. To remove it is stealing from the gods.

This exchange reveals different views. On one hand, it is seen as insulting to the gods to remove remains from burial grounds, and the justification of scientific excavation is considered a disingenuous cover for road building, which is viewed with a high degree of antagonism. On the other hand, one audience member is not unsure of what the gods think about this problem and is positive about gaining more information about the past, a recognized interest. The problem regarding human remains was considered by the audience but it was not clear to all of them what the problem was:

Audience member: What about the Egyptian mummy? I've heard that Egypt don't want them back, or the curators don't, so it's going to China. I'm not sure what I would think but I would like to stay

here . . . But it's an interesting thought, that not all communities want them back. A particular ancient dead feller might be more honored by others than their kin.

This woman cited a rumour that a mummy from Manchester Museum was going to be sent to China in order to express her ambivalence about the issue. In reply, Restall Orr identified the villains of the piece as western-trained scientists and curators:

Restall Orr: The Egyptians' changing attitudes towards their mummies is frightening for Pagans in Egypt. It leaves them bewildered to see the mummies on display. They cry out in pain. It's because Egyptian curators have been trained abroad in Britain and America as scientists, and it's ridiculous.

A member of HAD then commented, contradictorily and without hostility, that he had no real issue with the mummies or their potential transfer to China:

But if I was a mummy and had been stuck in Manchester for 200 years I would want to go to China, you know, I would be bored with Manchester. [Audience laughter]

This exchange indicates that Restall Orr's critique of western science was not strongly held by all members of the audience, and that the display of human remains was not firmly held to be a problem.

This is not to say that Restall Orr's ideas about human remains had no purchase at this event. One individual from Ireland was determined to go back and raise the issue in his country. Another audience member expressed his concern with the 'dualistic thinking of rationalist scientists' and their 'lack of respect for the faceless dead.' One individual questioned the reliability of the scientific information that could be gained from research on bones: 'We cannot assume to know from one bone or site. One bone cannot say this for sure, we are in serious danger of make believe.' An archaeologist gave a presentation on his campaign to save the Thornborough Henges, an ancient neolithic henge monument, and explained how he had come to focus on the problem of the excavation of human remains as a reason to stop further development of the surrounding countryside.

While four people present at this conference strongly supported HAD's campaign, the attempt to identify the problem of human remains was firmly resisted by other audience members when it was seen to conflict with the value that Paganism places on the past and memory. The greatest tension was created in response to the suggestion that human remains should not be excavated, because this research is considered important and integral to the commitment Pagans have to honoring and knowing the past.

Audience member: You cannot just say it is all science which is bad. We are recovering the stories of the, our ancestors. It needs more dialogue, digging up doesn't mean they don't respect it as a person, they are interested in the ancestors . . . let's not demonize the archaeologists [. . .] Memory is a far more important way of respecting the ancestors than reburying them and forgetting them again.

This comment received support from a few people in the audience. The identification of the problem of human remains, and the suggestion that they should be buried or research restricted, was opposed by three audience members because of the positive values attributed to archaeology for investigating the past. One audience member has subsequently established on the social networking site Facebook the group *Pagans for Archaeology*, which states:

We're Pagans who love archaeology and believe that it has contributed hugely to our knowledge of our ancestors and the religions of the past [. . .] [W]e are opposed to the reburial of ancient human remains, and want them to be preserved so that the memory of the ancestors can be perpetuated and rescued from oblivion, and the remains can be studied scientifically for the benefit of everyone.

The rhetorical critique of science and archaeologists, and the establishment of reburial as an aim, has not gathered popular support within Pagan circles. In his research, sociologist Jon Bloch identified many differences of opinion within Paganism and between individuals, which, he explains, were 'fully tolerated' (1998: 3). In this conference discussion, disagreement about human remains and other questions such as how many gods exist, or whether any exist at all, was good-natured. Nonetheless, the lack of purchase of, and support for, the problem of human remains amongst Pagans has contributed to the confusing aims articulated by HAD and posed difficulties for frame construction.

A COALITION OF CLAIMS-MAKERS

The two most successful museums at the moment have been Manchester Museum and Leicester Museums . . . um . . . I think people involved in there have been a lot more open in listening not just to the Pagan voice, but other areas of the community as well. And I think they are leading the way in that, leading in consultation . . . uh. As they've been doing that more and more museums are getting prepared to listen. (Interview with a HAD member, April 2007)

For claims-makers to be effective in establishing a social problem, it is necessary to show several things: that the problem exists, is widespread and growing worse; and that it causes real harm (Jenkins 1992). Given

the weak construction of the claims made by Honouring the Ancient Dead (HAD), the question we now turn to is why and how the group has achieved moderate success. To clarify: HAD does not achieve anything like the recognition or institutionalization of the problem that has been achieved by overseas indigenous groups who suffered colonization. Claims-making on the part of these groups resulted in the endorsement of the problem by government in policy reports and legislation, as well the high-profile transfer of human remains to overseas communities. Regarding HAD, the Prime Minister does not endorse its cause, the law is not changed, and the group receives no human remains. However, HAD does achieve a minor amount of involvement in museum institutions around this problem. Of relevance to this study is why this group receives even limited endorsement.

Despite the diffuse claims-making activity of HAD, one important response to the group was a strongly positive endorsement in three institutions where there has been a meeting of agendas. The interests of the institution, or the individuals within it, have met with HAD's interests and claims for recognition. Manchester University Museum, Leicester City Council Museums, and Colchester and Ipswich Museum Service, responded very positively to HAD. Professionals in all these institutions are 'advisors' to HAD, and they have all involved the group, along with associated Pagans, in a number of activities. Indeed, Emma Restall Orr of HAD and Piotr Bienkowski, the deputy director of Manchester University Museum, forged an alliance to campaign around the problem of all human remains in museum collections. One outcome of this alliance was the exhibition of the bog body, Lindow Man: a case discussed further in Chapter 7. HAD have also been involved by these organizations in consultation on the display, storage and burial of human remains (see for example, Levitt and Hadland 2006). This chapter concentrates on Manchester University Museum and the coalition it formed with HAD, as this relationship is the most significant.

Manchester University Museum (MUM) was opened to the public in the late 1880s. The University of Manchester owns the collections and buildings and employs the staff. The contemporary mission of the museum straddles both a commitment to the pursuit of research and learning and an orientation away from an empirically-orientated remit, stating that its focus on is less on the collections than what is considered to be a broader public benefit. As MUM states in its 2003 Annual Report, in a section titled 'Re-aligning the Museum and its Staff':

> In the past, museums were judged largely on the quality and scope of their collections. Nowadays it is the measurable benefit that people derive from a museum that is the main yardstick of quality.(MUM 2003: 6)

The institution aims to engage with a variety of contemporary social issues, in order to be relevant to the present period. As its *Policy on Human Remains* states:

The museum will [. . .] [r]e-think the role of a global museum in the 21st century by engaging people with the issues of globalization, post-colonialism, climate change, biodiversity and sustainability.(MUM 2007: 4)

At Manchester Museum the institutional response to the claims made by HAD is driven by particular individuals within the museum, who negotiate and cultivate Pagan claims to give their own activities legitimacy. This can be seen as part of a broader agenda to influence other museum professionals on questions of the shifting role of the institution. While the activities conducted with HAD are driven by concerns internal to the museum institution, the endorsement of this group's claims contributes to validating them. Two senior individuals at Manchester University Museum have been central to the promotion of the problem of human remains in its different manifestations. In the late 1990s and early 2000, the then director of the museum, Tristram Besterman, was a repatriation advocate and member of the Working Group on Human Remains. Since his retirement in 2006, Besterman has acted as an expert advisor to a number of institutions, including the British Museum, on the problem of overseas human remains, as well as writing the human remains policy of University College London, (UCL 2007). When Besterman left Manchester Museum in 2006, a new individual emerged to pursue the human remains agenda: Piotr Bienkowski, deputy director of the Manchester Museum and Professor of Archaeology and Museology at the University of Manchester. By this stage, however, the contestation over overseas human remains had reached some resolution, although Bienkowski continued to be involved in campaigning for the transfer of the Aboriginal remains from the Natural History Museum to the Tasmanian Aboriginal Centre in 2006. Subsequently Bienkowski has promoted the cause of HAD and raised concerns about the treatment of all human remains, including Egyptian mummies.

The *Manchester Museum Policy on Human Remains* (MUM 2007) states that it is broader in scope than the DCMS *Guidance for the Care of Human Remains in Museums* (2005), in what is a pointed criticism. It argues that one reason the guidance should be changed is the 'growing interest' in human remains among communities. The guidance argues that MUM's policy on human remains, is consequently too narrow in who it consults:

We are fully aware that the resulting policy goes beyond the recommendations of the DCMS guidelines [. . .] and there are good reasons for this. There is growing interest in the fate of human remains among many communities. What are valued as human remains in many communities go beyond the strict scientific definition contained in the DCMS guidelines and we believe that any consultation should be extended to include those alternative views. (MUM 2007: 2)

Claims-makers often forge alliances when it will serve their interests (Lee 2003). Restall Orr and Bienkowski have worked together on a number of projects to further their claims. The usefulness of HAD for Bienkowski is that the group lends force to his claim that there are problems and concerns about the current attitude of museums and archaeologists towards human remains. HAD legitimizes the claims made by professionals at Manchester University Museum that communities are concerned about human remains, and that the DCMS guidelines should be widened. The alliance also demonstrates that the museum is actively involving communities. Bienowski and Restall Orr work together on a number of conferences and papers that target the professional authority of the museum professional and institution. In turn, Bienkowski's support of HAD furthers the group's legitimacy claims.

The Discourse of Respect

The first partnership of Bienowski and Restall Orr was a conference that they organized in November 2006, held at Manchester Museum and supported by the Museums Association. Titled *Respect for Ancient British Human Remains: Philosophy and Practice*, papers were presented to an audience of museum professionals and museum studies students on the need to treat all human remains with respect, aiming to extend the issue from the problem of overseas human remains to all such material in collections. Presentations included the social scientist and Heathen Jenny Blain, Restall Orr, Bienkowski, and Sarah Levitt and Laura Hadland from Leicester Museums, who were sympathetic to HAD's cause. Potential critics were invited, but they did not agree to participate. The conference programme linked the issue of repatriation to overseas communities with the need to consult with communities in Britain. As the flyer for the event read:

> It is becoming standard practice for UK museums to repatriate human remains to their originating communities in Australasia and North America for reburial. An emerging issue, hotly debated, concerns the British counterparts of those remains: the communities for whom they are important are advocating with museums and archaeologists for respectful treatment, storage and sometimes reburial of ancient British human remains, both those recently excavated and those accessioned long ago and held in museum stores.[10]

The use of the term 'standard' implies that the transfer of human remains is now accepted practice, that anything different would be unusual, and that the claims from within Britain are comparable to those from originating communities abroad and should be considered for reasons of consistency. This conference framed the problem as one

of respect, used by these claims-makers to extend the problem from contested remains to uncontested remains, thus suggesting the existence of a problem in vague terms. This frame is also used in the following letter, written by Nick Merriman, the director of Manchester University Museum, Malcolm Chapman, Head of Collections, and Piotr Bienkowski, and published in *British Archaeology*:

> The Manchester Museum's overriding principles are to treat all human remains in a consistent, respectful way—irrespective of their age or provenance, and whether they are so-called 'contested' or 'uncontested'—and to involve all interested parties in discussions and decisions. This means the interests and values of archaeologists and scientists are always included, but are not privileged above those of other communities. (Merriman, Bienowski and Chapman 2008: 53)

In this example, the question of whether remains are contested or uncontested is presented as mere semantics. The motif of 'respect' is used to suggest that all human remains need special treatment, and it is implied that not to do so would be discriminatory. Treating human remains with respect, for these campaigners, is to question the process of decision-making and the expertise of scientists and archaeologists, rather than to propose particular treatment of the remains.

The paper presented to the 2006 MUM conference by Bienkowski and Restall Orr, 'Respectful Treatment and Reburial: A Practical Guide' (2006), outlines their case in more detail. At twenty-one pages, the paper is lengthier than the others that were presented, and advises on practice for every conceivable action concerning human remains including excavation, interpretation, retention, acquisition, loans, research, publication of results, conservation, storage, photographing, images, and display. However, the questions of what is respected, how, and why, are ill defined. What is more clearly defined is the problem with professional authority. The paper begins by stating that the authors' purpose is to offer guidance in relation to how respectful treatment can become common practice:

> The purpose of this paper is to offer practical guidance to archaeologists and museums on how to ensure that respectful treatment of human remains is embedded through proper consultation with all interested parties at all stages: before, during and after excavation, within the museum, and when contemplating and carrying out reburials.(Restall Orr and Bienkowski 2006: 1)

They assert that professionals, especially those with an archaeological and scientific background, should no longer be the key decision makers. As they make explicit:

The care, interpretation and decisions about retention and use of human remains can, ethically, no longer be left simply to the museum, archaeological and scientific communities alone without taking into account the sensitivities of other communities. (Restall Orr and Bienkowski 2006: 1)

Each section of this paper, which is organized around the different actions around human remains, makes the point that professionals should not decide these questions alone. For example, in the section titled 'Post-excavation', the authors state:

Once human remains have been excavated, there is a clear choice of what to do next: whether the remains are to be reburied after recording and analysis, or retained long term (usually in a museum). Up to now, those decisions have been taken unilaterally by archaeologists and museum curators [. . .] [T]hat decision-making process should now be broadened out and shared. (Restall Orr and Bienkowski 2006: 4)

The argument that decision making should be 'shared' is also promoted in relation to the publication of results from research: 'it is vital that archaeologists share more widely—ideally through consultation networks—the progress of publication' (Restall Orr and Bienkowski 2006: 5). The problem identified throughout their paper is professional decision making, which, they argue, can be resolved by limiting the authority of the museum sector through consultation with others. The elevation of listening to other views or claims over human remains is a way of demoting professional authority. The critique of cultural authority through the discourse of respect is one that Bienkowski has continued to develop in the *Museums Journal, British Archaeology,* and at professional conferences, whether on his own, with Restall Orr, or with colleagues from Manchester University Museum (see for example, Bienkowski and Chapman 2007).

LIMITS TO PAGAN AND PROFESSIONAL CLAIMS-MAKING

In 2001, Melbourn Parish Council in Cambridgeshire made a request to Cambridgeshire Archaeology for the burial of some Anglo-Saxon skeletons excavated from the village in 2000. In 2006, after a protracted period of consideration, Cambridgeshire Archaeology referred the request to the DCMS Human Remains Advisory Service (HRAS) for its advice. As we saw in Chapter 2, the DCMS set up the HRAS to help museums deal with claims of human remains in their collections. On hearing that the Melbourn claim was referred to the HRAS, Restall Orr and Bienkowski tried to form links with campaigners in Melbourn, to put extra pressure on the DCMS to widen the guidelines. In 2007, Bienkowski and Restall

Orr attempted to build a further coalition with Melbourn Parish Council in Cambridgeshire, to apply pressure on the DCMS to widen the scope of its guidance, and to achieve the transfer of the human remains requested by Melbourn. While campaigners in Melbourn have engaged with Bienowski and Restall Orr, they have not forged formal links with them, believing them to be 'too extreme' and 'potentially unhelpful' to the Parish Council's aims.[11] What this interaction demonstrates is that claims-makers try to forge coalitions with others who may support their broad argument but in other circumstances would not: in this case, Pagans and museum professionals trying to ally themselves with a Parish Council. It also indicates that approaches are not always met with agreement, as the Parish Council distanced its claims from the activities of Bienowski and Restall Orr. At the time of writing the request from Melbourn Parish was unresolved. One member of the HRAS argued that Melbourn Parish should receive the human remains[12]. The other took the opposite view, in what he said was an 'acrimonious' process[13]. After a protracted period, after the HRAS failed to reach a unanimous decision, the DCMS dismantled the body in 2007.

Limited Resistance to Pagan Claims-Making

While Manchester University Museum endorsed HAD and involved it in decisions over the future of human remains and in museum practices, the response of the rest of the sector to HAD's claims has been far more critical. Some organizations strongly feel that HAD should not be involved and that Pagan claims-makers are not credible. This indicates that some claims-making groups are considered more legitimate than others, despite the discourse that insists on the inclusion of all groups that is dominant in policy and the new museology. This in turn suggests that there are potential tensions between the discourse of recognition and the lived reality of it. However, the negative response to HAD is uneasily held. As a consequence of the confusion about the basis for professionals' authority, professionals do consult with HAD despite their reservations about the group's legitimacy. They do not recognize Paganism as valid but find it difficult to draw a line that excludes Pagans and includes others.

Six individuals with whom I spoke in different institutions—two curators, one scientist, two archaeologists and one director of a national museum, during the first six months of 2007,—were adamant that HAD did not have a legitimate claim to human remains. They all laughed when I asked them about possible approaches by the group, and compared HAD's claims to what they considered to be the genuine claims of overseas indigenous groups. One curator at a national museum explained:

> Native Americans and Aboriginals have a case, not like the Druids, that's just potty isn't it, they have no claim and besides it's really just

attention seeking . . . It's not their ancient beliefs, and they've not been treated badly like the Aboriginals and Native Americans.

She told me she would 'ignore' any approaches until they went away: 'We just won't reply'. One archaeologist condemned HAD as illegitimate and criticized its suggestion of removing researchers' right to study material:

> [T]his so-called, self-defined, self-appointed Druid proposes actions which infringe the rights of the majority to examine human remains in museums.

One scientist was confident that the Pagan group should not have a claim, but was worried that it would be successful, and that this represented another attack on science:

> Now we have to start fighting the Pagans, of course . . . I mean that's an extraordinary thing. Did you go to that meeting? I mean, they found someone weirder than Besterman. But I just cannot understand it. This and the creationists. Where will it end?

One of the six interviewees did not think the Pagans should receive human remains, but he did qualify that Pagans should be accepted as a community. He also narrowed his comments to pertain to that material considered of scientific value, potentially suggesting that the human remains that are not considered to hold scientific value could be claimed:

Interviewee: I cannot see any reason why, if there is a strong scientific value, British remains should be returned. You know, the Pagans, I have every sympathy with them as a community, I accept that they are a community and they have every right . . . I have no problem with them at all wanting to be consulted but I cannot see any reason on earth why they should have any human remains returned to them.

TJ: What will you say to them if they get in touch?

Interviewee: Without getting too old-fashioned. We live in an open democratic society. We do recognize different communities, they have rights, we live in a society where we are public servants. But you know. That's it [Laughs].

Many of the professionals with whom I spoke were initially sceptical of the legitimacy of Pagan claims, counterpoising them to that of Aboriginal and Native Americans. One senior curator at a national museum said of HAD: 'Well, [laughs]. My initial view, is a personal view, is that were claims to arise from a group such as that I think it would be a claim of a rather different order from the Maori or the Tasmanians'. Later on in the

interview, however, it became clear that the museum was consulting with a different Pagan community as part of a policy that consulted faith groups on the collection:

Interviewee: [W]e already include members of the Pagan community in a number of our activities. Nothing too silly. But they do have beliefs and they are harmless. They come in like our other groups, you know we cannot just have Islamic groups and no one else. That wouldn't be on.

TJ: Does that mean you will respond to HAD saying yes, or . . . ?

Interviewee: No, I think what it means is that we will probably have to talk to them, you know, invite them in, hear what they say, etc etc. But we won't give them much, maybe listen to what they say and see. But they don't have a right to demand reburial.

It is interesting to note that this professional was keen to add the caveat that his view was a personal view. I found that those who were unsure or even highly dubious about HAD were careful to indicate that their view was a personal one, as if they were not speaking more broadly. For example, another professional at a national museum commented:

Personally, I think, one could come to a view that claims made by Pagans have some basis or issue. But you cannot just say everyone is legitimate, not to say one is rational or irrational, but this strategy is not helpful.

As I asked interviewees what they thought of the Pagan claims and how they might respond, they struggled to find a justification for exclusion. There was a concern, as the above quote indicates, that inclusion would mean that everyone has a claim—'you cannot just say everyone is legitimate'—which is seen to be as 'not helpful'. This is then qualified by the remark 'not to say one is rational or irrational', suggesting that this professional questions the legitimacy of the Pagans but finds it difficult to say why.

Initially some professionals would mock or dispute HAD's claims, but they also found it difficult to state categorically that the group should be excluded. One policy maker and WGHR member tried to work through the distinction between overseas indigenous claims and Pagan claims in relation to who should receive human remains. He first based his argument on continuity of belief, and considered each group's suffering, after which he too found it difficult to rule out the idea that HAD should be consulted on some level: although he would not wholly endorse it either. The following exchange indicates the confusion of his argument:

Interviewee: [T]he thing I found very important was this idea of continuity of belief. I think . . . um for me, although the dead don't have

human rights, I don't think … hum I'm not quite sure about that [laughs], although the rights are of living people, somehow for me there is a link between their rights and the right of their ancestors, and for them to be their ancestors, in inverted commas, there has to be a continuity … And so it seems to me there is big difference between the rights of Pagans or Neo-Pagans, or whatever they are, to speak on behalf of Saxons, there is a big difference between that and Australian Aboriginals and some cases of Native Americans where there does appear to be a continuity of belief as far as I can tell, so I think there is a difference there.

TJ: So continuity of belief is what is important for you in assessing claims?

Interviewee: Yes, I mean on more than one occasion the argument was advanced that part of the suffering, almost the material suffering as well as the spiritual suffering, but all issues around confidence and so on, which mix those up, uh of Aboriginal communities, a key part of that is the fact that their ancestors are not at rest. Um, I'm slightly, you know, I mean, we were never given any empirical evidence of that, it was more assertion, but I'm willing to believe that the people who said it to us believed it and they weren't just shooting us a line I think I'm saying. So I think that's almost, in the context, that was almost enough really, cause in a way we were going to the scientists and saying can you tell us what you will find, and of course they said, well no it's hypothetical [laughs] so in a way to go to the Aboriginals and say 'can you prove to us that it will heal this disenfranchised Aboriginal?' also seemed to be a bit, you know, it wasn't really it was more prediction than you know, evidence, yeah.

TJ: So the Pagans?

Interviewee: Yes, I mean and at that Pagan conference, the Manchester conference, it was interesting that the main demand, seemed to be that the views of these people should be respected and taken seriously, and it seemed to be mainly a plea to be heard or be listened to than anything else actually. Which, it seemed reasonable really, it seemed like to be very deliberately coming across as reasonable, and in a sense her argument was we are a group who are very interested in the dead, and um, we believe therefore museums should take account of what we think, I suppose it wasn't quite what I expected. I suppose I was going there expecting there to be all sorts of demands to rebury all these things with all sorts of um newly invented morris dancing type rituals, um … but I suppose I was pleasantly surprised that it all seemed much more … uh reasonable. I guess though that I suppose they just want to be listened to and well, that is what we are here to do, so, yeah … I mean why shouldn't we involve them on some level? We do the others.

In this interview, a policy maker first suggest that continuity of belief is what is important in assessing claims, although he indicates that this continuity may be more felt than provable, by his use of inverted commas around the term 'ancestors'. Similarly when talking about the importance of alleviating suffering as a reason for recognizing the Aboriginal claims, he also notes that he did not receive evidence of the therapeutic impact of repatriation. This interviewee acknowledges a subjective element in the claims of the Aboriginal groups, and then the scientists. When it comes to the Pagans and their request to be listened to, he cannot really see a problem with it, even though he is very unsure of their legitimacy. He finds it difficult to mount further rationale for their exclusion, especially when he refers to the role of museum institutions in inclusion and recognition: 'that is what we are here to do'.

Theorist Francis Fukuyama (1995) has expressed concern that the automatic granting of esteem avoids the making of moral choices about what should or should not be esteemed. What the interaction in this case suggests is that where professionals are not confident that the Pagans should be included, they are unable readily to justify this and then are unable to explain why. They avoid making the choice between who should be recognized and why, because they are not sure themselves. I observed a similar reaction in a curator from a regional museum who explained:

> [W]ell I've had to examine my views. I mean I wasn't at all sure when I first heard about this, but really why not, you know? I am not sure I have a good reason for you . . . We are, you know we are very sympathetic when it comes to certain groups—the Maoris and Aboriginals. We are working with refugees and a Nigerian community . . . really we should be consistent. Who is to say they are not valid?

Here, we can see the problem is that the curator does not feel comfortable about deciding who is worthy of recognition and who is not. He is unable to state why the Pagans may or may not be valid.

In ten institutions, the Pagan claims were looked upon sympathetically as part of a wider consultation agenda without a particular interest in the group's beliefs. One of these was Leicester City Museums, which has been broadly supportive of HAD. Its approach is part of a wider consultative approach that takes into account faith groups and issues of multiculturalism. One of the museum's curators explained:

> One of the most interesting changes we have made here is because we have got to know a wider range of our communities. That's been in our attitude because of new considerations about faith and spirituality.

The involvement of HAD came about because of the institution's programme of recognizing and involving faith groups. When HAD approached

the museum, the group was invited to be part of a consultation processes on the content and practice of the institution run by the museum. This consultation process also included non-faiths, when competition developed between these groups for recognition, illustrating that recognizing groups may stimulate antagonism over affirmation:

> We also promote non-faith perspectives. When the Secular Society complained about our support for Islam Awareness Week, we explored what we could do to reflect their particular contribution to Leicester's diversity. As a result we now have a Humanist celebrant available for weddings at two of our sites.(Levitt and Hadland 2006: 4)

One other museum director felt strongly that not only should HAD be involved, but that museums should be proactive about this involvement. He took the view that 'really excluded' groups won't approach museums, so they should go and look for them: 'the universal museum cannot simply have relationship with one interest group. We need to make special steps to give disempowered voices a place. We need to empower them'.

The reactions to HAD by museum professionals indicate that some groups are considered more worthy of recognition than others, despite the inclusive discourse of the politics of recognition. This indicates potential tensions between the rhetoric and lived reality, particularly when, it would seem, it also invites claims for recognition. However the reaction to these claims also suggests that professionals, unsure of the legitimacy of the group, feel unable to draw a clear line to exclude them. Some in the sector appreciate that this creates a problem; institutions cannot affirm everyone as legitimate without some basis for evaluating them, but they are unsure how to do so.

Sociological examinations of claims-making have demonstrated that effective resistance to the problem may slow, stop, or re-orientate its development (Lee 2003). The case study of HAD indicates that the difficulty in finding a rationale for exclusion allows the claims-making activity of a small group to have an impact. The rest of sector finds it difficult to stop this continued challenge from a few individuals, who have disproportionate effect; not because of their effective advocacy work, but because the context that they are seeking to influence is unstable. The central conclusion to be drawn is that the shift in the remit of the institution to a more inclusive model and the unstable nature of the museums' cultural authority applies pressure on professionals to include groups asking for recognition even when they are not confident of their legitimacy. The fundamental problem of cultural authority, on which basis cultural content and the relationship of communities to the institution is to be decided, leaves the sector disorientated.

5 Explaining Why Human Remains are a Problem

In 1999, the Lakota Sioux Ghost Dance shirt, held in the Kelvingrove Museum, Glasgow, was repatriated to tribal elders in South Dakota. It was associated with the Battle of Wounded Knee and considered sacred to the Lakota Sioux. As with skeletons and body parts, objects in museum collections have been requested and their care problematized by indigenous groups, academics and professionals, partly through a motif of 'making amends' for colonization, and a case has been made regarding the therapeutic impact of the repatriation of such material. Indeed, the Native American Graves Repatriation Act (NAGPRA) included funerary artefacts, objects of cultural patrimony and sacred objects, as well as human remains.

Concerns about human remains in Britain are, at times, intertwined with concerns about artefacts and sacred objects. The Museums and Galleries Commission policy *Restitution and Repatriation: Guidelines for Good Practice* (Legget 2000) advises that claims for human remains or sacred objects should be treated with sensitivity, implying that the two are similar. Taking a different stance, the Human Remains Working Group Report primarily argues that human remains have a unique status: 'Human remains, irrespective of age, provenance or kind, occupy a unique category, distinct from all other museum objects. There is a qualitative distinction between human remains and artefacts. Human remains require special consideration and treatment' (DCMS 2003b: 166). However, while stressing the uniqueness of human remains, the same report tentatively ventures that sacred objects require similar consideration, and proposes setting up a Ministerial Advisory Group to make recommendations on sacred objects and objects of spiritual or religious significance (p. 160). A consultation that followed asked respondents to consider the future of sacred objects and whether there should be a survey of their holdings (DMCS 2004). No survey was conducted, nor an advisory group established. The burgeoning interest in sacred objects lost momentum. Despite being associated with human remains as an issue, artefacts have not been the focus of consistent attention in Britain.

Since the implementation of the Human Tissue Act 2004 many activists, especially those who were occupied with redressing the detrimental

impact of colonization and the therapeutic possibilities of repatriation, have extended their claims-making activities to making demands for the repatriation of artefacts, special treatment for sacred objects, and the cultural stimulation of indigenous communities (see for example Simpson 2007; 2008). Issue entrepreneurs, such as Tristram Besterman and Cressida Fforde, have continued to research collections, looking for undocumented human remains from overseas community groups, concentrating on the British Museum, National Museums Scotland and Oxford University. The anthropologist Laura Peers, from Pitt Rivers Museum Oxford, promoted an (unsuccessful) internal review, to remove unclaimed shrunken heads (from overseas indigenous communities) from display.

In Britain during the same period, other campaigners, far fewer in number, promoted the cause of Pagan groups, putting the case for treating all human remains with respect, and arguing for the covering of Egyptian mummies, as I go on to discuss in Chapter 6. Claims-makers need to keep the issue fresh and often create new problems or expand the issue (Best 1990), and these activities are clearly one way of doing so. Not all of the original campaigners have pursued the agenda of problematizing all human remains in British collections, but they have noticeably refrained from publicly criticizing others who have taken this direction. While the focus on the problem of all human remains has not been such a successful claim as the focus on human remains from overseas indigenous groups with associations with colonization, it has had a limited impact. Certainly, claims made about human remains have been more successful than claims made in relation to artefacts.

I now address why human remains have been subject to such an intense and divisive a battle, why this focus has been more successful than the focus on artefacts, and explore what features human remains hold that make them an effective locus for debate. In Chapter 1 I noted that activists linked the problem of overseas indigenous remains, which they tied to period of colonization, with contemporary controversies over body parts stored by hospitals. This was a highly effective linking to a prominent issue. The association presented the impact of colonization on overseas communities, the illicit removal of human remains from museums, and the unauthorized retention of body parts from children, as existing on a continuum. The alignment stimulated greater attention to the problem of overseas human remains and furthered the purchase of the problem of all human remains in museum collections. It had legislative consequence in the Human Tissue Act 2004, which introduced the need for a licence for all human material.

Chapter 1 also illustrated how activists referred to human remains with terms such as 'body pieces', which rhetorically evoked the more empathetic body than could be evoked with objects and artefacts. The language employed by campaigners that invoked the defleshed body effectively constructed a 'victim'. Chapter 2 demonstrated that in order to protect cultural artefacts from repatriation claims, professionals at a national museum

responded to claims by promoting the unique qualities of human remains. Reacting to the claims on human remains, those resistant to repatriation tried to insulate the rest of the collection from repatriation claims by elevating the status of human remains as different and unique material. Nonetheless, this advocacy work, which has promoted human remains as unique or the focus of attention, would not have had such considerable purchase unless it was reinforced by broader cultural and social trends. Campaigners gravitated towards human remains rather than artefacts, because these had a wider cultural resonance.

In this chapter I show that human remains are an effective symbolic object that can locate particular issues, due to their unique properties, as well as broader contemporary social influences on their cultural meanings. In other words, there *is* something special about human remains as opposed to artefacts, which contributed to their symbolic efficacy. Crucially, how this is interpreted and granted meaning is historically contingent, and enacted by those living in the present.

HUMAN REMAINS AS SYMBOLIC OBJECTS

The metaphorical work of human remains has historically been evoked in a variety of ways through the use of human remains—both the actual remains and visual representations—by different actors and interest groups. Theorists Hallam, Hockey and Howarth (1999) note the symbolic use of human remains across history and discuss how their display has been put to use in protest, but they also demonstrate how they can be used to reinforce political and institutional authority. For example, the body of Vladimir Ilich Lenin was embalmed after his death in 1924, and lay in state in its mausoleum as a place of pilgrimage. This was an act opposed by Lenin's closest advisors, who recognized it as a move linked with political developments. Preserving and presenting Lenin's corpse was part of an attempt to consolidate Soviet power and Stalinism (Chamberlain and Pearson 2001: 35–37). Lincoln (1989) describes how during the Spanish Civil War, opposition by the political left towards the church was expressed by leaving the exhumed bodies of priests and nuns in churches. Lincoln interprets the strategic placing of these human remains as an iconoclastic act, and an attempt to constitute a different social identity in opposition to the existing social order. In an act that reinforced medical authority, the philosopher Jeremy Bentham chose to display his body as an 'auto icon' in University College London, which acts as an affirmation of the cause of medicine and dissection (Fuller 1998). This observation, that human remains can be used in what seem to be paradoxical roles, questioning and reinforcing authority, illustrates the ambivalent meanings of this material and how it can be manipulated to promote different agendas.

In *The Political Lives of Dead Bodies*, anthropologist Katherine Verdery (1999) analyzes the use and meaning of dead bodies in post-Socialist countries. She examines the transformation of Eastern Europe and the former Soviet Union following the end of Communist rule, documenting how dead bodies served as sites of political conflict and the reordering of political structures, which involved the elite and large populations. The bodies of named rulers or religious figures, and nameless victims from the past, were exhumed or buried to legitimize new elites and associate them with, or distance them from, the past. Verdery presents a number of reasons as to why human remains are uniquely useful symbolic objects. One of the key properties about human remains as symbolic objects, she identifies, is that they are ambiguous. There is no one meaning: 'Remains are concrete, yet protean; they do not have a single meaning but are open to many different readings' (Verdery 1999: 28).

Human remains hold a social category as a 'person' (human, body), but are also a 'thing' (remains, corpse, cadaver, skeleton). As a 'border subject', human remains disturb the boundaries between the real and the not-real, between person and non-person. They have once embodied personhood and, at the same time, that personhood has come to an end (Geary 1986). In anthropology, observations about ambivalence of the dead body are developed in the work of Mary Douglas (1966). The liminality of the body means, for Douglas, that it is a source of metaphors about the organization of society. Anthropologist Ewa Domanska (2006) builds on these observations, in her work on the missing in Argentina, where she analyzes the divided reaction to those who have disappeared[1]. Domanska shows that the missing or present human remains become a focus for conflicting interests amongst the living, which allows them to mean different things to different people and thus become the locus of a contemporary political struggle. As she writes:

> The dead body is a witness ('a witness from beyond the grave') and evidence at the same time. It is also an alternative form of testimony. In this way it serves the living, becoming the space of conflict between different interests of power, knowledge, and the sacred. The body is politicized, it becomes an institution, and death itself turns out to be more of a political fact than an individual experience. (Domanska 2006: 344)

This observation, that the dead body is the focus of a struggle of different interests and meanings within the living community, is important. Domanska's point that the ambivalent status of the missing body, also when it is made present, allows it to become to focus of diverging claims manipulated by the living is insightful. Her observations suggest that different claims and often opposing conceptions of the meaning of the dead body can be located on human remains, or on the idea of them. While holding no particular meaning in and of themselves, human remains provoke important

associations with particular meanings: the sacred, and knowledge, which means they can locate these conflicts with resonance.

Museologist Paul Williams (2007) discusses the use of human remains on display in memorial museums. He observes that the display of human remains is sometimes made central to the understanding of the historical traumatic event documented in such monuments and museums, although not without controversy. He too notes that human remains appear to hold profound meaning, although this meaning of human remains is open to interpretation. In particular, he explains, they appeal to the contemporary popular idea that something was 'there': '[B]oth irreducibly personal and yet unable to convey much beyond the person's demise, human remains possess an unsettling ambiguity. Second, bones fulfil that primary urge amongst visitors to history museums to experience an object that was *actually there*' (Williams 2007: 40). Verdery discusses the idea that human remains connote a sacred meaning. They are not just any old symbols, she explains—they can be associated with life and human beings. For Verdery, they can evoke 'the awe, uncertainty, and fear associated with "cosmic" concerns, such as the meaning of life and death' (Verdery 1999: 31). Verdery argues that this is one reason why human remains lend themselves particularly well to politics in times of major upheaval.[2]

Another feature of human remains that makes them effective symbolic objects, Verdery suggests, is that they are material things. Human remains are a physical object, unlike concepts or ideas, and can thus locate the ideas and values with which they become associated. As she writes:

> [A] body's materiality can be critical to its symbolic efficacy: unlike notions such as 'patriotism' or 'civil society', for instance, a corpse can be moved around, displayed, and strategically located in specific places [. . .] [T]heir corporeality makes them important means of *localizing* a claim. (Verdery 1999: 27)

The materiality of human remains—the fact that they are a physical object—is one reason why human remains can become symbolic of the shifts in the purpose of the museum institution. When taken off display, or sent to different groups and countries, the process, in this context, indicates that their study is no longer considered central to the purpose of the museum. These actions perform the distancing of a commitment to an empirical rationale.

Verdery's related insight is that while the meanings human remains have are culturally constructed and can be manipulated, their physicality and association with a person can suggest the opposite. While the meanings of human remains change, they can be presented as having one meaning. This is important in the construction of the problem of human remains in British collections, where there were a number of definitional debates. The definition of human remains, however, was rarely under discussion, as illustrated by

the policy papers on human remains published by different museums. There are 17 policy documents pertaining to specific museums,[3] and these show a degree of confusion about how to treat this material. They all differ slightly in relation to how human remains should be held or displayed and why, how sensitive or scientifically valuable the material is, and how it should be used in education projects. There is no comparable confusion when it comes to defining human remains. The majority use the definition issued in the DCMS *Guidance for the Care of Human Remains in Museums*:

> *Human remains:* In this guidance the term human remains is used to mean the bodies, and parts of bodies, of once living people from the species *Homo sapiens* (defined as individuals who fall within the range of anatomical forms known today and in the recent past). This includes osteological material (whole or part skeletons, individual bones or fragments of bone and teeth), soft tissue including organs and skin, embryos and slide preparations of human tissue. (DCMS 2005: 9)

Only two museums out of the seventeen—Manchester University Museum and Bolton Museum and Archive Services—try to extend this definition. The Manchester policy states:

> The Museum extends the definition of human remains given in the DCMS guidelines to cover osteological material (whole or part skeletons, individual bones or fragments of bone and teeth), ashes, soft tissue including organs and akin, blood, hair, embryos and slide preparations of human tissue. (MUM 2007: 6)

As with Manchester, the policy for Bolton also includes hair and nails (Bolton 2007). Even so, despite attempting the extending the definition of human remains, what is pertinent here is that the definition still applies to recognizably human material. The stability of the definition is important to locating claims, in this instance.

This observation is reinforced by comparing the constancy of the definition of human remains to the less stable definition of sacred objects. As indicated, certain activists have tried to problematize sacred objects. One difficulty in doing so is that it is difficult to define what one is. This problem is recognized in the Human Remains Working Group Report, when it recommends that sacred objects may be a future issue to be addressed: 'In making this Recommendation we entertain no illusion about the ease with which a definition of sacred objects can be formulated and agreed' (DCMS 2003b: 160). This definitional problem is also raised by University Museum Group UK in response to a question regarding a potential consultation on sacred objects. :

> [T]abots from Ethiopia, every battered suitcase and shoe at Auschwitz, the type specimen of a louse, a churinga from Australia, the escritoire used by

Emily Bronte: an object is as sacred as people believe it to be. However, sacred value changes over time, and it varies between peoples and between individuals. So a more awkward question, but perhaps a more telling one is to ask what is *not* sacred in the museum? (UMGUK 2004: § 17)

The human remains in museums that are of interest vary greatly in age, provenance, affiliation and materiality. The subject of one claim on the British Museum was cremated bundles—ash, not bones nor recognizably a body. Remains transferred out of collections include tattooed heads from New Zealand and Aboriginal skeletons. Human remains moved about, removed from display, and covered in museums include bog bodies, Egyptian mummies and disarticulated bone from the British Isles. Despite this diversity in type of human remains, unlike sacred objects, which could include an escritoire, a louse or a churinga, there is no doubt that all these human remains are human remains. This solidity of definition makes them a useful object on which to focus claims.

CONTEMPORARY INFLUENCES ON THE MEANINGS OF HUMAN REMAINS

The changing meaning of death and the varying treatment of dead bodies throughout history indicates that while death is a physical event, how it is understood varies and is constructed through cultural custom (Seale 1998; Jupp and Howarth 1997; Lupton 2003). Philippe Ariès (1981) was one of the first historians to research the history of death, producing a substantial account of the changing reality and treatment of death from the Middle Ages until the present. His periodization has been challenged, as has his overall thesis (Porter 1999), but he usefully documents a highly varied treatment of death across time and place. Similarly, anthropological accounts have demonstrated that societies conceive death, personhood and the attachment or link to the body in different ways (Strathern 2005). Studies of the conception of the body (for example Bottomley 1979) demonstrate overlapping but shifting conceptions of the body across history, as influenced by and influencing religion, politics, medical science and technological advances. These works establish that human remains may be conceptualized in different ways, in particular as an object of mourning or a scientific object, depending on the cultural context. Important social influences have impacted on the cultural meanings of human remains in the contemporary period, and thus their symbolic efficacy in the contestation in the museum collections of Britain.

The Scientific View of Human Remains

Medical historian Roy Porter points to a complexity of religious, moral and value systems that have changed over time, influencing different

relationships between the body, mind and soul and the wider body politic (Porter 1991). Until the late sixteenth century, death and religion were a major influence on the dominance of death and response to it (Prior, L. 1981). Towards the end of the seventeenth century and specifically in the eighteenth and nineteenth centuries, a new image of death emerged, which moved away from the idea of random death and established the idea of controlling death—an idea that is key to the modern period. The introduction of medical science meant that death began to be seen as a natural phenomenon over which man appeared to have some control. Life expectancy rose when it began to be possible to prevent and cure illness. The doctor began to replace the priest at the deathbed (Porter 1988). The most significant influence on the modern conception of the body emerged in the nineteenth century. Porter writes that during this period a 'scientific' understanding of the human body as a complicated mechanism, operating according to principles of cause and effect and understood through empirical observation, developed. This conception displaced theories of the body in terms of humors, which were four fluids that were thought to permeate the body and influence its health (Porter 2003: 45–54).

Subsequently, Western medicine has treated the body as a machine (Synott 1992; Andrews and Nelkin 1998). Michel Foucault (1989) explains the change from classical to modern medicine as a move from categorizing illnesses in terms of their distinctive qualities, to tracing the causal connections between symptoms. As a consequence, he argues, anatomical dissection became crucial in understanding the nature and progress of diseases. According to Foucault, the dead body developed a newly important status. Prior to the end of the eighteenth century, death was inaccessible to the living. As the development of disease and death began to be found in the body, the cadaver became the answer to this information. Medical sociologist David Armstrong (1987) points out that the corpse was no longer simply a symbol of the unknown, or a source of anatomical information, but was the key to understanding the processes of living and dying. The truth of death was found in the corpse. Today the examination of the dead body is one method by which medical students develop clinical detachment (Hafferty 1988; 1991). Of course, it is important not to over-state the influence of the scientific view of the body historically, as it developed in an uneven process. Furthermore, other political and social influences need to be taken into account, such as those discussed by historian Ruth Richardson (2001b), who attributes the greater willingness of people to donate their bodies to the growth in collectivist sentiment of the post-war years. Despite these caveats, this outlook has influenced the conception of the body for centuries.

One interesting study that illustrates how human remains may be considered scientific objects is by sociologist Susan Lindee (1998), who explored culturally-influenced meanings of human body parts in her research on the transfer of the body parts of atomic bomb victims to Japan from the United States between 1967 and 1973. After the atomic bomb, bodily

material from Japanese people was sent to America for scientists to study at the Army Institute of Pathology. Research on these remains was also conducted in Japan, mostly overseen by American scientists. Through the framework of scientific research—the numbering, filing, classification and relationships between researchers—this material came to be understood as data. Lindee describes how in the late 1950s, questions developed amongst scientists in Washington about the reliability of the material for specific questions, and the appropriateness of keeping such items. In 1967 the Japan Science Council requested the return of the material. Yet, rather than basing its appeal for return on Japanese victimization, it suggested that science could draw out a universal value for this material. Lindee notes that the body parts of Japanese people killed by the atomic bomb were considered important missing data by both the Americans and the Japanese and became a focus for debates about the legitimacy and morality of the use of the atomic bomb. She notes, with surprise, little discussion of the meaning of the body parts that attributed a religious or mourning role to the return and the parts. In this case, the body parts of Japanese people functioned as natural objects that could reveal scientific truth, and as diplomatic objects that both Japan and the US could use as a focus for negotiating their post-war relationship. Lindee concludes that the context in which the human remains were interpreted was essential to their meanings and significance. Body parts became considered natural objects through the application of science (Lindee 1998).

One consequence of the scientific conception of the body is that it has been possible to display and research human remains, and to view them as objects of science. The older, and the further outside social relationships the remains are, the easier it is to consider them anatomical or research objects. Theorists thus commonly interpret the display of human remains in museums as permitted due to the scientific conception of the body, the institutional context, and also the age of the remains, all of which recontextualize these potentially problematic human objects as research objects for learning. Hallam, Hockey and Howarth (1999) discuss how, at the exhibition of plastinates in Gunther von Hagens' *Body Worlds*, the corpses may be displayed because they are viewed as objects of science in an authoritative institution. Indeed, they argue, the display of human remains reinforces the authority of scientific and technological discourses (Hallam, Hockey and Howarth 1999: 39). For these theorists the display of human remains demonstrates and affirms the scientific method of studying, and, it is implied, controlling the natural world, which includes the human body. The dead body on display is considered a scientific object in an institution that is considered authoritative.

However, one problem with this analysis is that while it may apply historically, it does not address the concern expressed about the holding and display of human remains in museum collections that has emerged and grown in the last few decades. Nor does it entirely capture the nature of

the exhibits curated by Gunther von Hagens. His exhibitions may reference anatomical history, but the plastinates are also posed in lifelike positions, unlike that of a medical laboratory. Similarly, while von Hagens shows his work in science centers in some countries, he displayed his first show in Britain in a space more akin to an art gallery. His work is not solely the display of anatomical objects in an authoritative institution, but slips between this context and an artistic context, where the anatomical specimens are humanized and aetheticized (Hirschauer 2006).

The assumption made by Hallam, Hockey and Howarth is that the institution is authoritative. But as we have seen, the remit of the museum institution has been under sustained scrutiny and criticism from external and internal forces. Thus the context in which the human remains are exhibited is not as legitimate as they suggest. Furthermore it is not just the museum context that is problematic. It is widely recognized that scientific medicine and clinical detachment have come under criticism (Gabe, Kelleher and Williams 1994; Fitzpatrick 2001;). The medical profession in the Western world is considered to have experienced a crisis dating from the 1970s, although there is some disagreement about its causes, the timing of decline, and how this crisis differs to that experienced by other institutions (Fitzpatrick 2001; Pescasolido, Tuch and Martin 2001; Schlesinger 2002). In *The Social Transformation of American Medicine* Paul Starr (1982) explains that in the 1970s the economic and moral problems of medicine displaced scientific progress as the center of attention. In a discussion on the end of the medical profession's mandate, Starr notes that the loss of momentum in the civil rights movement opened the way for new social movements. This expanded the rights demanded by different groups, including feminists, many of which took the form of demands for health rights and patients' rights. The health rights movement, explains Starr, went beyond rights to more medical care; it also challenged professional power and expertise, for example, by questioning the idea that the doctor always knew best, particularly in such fields such as childbirth. The 1980s brought 'the generalization of doubt' that followed the end of the era of consensus (Starr 1982: 408). This trend represented a growing scepticism about the scope for positive intervention into society by the state or professionals, in the spheres of education, social services or health. It was during this period that concerns about the medical profession became generalized (Starr 1982; see also Fitzpatrick 2001).

The rise of distrust in scientific medicine is an uneven process that contains contradictions. Deborah Lupton (2003) observes that in the early twenty-first century, Western societies can be characterized by increasing disillusionment with scientific medicine, while at the same time there is also an increasing dependence upon biomedicine in the medical and also in the social sphere. Overall the important trend that can be identified as pertinent here is that clinical detachment has come under criticism for dismissing or relegating the patient, with a concern often expressed in this

discussion about the treatment of the dead body (see for example Francis and Lewis 2001). Clive Seale, Debbie Cavers and Mary Dixon-Woods (2006) have observed that as a consequence of the rise of distrust in scientific medicine, bioscientists are increasingly required to be seen as respectful toward personal and social meanings of human materials and diminish the sense of objectification that their separation from the body for medical purposes may entail (Seale, Cavers and Dixon-Woods 2006). At the same time, advances in biomedicine have prompted questions about the status of dead bodies. Lynn Folytn (2008) notes that recent developments in the biomedical sciences, such as genomics, stem cell research and cross-species transplants, have 'recoded', 'desacralized' and commodified the corpse, which, she argues, is one development that has raised issues about its status and treatment (Folytn 2008: 100). The possibilities for the commodification of bodies, the patentability of human genes, and the distribution of body tissue, for example, which are taking place in a commercial context, have raised questions about the nature, purpose and use of this material (Andrews and Nelkin 1998).

This ambivalence towards the concept of the scientific view of the body can be identified in the debate over human remains in museum collections. Indeed, if we look at the criticism mounted by campaigners on this issue, they identify medical detachment as being tied to the domination and death of indigenous peoples. Influenced by this concern, they also are able successfully to evoke this problem in their campaigning. Let us recall the book chapter co-written by activist Jane Hubert and Cressida Fforde (2005), in which they suggest that medical detachment has permitted terrible treatment of the dead: 'Such "medical detachment" would perhaps explain why early scientists with close indigenous friends felt able to deflesh their bones as soon as they died' (Hubert and Fforde 2005: 116).

The context of both the museum institution and the scientific view of the body has come under criticism, and thus the display of material previously on show in this location is no longer straightforward. The consequence of the unstable context in which human remains are held, combined with a museum institution undergoing a crisis of legitimacy and contemporary ambivalence about the idea of scientific detachment, is that the display of human remains cannot be easily interpreted as a valorization of science confirmed in the context of an authoritative institution. Furthermore, there are two related influences on the cultural significance of the body, which have contributed to the interest and anxiety about human remains. These are the rise of the body as a site of identity and the body as a site of political struggle.

The Rise of the Body

There is a rich literature on the importance of the body that has developed rapidly since the 1980s, when the sociologist Mike Featherstone argued

that the twentieth century saw the emergence of the 'performing self' (Featherstone 1991: 189). Subsequently a corpus of work has developed debating the varying significance of the body. The turn towards theorizing the body can be partly explained by a number of social changes and developments in theory. Bryan S. Turner was one of the first to identify the body as important for sociological theory. Turner advanced the argument that we are living in an increasingly 'somatic society' where our search for meaning has shifted away from the public sphere towards the self and the body, as a result of a number of social factors within the transformation of Western societies. According to Turner, the shift from industrial to post-industrial capitalism, the erosion of Christian orthodoxy, and the spread of consumerism have meant the separation of the body from the political and economic spheres. This can partly explain the prominence of the images of and interest in the body in the contemporary period (Turner 1996). Turner suggests that through modernization we have witnessed the 'emergence of somatic society, that is, a society in which the problems of the body dominate the center stage of political debate and political process' (1995: 258), where 'the body is our "ultimate concern"' (1995: 257). While qualifying that in earlier society Christian teaching used the body in regulatory practices and that the body has always been of concern historically, he also points out that these regulatory practices were directed at the future of the soul. Today there is no external or future focus akin to the focus on the soul. The end focus is the body (1995: 256–257).

Sociologist Chris Shilling argues that in high modernity the decline of formal religious frameworks and the collapse of grand political narratives that sustained ontological meanings outside the individual means there is a tendency for people to place more importance on the body (Shilling 2003: 1). As a consequence, he contends, the body becomes increasingly important to people's sense of identity. Shilling notes that while the focus on the body is not completely new, its position in contemporary culture reflects unprecedented 'individualization of the body' (p. 1). In the nineteenth century, self-improvement could be achieved through the development of character-forming habits. By contrast, twentieth-century individuals are encouraged by consumerist culture to develop their personalities through the body. The body in modern social systems has thus become a location of political and cultural activity.

Sociologist Tony Walter (2004) researched visitor responses to Gunther von Hagens' exhibition *Body Worlds* in 2002. He set out to answer the question: if late modernity's celebration of the living body makes the dead body 'problematic', how do visitors respond to the 'aestheticized' dead bodies on display? (Walter 2004: 464). When Walter refers to the display as aestheticized he means that the exhibits do not act like dead bodies, which decay and smell, but the displays are recognizably dead bodies nonetheless. Walter concludes from his research that the response of the audience suggests that some of those surveyed looked at the plastinated bodies with

'fascination' and even 'awe'. He explains that, for some, the displayed bodies were not just celebrated, but were like a shrine of worship. He writes:

> Certainly the fascination, sometimes turning into wonder and awe, at the bodies on display, and hence at their own body, to be found in some guest book writers hints at a secular notion of their own body as divine. (Walter 2004: 479)

Walter suggests that this corresponds with the sociological thinking on the body as self. What is new, he ventures, is that this divinity is inspired by the body's interior (although he notes that it is a highly controlled, aestheticized interior). He concludes that *Body Worlds* does not follow the usual distinction between the body's ugly insides, which are taboo, and its acceptable surface. This distinction was observed by Sawday (1995), where dead bodies, and in particular their interiors, is problematic. Walter's interesting study suggests that the present-day interest in viewing the body has influences in the shift towards the perception of the body as a site of identity. It is also a reminder of the fact that as body parts in museums came negatively under scrutiny, a congruent trend was their popular display, as in the von Hagens exhibition.

The Body Is Political

I have noted in passing that feminism has been an important influence on the significant of the body in broader cultural thinking, as has the work of Michel Foucault (Porter 1991; Watson and Cunningham-Burley 2001). In relation to the cultural significance of human remains, these influences are of particular importance, because they contributed to identifying the body as a site of political struggle (Lupton 2003). Many of the early feminist campaigns initially drew on classical liberal theory and the idea of individual rights. They then developed beyond that to look at how the control of women's bodies was involved in their oppression and domination. This has been discussed as the rise of 'second wave feminism' and dated from the 1960s onwards (Shilling 2005). Campaigns such as rights to contraception, abortion and the management of childbirth, as well as concerns about domestic violence, identified the control over and protection of one's body as essential to autonomy, and contributed to a critique that saw power over women as being conducted through their bodies (Starr 1982; Twigg 2006). Subsequently feminist and queer theorists have interpreted the body as a location through which cultural and political meanings are produced.

The focus on the control of the body is often coupled with a critique of medical power. The women's movement criticized medical control and intervention in their lives as paternalistic, questioning the control doctors had over reproduction. The British feminist Ann Oakley, for example, argued that the political programme of the women's movement should aim

to regain control over reproductive care, taking it away from doctors and giving it to 'wise women' (Mitchell and Oakley 1976: 52–53). Thus, as we saw earlier, there was a coincidental and then related relationship between a rising distrust in scientific medicine and the focus on the body as a site of domination and resistance.

In this critique, feminists draw on the influential work of poststructuralists and of Foucault, in particular. In both the *Birth of the Clinic* (1973) and *Discipline and Punish* (1977), Foucault argues that since the eighteenth century the body has been the focal point for the exercise of disciplinary power. Through the body, elements of the state apparatus, such as medicine, the educational system, psychiatry and the law, define behavior. In the *Birth of the Clinic* (1973) he describes the 'anatomical atlas' (pp. 3–4), which he explains as the human body constituted by the medico-scientific gaze. He considers medicine as a significant institution of power. It marks out bodies as normal or not, and in control or not (p. 54). For Foucault, therefore, the body is the ultimate site of political and ideological control, surveillance and regulation. In this thinking, power operates differently to the political theory that suggests it is exercised by distinct groups in society.

This approach to the body has been highly influential, and is deployed within the social sciences, the humanities and social history. Historian Roy Porter (1991) points out that the influence of second wave feminism and the corresponding cultural shifts have subverted the traditional distrust of the body, and directed scholarly attention on to it, in particular focusing on discourse and representation. Laqueur's works (for example Gallagher and Laqueur 1987) draw on Foucault, suggesting that how we know the body must be seen as a product of particular contexts and practices. Social constructionist approaches to the body have been influenced by these theories and, in the main, address the relationship between the corporeal and the social, downplaying the significance of the biological basis of disease.

The combination of these interrelated social and intellectual influences have identified the body and its representation as central to politics and power. In Chapter 1, we saw the influential activism of Cressida Fforde. Along with Fforde, Australian academic Paul Turnbull outlines that the specific study of the body, conducted on the human remains, was central to the domination of the Aboriginal people (Turnbull 1991; Fforde 1997, 2004). Fforde drew on Foucault's analysis that from the seventeenth century the body became an object and target of power, which is realized through a technique of scientific classification and regulation (Foucault 1977, cited in Fforde 2004a: 84–85). Fforde and others argue that scientific knowledge about the Aboriginal body has been fundamental in sustaining and constructing relations of power (see also Zimmerman 1989; Peirson Jones 1993; Riding In 2000). The identification of the domination of the body through medical power and discourse influenced these campaigners and informed their claims-making. Human remains were more important

than objects as a focus for their activities because the body was identified as a significant site of oppression. The scientific outlook that researches and objectifies these body parts as human remains was thus identified as a problem.

The contribution of this thinking can also be identified in a growing body of work that studies the dead body through history, often focusing on dissection, and which compares present day medical practice with that of the past (see for example Richardson, R. 2001b). Australian historian Helen Macdonald (2006) tells the story of dissection in Britain and its colony Van Dieman's Land (Tasmania) in the eighteenth and nineteenth centuries. She traces the relationship between anatomists and colonialists, and the movement of human remains between them. Her central point is that that anatomy is a cultural activity that encourages a proprietary attitude toward human remains, which allows and even encourages the use and abuse of human beings across history and countries. She identifies that anatomy, which she compares to colonization, was central in the domination (and deaths) of the Aboriginal Tasmanian people (Macdonald 2006).

Similarly influenced, the majority of research on the display of human remains in exhibitions has focused on the display of disempowered groups as a method of domination. Theorists have suggested that the lack of political power held by these groups permits this, and is reinforced through the use of their bodies in exhibitions (Lindfors 1985; T. Bennett 1995; Butchart 1998). One well-known case that became the center of political bargaining between France and Africa from the 1950s was that of Sara Baartman, known as the Hottentot Venus. She was a Khoikhoi woman taken from South Africa and exhibited in London in 1814, due it is now said, to the large size of her buttocks (Netto 2005). Her plight both before and after her death has stimulated a large body of theoretical work and campaigning influenced by feminism and postcolonial thinking, which argues that the display of her body reinforced the colonial domination of African people, and the domination of women (see for example Gilman 1985; Butchart 1998; Lindfors 1999; Netto 1995).

In a thoughtful paper written about the rise of interest in the plight of the Hottentot Venus, sociologist Zine Mugubane (2001) critically identifies the influence of poststructuralist thought:

> The theoretical groundswell her story precipitated cannot be separated from the growing popularity of poststructuralist analysis of race and gender. The ways in which science, literature, and art collectively worked to produce Baartmann as an example of racial and sexual difference offered exemplary proof that racial and sexual alterity are social constructions rather than biological essences. Thus, her story was particularly compelling for anyone interested in deconstructing difference and analyzing the 'othering' process. (Mugubane 2001: 817)

The central point is that postcolonial and feminist scholarship identified Sara Baartman as a vehicle to make broader theoretical points about the domination of the body and the construction of race. Baartman's body was an icon for this theoretical outpouring. It is worth noting that Mugabane sees this as a problem, for it is ahistorical and neglects an analysis of the broader material relations influencing the treatment of Africans. As she writes:

> Baartman's exhibition provoked varying and contradictory responses. These responses can be better understood if they are analyzed as part and parcel of larger debates about liberty, property, and economic relations, rather than seeing them as simple manifestations of the universal human fascination with embodied difference. (Mugubane 2001: 827)

Mugabane points to the consequences of this intellectual approach: that despite using words such as 'invented', 'constructed' and 'ideological', these critiques contribute to the biological essentialism that they purport to deconstruct. The expressed aim of the discussed scholarship on Baartman has been to critique racism and essentialism, but it ends up reproducing the idea of racial difference, which is made manifest by the body.

These three social influences on the problem of human remains—the scientific view of the body, the body as a site of identity, and the location of the body as a site of power and struggle—informed the focus on human remains, and have granted purchase for the claims that these objects require special attention. These interrelated influences work together to impact on how the display and research of human remains is considered. The museum context in which the human remains are displayed has become problematic because it is not considered legitimate. This problem is more acute due to the tension between scientific view of body and the rise of the body as the self and as a site of political and ideological control, all of which has consequences for the interpretation of the display and holding of human remains.

But this does not mean that human remains cannot be objects of display or research: indeed, the converse can occur. What is crucial is the stability of the context in which this takes place. For example Megan Stern, a lecturer in critical theory and media studies, discusses the *Body Worlds* exhibition and *The Visible Human Project*: a project where dead bodies were frozen and sliced into microscopic layers which were photographed, scanned, then presented as three-dimensional maps of male and female bodies. Stern argues that these exhibitions present the bodily interior as 'utopian' (Stern 2006). What is interesting about Stern's analysis is that she argues that the human remains have 'utopian potential' because they are exhibited in a 'democratic' way. Stern suggests that previously 'ordinary people' have been unable to access the dead body, because doctors have

controlled it since the 1830s when anatomy stopped being shown to be public. Thus these exhibitions, for Stern, 'liberate' the body (p. 74). As she writes:

> In so far as they render the body accessible to non-professionals, *The Visible Human Project* and *Body Worlds* can be seen as part of these changes in medical culture and by extension, part of a liberating reclamation of the body. (Stern 2006: 75)

Here we can see the influence of a combination of factors that contribute to the growing symbolic significance of the display of human remains. First is the importance of the context in which human remains are on display; second is the influence of feminist politics. Because, to Stern, these bodies are exhibited in a 'democratic fashion'—that is, outside of a medical laboratory or a museum—they can be interpreted as liberating, which is due to the focus on the body as an important site of domination. Such exhibitions would not be interpreted as part of a liberating reclamation of the body if they were in a medical or museum context.

To illustrate this point in another way, take the following two excerpts: one from responses to body parts controversies, and the other concerning art created with bodily material. Both are taken from the period when the debate over the Alder Hey 'body parts scandal' and the return of indigenous human remains in museum collections was at its height. The first quotation is taken from the Royal Liverpool Children's Inquiry and Report: 'Perhaps the most disturbing specimen is that of the head of a boy aged 11 years' (Royal Liverpool Children's Inquiry 2001: § 20.5). Contrast this description with the art review in the *Guardian* newspaper of the artist Mark Quinn's portrait *Self*, which was a shape of a head filled with blood: 'The blood head was a tremendous thing to behold—a premature death mask made of the exact quantity of the substance needed to keep us alive.' (Cumming 2000).

Drawing comparisons between these two excerpts may seem difficult. One is an official report into the retention of children's body parts; the other is an art review in a national newspaper of an object that contains blood—not even human remains. However, on another level both the excerpts express the different concerns and interest in human remains discussed previously. The first excerpt articulates a concern about the problematic treatment of the dead by the medical profession. The second identifies the display of a blood head as magnificent due to the importance of blood to our life. This would suggest that it is the context in which human remains are kept is highly important; and in the case of medicine and museums, where legitimacy and authority are challenged, the holding of remains has become potentially problematic. This is especially the case because there is a heightened significance accorded to the body in the present period.

6 Covering Up the Mummies

A confluence of influences has contributed to problematizing the holding of human remains in collections. In particular, these are the crisis of cultural authority contributing to professional activism and weak resistance to it, and the rise of the body as a site of identity and political struggle. So far I have examined this development in relation to remains from overseas indigenous groups, and the formation and impact of a particular Pagan group. This chapter analyzes the activity around uncontested human remains, focusing primarily on their display, and further examining the influences and limits to the construction of this problem by looking in greater detail at the interaction between professionals and particular bodies. The impact of concerns about human remains on those uncontested is eclectic and inconsistent, but there is an identifiable impact. I first discuss the exhibition of the bog body Lindow Man, then the covering of Egyptian Mummies at Manchester Museum. Following which I present further analysis of the respect discourse and the policies of particular museums. Finally, I turn to the exhibition *Skeletons: London's Buried Bones*, where I suggest professionals are attempting to reauthorize scientific research and the display of bodies by adopting the discourse of identity work.

EXHIBITING LINDOW MAN

Bog bodies—preserved ancient human bodies found in sphagnum bogs—are an archaeological phenomenon that has attracted extensive scholarly and public attention since the bodies were first discovered, in the eighteenth century, in Northern Europe, Britain and Ireland. Thanks to the conditions of the bog, many have preserved skin and internal organs, skin, hair and body parts, which means that they resemble the human person more closely than ancient skeletons. As well as extensive academic research, bog bodies have been the inspiration for popular writing, art work and poetry, such as that of Seamus Heaney (1975).

Archaeologist Nina Nordström (2007) describes how certain bodies from the past become the subjects of great public and academic interest.

There are various contributing factors to this, she suggests, deriving from the particular bodies as well as the cultural climate in which they are discussed. Despite the influence of the present on how we view these bodies, Nordström makes the point that our consistent ambition is to find out 'the truth' about them: who they were and how they lived. This is an observation that should be borne in mind as we discuss the process and outcome of the Lindow Man exhibition.

Lindow Man is the name given to the naturally-preserved bog body of a man from the late Iron Age, discovered in the mid-1980s in a peat bog at Lindow Moss, North England. He is Britain's best known and most studied bog body. Archaeologists Stead, Bourke and Brothwell (1986) edited the first comprehensive book on Lindow Man, which compiles all the initial different strands of research that had been carried out on the body. This was followed by a number of works (see for instance, Turner and Scaife 1995). Questions considered pertain to discovering who Lindow Man was, how he lived, what he ate, what he wore and hunted with, what religion he might have been, what ritualistic practices he might have partaken in, when he lived, and how he died. He is of particular interest due to speculation that he was the victim of a sacrificial killing.

Hallam, Hockey and Howarth (1999) explain that with specific cultural and specific institutional contexts, such the passage of time and the establishment of the coroner's court, the body parts of the dead shift from the category of 'dead body' to that of 'anatomical objects'. As an example of this re-contextualization, they describe the status of Tollund Man, a bog body from the fourth century BC, found in Denmark in 1950. Hallam, Hockey and Howarth argue that this bog body is no longer considered a 'dead body' because he falls outside of social relationships. Instead, they posit, he has become an anatomical object due to the context in which is displayed: '[H]e became a clinical object, a focus for scientific interrogation, an objectified ornament of antiquity. The Tollund Man, as he is now known, lies in a glass case in the Museum of Silkeborg' (Hallam, Hockey and Howarth 1999: 92). Given that bog bodies fall outside social relationships, and are not tied to a contemporary claims-making group or associated with a particular past—unlike the human remains of Aboriginal peoples—how is Lindow Man considered in the period of the controversy over human remains?

Lindow Man is usually held in the British Museum, but was loaned for a temporary period to Manchester University Museum (MUM). Earlier exhibitions at MUM in 1987 and 1991 examined Lindow Man's life and times and presented the results of the latest forensic work. The exhibition of 1987 was one of the most popular in the history of the museum (Alberti et al. 2009). The 2008–2009 exhibition *Lindow Man: A Bog Body Mystery* drew upon research carried out over the past 25 years and aimed to explore the different meanings that Lindow Man's body holds for different people. The explicit intention was to reflect changes

in society and in academic thinking that had taken place since then. As Bryan Sitch, curator and Head of Humanities at MUM, explained:

> When it accepted the offer of the British Museum to lend the body of Lindow Man for a year, the Manchester Museum was anxious to take account not only of changing academic interpretations of the discovery but also of increasing sensitivity towards human remains within society more generally. (Sitch 2009: 52)

Sitch continues: '[H]uman remains had become more contentious, partly because of the Alder Hey scandal, in which it emerged that organs had been removed by hospitals from hundreds of deceased children without the families' permission', and also 'because of the repatriation of human remains to indigenous communities in Australia, New Zealand and the Americas'. In addition, he notes 'the voices of marginalized groups such as pagans, whose relationship with the dead is based on spirituality and a respect for the ancestors', thereby associating these three issues together.

The museum ran a consultation on the exhibition, to which a number of Pagans, archaeologists, curators and local figures were invited and I attended. Two meetings were held, at the museum, one in February 2007 and the other a year later in February 2008. Piotr Bienkowski, the deputy director of Manchester University Museum, opened the first meeting, stating:

> At Manchester Museum we are increasingly consulting as a museum with all stakeholders. We no longer stand as a single authoritative voice—those days are gone. There is an exciting wide range of voices here: museum staff, university staff, archaeologists, councillor Paul Murphy, the community advisory panel, Pagans, and Honouring the Ancient Dead: I hope I haven't missed anyone out. The plan is to produce a unique exhibition. We don't want to produce just one view, we want to bring out different ways of presenting different views of Lindow Man. We want your views, not just those of the traditional establishment voices.

This represents a clear attempt to portray the new inclusive museum as different to the past, and moving away from the 'traditional establishment voices'.

At the first meeting for the consultation, participants were asked by Bryan Sitch and Piotr Bienkowski, who co-ordinated the event, how they felt about exhibiting Lindow Man; specifically whether he should be buried and what would constitute respectful treatment. Despite anticipation that there would be disquiet about his display, what was notable about the consultation was that no one argued for the burial of Lindow Man. Nor did participants have firm ideas about how to organize the exhibition. Instead,

those consulted raised a variety of different concerns, all of which had very little to do with this particular bog body. In short, Lindow Man became a vehicle for their individual preoccupations.

The Labour Councillor, Paul Murphy, wanted to raise the issue of multiculturalism through the exhibition, and was worried about how to entice local visitors into the museum. He speculated that the museum could show that his constituency was genetically related to Lindow Man, through DNA research, which would make the show relevant to them. He posed the question of how the museum could involve the Afro-Caribbean community members of his ward, which revealed this councillor's underlying concerns about connecting to the electorate. A couple of archaeologists ventured that the exhibition could foster an interest in the past, in order to address contemporary confusion about identity. One Druid suggested that the display of Lindow Man could promote a sense of community. A number of Pagans and archaeologists thought the exhibition could stimulate discussions about death, and confront what they described as the 'death taboo' of the present period. Three archaeologists argued that the display of Lindow Man could draw attention to the problem of the environment, by flagging up the nature of the peat bog in which he was found and how it is threatened by building on the site. As the following exchange demonstrates, the promotion of multiculturalism and identity was an accepted concern of this meeting:

Councillor: It's good to hear about Paganism. It should be central in the exhibition. It shows that multiculturalism is possible through this exhibition.

Sitch: Yes it's important to discuss diversity. Pupils should show an understanding of different views. If they can understand Lindow Man maybe they can understand what it is to be a Muslim.

The particular concerns about diversity are projected on to Lindow Man (and Paganism) as potential themes of the exhibition, although there is no obvious reason why the exhibition of a bog body from the Iron Age would address Muslim identity, or multiculturalism more broadly. Bryan Sitch subsequently suggested that Lindow Man could be an 'ambassador for diversity'—for if the audience could understand Lindow Man, they might be able to 'appreciate that other people are different too'. In the report on the consultation, Sitch wrote:

Lindow Man could be a community ambassador. If schools, children and students can be taught to appreciate his way of life, some sense of his spiritual values in so far as they can be reconstructed from 2000 years ago, how much easier might it be for the same children to understand a present day religion or culture? (Sitch 2007a: 8)

In a similar vein, Sitch suggested that the show might help promotion constructive discussion about the environment and terrorism:

> There is also the question of his relationship with the landscape and the importance of green issues in present day society. Potentially there are wider issues involving ethnic diversity, regional identity and even terrorism.(Sitch 2007a: 9)

Overall, nobody argued that having Lindow Man on display was a problem, and very few were interested in the particular body or its history. The majority of attendees at this consultation used Lindow Man to discuss their specific preoccupations. Despite the rhetoric of concern about how human remains should be treated in museums, and the specific consultation on Lindow Man being held ostensibly in response to this concern, the bog body itself was not an object of concern. Rather, Lindow Man was a focus for participants' interests, which were influenced by present day preoccupations that included identity, multiculturalism and environmentalism.

The main conclusion reached after consultation was that the diversity of opinion and interpretation about Lindow Man, from within academia and the public, should be centrally promoted in the exhibition. This approach was counterpoised to previous ways of exhibiting the bog body which, it was suggested, falsely implied a degree of certainty about the theories of how Lindow Man lived. Previous exhibitions, it was suggested, exaggerated the knowledge of what is merely speculation about his life, and did not reflect different interpretations. The MUM show would tackle this:

> The exhibition should explore alternative points of view, including archaeological interpretation and more spiritual perspectives. It should be a questioning exhibit, particularly if there are few hard and fast facts or if the facts are disputed. It should not tell people but admit that there are some things we do not know. It could question the sensationalist glamorous interpretation of Lindow Man. There should be stories and contradictory stories.(Sitch 2007a: 3)

This approach, which questions the possibility of knowing about the life and death of Lindow Man, was made explicit in the show, by promoting a diversity of opinion and taking a pluralist approach. As the feedback to the second consultation notes, the exhibition enacted 'the principle of multivocality or "talking with more than one voice"' (Sitch 2007b: 1). In February 2008, Sitch told me that the exhibition was an 'exemplar in the museum' and that this was an example of the 'museum not speaking with a single authoritative voice'. The deliberate aim was to 'reflect uncertainty'. The show was organized around seven different

interpretations of Lindow Man, through recorded personal testimony from the following people: a forensic scientist, a landscape archaeologist, two museum curators, a former peat worker, someone from the Lindow community and Emma Restall Orr, of the Pagan group Honouring the Ancient Dead. Such an approach displaces curatorial authority by presenting these interpretations as equal.

The other central theme promoted throughout the exhibition was that human remains should be treated differently to the way they were before. It was argued that previously archaeologists have treated Lindow Man as an object and that this museum would instead treat him like a person. One of the curators explained in an interview in February 2008, that the old, archaeological way of looking at Lindow Man was problematic:

> I think maybe ten years ago I would have looked at Lindow Man as an example of a wonderfully preserved bit of archaeology [. . .] I think I now see him in a very different way, in a more emotive way and for that reason the approach that we've adopted to display Lindow Man, i.e. displaying him with sensitivity and respect, is one that I personally have a lot of sympathy for.

Archaeology, in the curator's view, was less emotional and sensitive than his own. He was not sure if the public would agree, however, reminding us that concerns about human remains are not driven by public demand.

> I think that our approach; the respectful, sensitive approach, while I find that praiseworthy, my impression is it might be in advance of what the public sensitivity actually demands. I . . . but I think museums can have a very important role in guiding public attitudes and on this very sensitive and emotive subject . . . I think it's no bad thing that we actually try and guide . . . not indoctrinate, but guide our public into perhaps viewing human remains in a different way than they've seen them in the past.

Activists at this museum presented archaeology and museum professionals as unemotional, controlling individuals who need to open up more and consider the different views of dead bodies, to treat them less like objects and more like people. Paradoxically, there was considerably less reflection on this particular body as a person who lived thousands of years ago. There was little discussion, compared to writing and previous exhibitions on Lindow Man, about who this person might have been and may have lived. Despite the rhetoric about the need to treat Lindow Man as a person, and with respect, this approach has the consequence of relegating research about his life to a lower priority.

COVERING THE MUMMIES

At the time of the launch of the Lindow Man exhibition, a controversy broke out when the Manchester University Museum took the decision to cover up the three unwrapped, or partially unwrapped, Egyptian mummies. In May 2008, the unwrapped mummy of Asru, the partially unwrapped mummy of Khary, and the loaned child mummy from Stonyhurst College, usually on display, were covered with white sheets. The stated aim behind this action was to raise questions through public consultation about the treatment of human remains. The museum explained in an official statement, that the covering was due to the recognized issue of the problems with the display of human remains: 'It is now generally recognized that the display of mummies, and indeed of any human remains, is a sensitive matter.' And that 'alongside positive comments' a 'a significant number of comments are regularly received from visitors who are concerned or disturbed about their display, questioning the public and educational benefit of displaying unwrapped mummies, particularly a dead child.' It explained that 'The Manchester Museum is not against the display of human remains; rather it wishes to develop sensitive and respectful methods of displaying them.' (MUM 2008a: 1)

Museum director Nick Merriman told *BBC News:* 'We're asking the public what is the most respectful and appropriate way to display them. It's good practice rather than political correctness'. He continued, asking, 'Is it appropriate to display them this way, given that they were originally wrapped, but then unwrapped in the nineteenth century to satisfy scientific and public curiosity? It's all part of the debate.'[1]

However, Egyptian Mummies are very popular with audiences and a major draw for museum visits (Day 2006). Postcards of mummies at the British Museum are said to sell as well as those of the Rosetta Stone (Beard 1992, cited in Walker 2000: 15). They fall a long way outside of any social relationships. Consequently, there was a strong negative public and professional reaction against the covering of the mummies in this case, which was widely covered in the press. The *Daily Mail* reported Bob Partridge, chairman of the Manchester Ancient Egypt Society, as saying that the cover-up was 'absolutely incomprehensible' (Narain 2008). Partridge continued: 'The mummies have always been sensitively displayed and have been educational and informative to generations of visitors. We are shocked this has been done in advance of any results from the public'. Josh Lennon, a museum visitor, was also reported in the same article as saying: 'This is preposterous. Surely people realize that if they go to see Egyptian remains some of them may not be dressed in their best bib and tucker', and that, 'The museum response to complaints is pure Monty Python—they have now covered them from head to foot rendering the exhibition a non-exhibition. It is hilarious'.

Shortly after this reaction, in July 2008, the museum changed the display and uncovered some of the mummies. In a press release with the title 'Egyptian Mummies: we're listening to your views', it was explained that this was due to the negative public response against the action:

> Director of The Manchester Museum, Nick Merriman, commented, 'We started the consultation process with a total covering of three of the Museum's unwrapped mummies. As public feedback showed that this is not the most appropriate long-term solution, we are trying out a range of different approaches to gauge public opinion. Some of these will include techniques which are used in museums in Egypt.'(MUM 2008b)

Even so, the organization didn't retract all the attempts to further problematize human remains, in this instance, Egyptian mummies. The museum's press release stated that 'For the next phase of the consultation period, one of the mummies will be left partially unwrapped in its original display state, while another will be partially covered leaving the head, hands and feet exposed.' And that it would continue to debate this issue and undertake research into attitudes regarding display, suggesting that the issue remains potentially problematic, and that the term consultation may be used to promote a particular agenda, while presenting it as open to influence from the public:

> The Manchester Museum utilizes consultation to inform its activities, and is commissioning research into visitor responses to displaying (Egyptian) human remains on the galleries as part of the ongoing consultation process on displaying the dead. The issue of choice as to whether visitors view the mummies on display or not has been addressed by installing panels at either end of the Egyptian galleries that indicate the presence of human remains, and offering an alternative route bypassing the galleries. (MUM 2008b)

Future practice planned at the museum involves trying to change public attitudes. In an interview that took place in February 2008, a curator at the museum explained in relation to the Egyptian galleries:

> [W]e prepare the children before we go into the gallery and ask them how they think we should behave when we go into a gallery which is full of in effect dead people really . . . and so we programmed in a prayer for the dead at the end of the session so that's very different to the way that mummies used to be the sort of um peep show, freak show, whatever . . . and there's still a sense of that that comes through in visitor feedback . . . that, you know, 'oh, we want to see mummies because they're scary and repulsive and what have you' . . . but I think,

> I think as people we have the right to take a stand, and say we feel as people that we should treat human remains in a different way.

This curator advocates that the mummies should be treated as dead people, saying a prayer to them after the children have seen them. Contemporary Egyptian curators or communities are not making claims about Egyptian mummies or requesting the treatment, and it is unlikely that the original Egyptians would. The prayer seems therefore to be primarily for the professionals at this museum.

This attempt to extend the problem to uncontested human remains is an example of how certain professionals in the museum sector continue to try and target human remains as an issue. However, there were important limits to their success in doing this. In this instance the lack of claims-making group to support their actions, strong professional and firm and publicized negative public reaction to the act of covering up the mummies, halted their attempts to problematize these particular human remains.

ANALYZING THE DISCOURSE OF RESPECT

Piotr Bienkowski and Emma Restall Orr are not the only individuals who have made use of a discourse of respect around the issue of human remains. By early 2000, archaeologists and museum professionals build on this discourse of respect that is used to advocate action and concern in relation to all human remains (Curtis 2003; Lohman, 2006; Brooks and Rumsey 2007). The use of the term in this instance changes over time and can be broken down into three arguments. Firstly, it is argued that respect must be shown is to other cultural values and feelings about human remains. This is either respect for the original community or their present-day descendants. For example, items two and three of the Vermillion Accord, the first code of conduct on human remains, adopted in 1989 at World Archaeological Congress, advocate 'respect' for the wishes of the dead and the local community (WAC 1989: unpaginated). In a similar vein, the Museum Ethnographers Group guidelines on human remains argues for restricted access to human remains 'where unrestricted access may cause offence or distress to actual or cultural descendants.' (MEG 1991: s.2.2) The guidance also states: 'All requests for the return of human remains should be accorded respect and treated sensitively.' (§ 4.1) Similarly concerned with the feelings of affiliated people today, the International Council of Museums (ICOM) Code requires that public display should be carried out 'with great tact and with respect for the feelings of human dignity held by all peoples' (ICOM 2002: 19), as does the Code of Ethics for Museums, published by the Museums Association, which states that museums should 'respect the interests of originating communities' (MA 2002: 17).

The second part of the case put forward for respect advocates parity of treatment. It is suggested that if some human remains are treated with special care then all should be. Edmund Southworth, curator at National Museums and Galleries on Merseyside and editor for the Society of Museum Archaeologists, points out in an article in the *Museums Journal*, titled 'A Special Concern', that there is a contradiction between displaying Egyptian mummies and Iron Age men, and hiding Maori heads (Southworth 1994: 23–24). Ratan Vaswani of the Museums Association also comments in the *Museums Journal*, 'The important questions we need to consider are those of consistency. By what standards do we consider it "acceptable" to exhibit Egyptian mummies but decide to withdraw Maori heads from display?' (Vaswani 2001: 35. See also Rumsey and Brookes 2007: 266). In a similar vein, Hugh Kilmister, a curator at the Petrie museum in London, suggests the removal of Egyptian remains, in order to avoid a 'double standard':

> [T]he public is generally positive about the display of ancient Egyptian remains, but we perhaps need to look to the future redisplay of these remains. This has been made more timely by the fact that contentious remains in many museums have been removed from display, but those remains that are unlikely to be repatriated have been left on exhibit, thus creating a double standard.(Kilmister 2003: 65)

Here there is a developing sense that if one set of remains is removed from display, others left on exhibit are thus treated without similar consideration.

Thirdly, there is the thinking amongst some professionals that all remains need special treatment and protection because of their unique status. This includes the idea that remains should be taken off display or buried. Commenting on the ICOM Code, Per Kåks of the International Council of Museums Ethics Committee argued that respect is 'not just a question of showing the objects in a solemn setting, but perhaps of not showing them at all, or not allowing them to be handled except by very few and relevant persons' (Kåks 1998: 10). The International Council of Museums Code of Ethics states: 'Collections of human remains and material of sacred significance should be acquired only if they can be housed securely and cared for respectfully' (ICOM 2006: § 2.5). The law academic Charlotte Woodhead argues that proper 'respect' for the dead means that they should be 'undisturbed'. In one of her articles, she makes it explicit that this also means European remains, while referencing the symbolic case of Truganini.[2]

> It is now appreciated that acts such as the exhumation and subsequent display of Truganni's remains, against her last wishes, showed grave disrespect to the dead. While we understand the importance of leaving our loved ones undisturbed, perhaps we should also extend this respect to our own ancestors. One might take heed of the advice: 'You

cannot fulfil your dreams if you insult your ancestors'. This should apply not only to indigenous peoples but equally to Europeans. (Woodhead 2002: 339)

Woodhead concludes that 'human remains warrant special attention' (p. 346) and that they are different to objects. She argues that all human remains should be treated respectfully because they were once individuals, regardless of public feelings on the matter. They 'deserve special consideration' due to 'the fact they were once individuals'. For this reason, although she recognizes 'there is no widespread movement in Britain for the removal of remains from collections' (Woodhead 2002: 337), she suggests that they should nonetheless be treated differently and suggests that they are left undisturbed and not in museums: 'We in Britain now have an opportunity to ensure this happens and should instigate a clear policy with regard to human remains outside the political arena with the primary intention of affording respect to those remains.' (p. 347) The Human Remains Working Group Report (HRWGR) similarly makes the case that all human remains should be treated as unique and proffers suggestions on the principles for the Human Remains Advisory Service, the second of which pertains to respecting human remains.

> Respect and reverence. Human remains must always be treated with respect. Responsibility for them should be regarded as a privilege. Museums owe the highest standards of care to bodies and parts of bodies within their collections, regardless of their age, origin, or the circumstances of their arrival in the collection. (DCMS 2003b: 171)

In this principle, the bodies and body parts (note that they are not described as human remains or skeletons) require respect and reverence. This does not apply because of the feeling of the communities or the circumstances of historical acquisition, but because all bodies and body parts require respect.

Even so, what this means in practice appears difficult to articulate. But at its most coherent, as we have seen in relation to the discourse of respect in Chapter 4, the actions advocated concentrate less on the human remains than on the actions of the researcher and the context in which the human remains are analyzed. In *Human Remains: guide for museums and academic institutions* (Cassman, Odegaard and Powell 2007), a publication for the sector on handling and caring for human remains, the discourse of respect and the idea that human remains require special protection is ventured. The book is dedicated: 'To institutionalized human remains wherever they are found' (p. v). The use of 'institutionalized' implies that their holding by an organization is difficult. The Foreword outlines that previously 'the treatment of skeletal remains' was 'one of archaeology's dirty little secrets' (Fagan 2007: xviii), a phrase that suggests that there is something

sordid about the way archaeologists used to treat human remains. Describing human remains as 'the dead' in many instances, this works to humanize human remains, as does the subject of the book's dedication, which would usually be to a named and often, living, person. The introduction makes the point that even the terminology needs to be reconsidered by researchers:

> The use of different vocabularies tends to reveal or impose a level of regard by those that word with the dead. Words that imply the greatest distancing include *artifact, object, specimen, decedent,* and *corpse* [. . .] Words that convey a sense of connection include *individual, person,* and *human remains.* The latter are used throughout this book to reflect greater respect in order to promote improve care and management. (Cassman and Odegaard 2007: 1)

With this approach, 'respect' means thinking of and describing human remains as connected to us and as holding human characteristics. 'Disrespect', by implication, is to distance oneself from the remains and consider them as specimens. Similarly in the Human Remains Working Group Report, not treating human remains as people is identified as a problem:

> All these human remains were once parts of living individuals. Museums have tended to objectify them, as this makes them easier to deal with, but many museum staff would now contend that society believes that human remains need special treatment. (DCMS 2003b: 352)

As we have discussed, here the critique is of the museum professionals: their disciplinary background, approach and how they describe the human remains. This point is explicit in a chapter written by the archaeologist Vicki Cassman and Nancy Odegaard, conservator at Arizona State Museum:

> At a minimum human remains should be accorded gentle handling, and handlers must have an awareness of the potency of the remains, the privilege given to handlers, and their responsibility. Human remains are not specimens; they were people—they are individuals. To begin with, handling should be undertaken only with a specific purpose. One should not browse as if in a library, picking up bones and articulated joints without purpose. Simply put, a mental state of propriety is required of handlers.(Cassman and Odegaard 2007: 49)

In this extract professionals are instructed that they require a special 'mental state of propriety' when holding human remains. The point is made again that to consider the remains as specimens is to treat them with disrespect. The discourse of respect, or the idea that human remains require

special treatment, in this context, appears to apply more to the professional rather than relating to something intrinsic about human remains.

POLICIES ON HUMAN REMAINS

Seventeen museums have drafted specific policy on human remains.[3] Many are very similar to the government guidance (DCMS 2005). Most advocate that signs are erected to warn audiences in advance about the display of human remains, even though there is no obvious public demand for this. The Royal Cornwall Museum in Truro, for example, states that it will take care not to show human remains without warning. As the policy outlines:

> Display methods will aim to prepare visitors for viewing human re-mains respectfully, will warn those who may not wish to see them at all and will display them in such a way as to prevent people coming across them unexpectedly. (RCM 2006: 6)

The policy continues that it will not be permitted to show images of human remains online or in any publicity material: 'No images of human remains other than wrapped mummies will be available online or will be used for marketing purposes.' (RCM 2006:6)

Eight policies in particular indicate a significant concern about the display of human remains. These state that human remains should be separated from objects in their stores and collections, or that handling by the public should no longer take place, and that researchers should wear gloves when holding them (B&H 2006; LCMG 2006; NMGW 2006; MoL 2006, RCM 2006; MUM 2007; UCL 2007; HEM 2009). The policy for Leicester City Museums and Galleries explains this in relation to the potential sensitivities of the audience, as well as respect for the remains:

> There is a high probability of the risk of offending religious and other sensitivities far outweighs the benefits of using human remains in han-dling sessions. A case could be made against this, but it must be care-fully considered. At the present time, Leicester Museums and Galleries is not comfortable for human remains to be used as handling material to maintain respect for their past lives. (LCMG 2006: s.9.1)

There is an unease in using human remains in handling sessions, and this is rationalized in terms of respect for the 'past lives' of the skeletal parts. It should be noted that Leicester City Museum and Galleries contains remains that are uncontested, unclaimed and ancient. Interestingly, previous to this policy, the organization had not considered human remains as a general overall collection, but rather viewed them as part of different collections organized by disciplines:

Leicester Museums and Galleries holds human remains in several of its collections. They come in many forms including skeletal, cremated and mummified remains. The human remains in the collections have not previously been assessed as an overall collection and are not always stored appropriately. (LCMG 2006 s1.3.1)

Whereas in the past, human remains were not considered 'a collection' but parts of different ways of organizing the whole collection and thus part of different disciplines, this policy begins to consider human remains as a category in and of themselves.

The policy for Brighton and Hove museum also states that contact with human remains should be avoided:

It will be the aim to place material in individual, marked boxes that also act as auxiliary supports to facilitate handling without direct physical contact. Physical contact will be kept to a minimum although, when absolutely necessary, direct contact with skin will be avoided through the use of conservation standard gloves.

Human remains will be stored so that access to them is allowed only to authorised staff and supervised visitors with specific permission. Where human remains comprise a small proportion of a larger collection, curators will identify a designated area where human remains will be stored, to create conditions supportive of respectful treatment. (B&H 2006: § 7.18–7.19).

With these policies, human remains take on a privileged status in the collection and are seen to require extra care that was previously not afforded to them. It should be noted that, in some instances, gloves are already used in institutions, although inconsistently, to protect the material from erosion. This practice now continues, but in the name of 'respect'. As with Leicester Museums and Galleries, the policy for Brighton and Hove museum pertains to human remains that are uncontested and unclaimed. It concerns the archaeological holdings of human skeletal material from the Neolithic through to the Anglo Saxon periods.

The Museum of London policy states that it takes into account (and takes a public stance on) the provenance of the remains; the use of consent; handling access; specific display methods; privacy; institutional responsiveness to visitors; loans; and internal reviews in relation to human remains. It notes that display requires 'careful thought' (MoL 2006: § 6.1). Indeed, in 2004, the remains of a boy with rickets were taken off display. The director, Jack Lohman, announced that he had set targets for the Christian burial of other human skeletons from archaeological excavations in London in the museum's collection. This decision was reported in the *Times* newspaper, where Lohman explained these actions as motivated by 'ethical reasons' (Alberge 2004). The policy explicitly includes traditionally marginalized communities such as Pagans in its consultation network.

While policies that advocate the different treatment of human remains are present in only eight institutions, none of which are major national organizations, their existence is worthy of note, because it demonstrates a moderate influence of the idea that human remains are a special object that should be treated differently to other objects in the collection.

The idea that human remains require special treatment in not being handled, or that they should be separated from objects, may meet difficulties in practice. This is partly because this is not driven by a rationale or an idea of how human remains *should* be treated and why, and partly because it has to work with other policies that may present contradictions. For example, the access agenda in museums, where policies outline that the public have access to the collection, may be contradicted by policies that advise that human remains are not on display or easily seen. It is worth noting, however, that the policies on human remains are not contested. They may have been adopted by only be a few organizations to date, but as one scientist indicated, professionals are unlikely to challenge their adoption elsewhere, telling me: 'I take a pragmatic approach to these guidelines . . . if it means I get to do my research, then I'll do it.'

I asked the director of one university collection why it was now policy to separate objects from human remains, in late 2007. She replied, referring also to the rule that handlers would have to wear gloves and that the human remains would have to be hidden or not easily visible to the visitor:

Interviewee: We haven't really started implementing it yet except that in the [museum name] human remains are all now in one part of the store and clearly it's not possible to go into it by accident. I'll suppose we'll have to do something about implementing the handling thing too. There is this thing about university collections being slightly different to other collections, and in the [museum name] everything will either be on display or in visible storage. There won't be anything hidden away . . . um and I mean . . . even the . . . there's some pathology collections here and we are talking about finding ways of putting them in cases so they can be used or examined or when they need to be . . . but so all the rooms can be used when they need to be, so we have a whole load of neurology specimens, currently in a room that is currently used by the German department [laughs].

TJ: How will you reconcile the issue of access and visibility while also putting up warnings about display?

Interviewee: Um . . . ideally one would have a system where they could be in tinted glass, where you wouldn't be forced to confront them if they . . . if they didn't wish to, but at the same time if you wanted to have a handling session or a session with medical students you could do that in the same room . . . So I think

what we are exploring is sort of visible storage or visible stroke invisible storage.

This interviewee is a director of a university museum with a broad range of material, including a medical collection. She was medically trained and did not think human remains 'have a special case'. Her museum had not begun to fully implement fully this new policy which would separate objects from human remains in storage, and would be careful about their display, and it did seem to be a major concern. She acknowledged that there could be difficulties in implementing this practice, due to their policy on access which means that all objects must be available and on display. Another reason is because medical students at the university use and require access to human material as part of their training. To reconcile the problem of removing and storing human remains at an institution that is also meant to have everything on show, this professional suggests a solution of tinted glass. In this instance, while the practice of granting human remains special new treatment contradicts the agenda of other policies in the museum, and the feelings of some of the professionals, this contradiction had not yet become a major problem. There is an attempt to reconcile these different practices without questioning them.

I interviewed the author of one of the policies that states that human remains should not be handled, that warnings should be posted, and that they should be stored seperately from objects, to explore further their feelings about the treatment of human remains and the rationale for these rules. The institution held no human remains that were or could be claimed by overseas indigenous groups. I asked her: 'What is it to respect human remains?' The interviewee replied:

> Respect is very complicated, it's about thinking about it really, you think about everything you do with them, and then I think it then it becomes more clear . . . We've a case of Roman remains I want to change. They are disarticulated pathological specimens and are just awful . . . It's not respectful the way they are . . . They've got letters and numbers on them to categorize them in relation to files, but that's a person . . . you know . . . They are treated as objects or just documents, you need to treat them as people. The scientific outlook that did that, needs to be more social, or personal. You certainly don't separate the parts of the skeleton . . . you know skulls in one case or femurs in another.

For this interviewee, treating Roman remains as objects or documents was a problem. Thinking of them as a person was essential. This means showing respect for the integrity of the body and storing remains separately from objects. The scientific outlook is clearly identified as a problem, as is the traditional way these remains were handled and presented, because it does not treat skeletons as people:

Skeletons are not the same as objects. They have an elevated position—
or they should do [. . .] You know I want to know who they are, not
their number. I am not religious at all, but if you've exhumed them,
studied them and put them on display, at least leave a note about what
you know about them as people [laughs]. The numbers are bad, some
of them are written on the bones, that's awful . . . science is too cold
really.

Here the curator identifies as a problem the numbers commonly written
on skeleton bone to categorize them. She proceeded to show me a collection
of Roman skeleton bones that had numbers written on them in pen and
explained that people should not write on them, in pen or in pencil, out of
respect. In this interview, it is possible to identify the view that a scientific
outlook dehumanizes human remains, because it is 'too cold'.

SKELETONS: LONDON'S BURIED BONES

The 2008 exhibition *Skeletons: London's Buried Bones* was on display at
the Wellcome Collection in London, organized in collaboration with the
Museum of London. A sign at the two entrances of this stand-alone show
warned, in line with new exhibitions of human remains: 'This exhibition
contains human remains, including those of young children'. There were
26 skeletons on show, taken from the Museum of London's collection of
17,000 skeletons. Each skeleton was laid out in its own display case, rest-
ing on a bed of black granules. The work of the osteoarchaeologists in
determining the age, sex and pathology of each of the bodies was given on
an accompanying label. Photographs illustrated what the burial sites look
like today.

Ken Arnold, head of public programmes at the Wellcome Collection,
introduced the cataglogue for the show with a short discussion of the debate
over displaying human remains:

In the sometimes heated discussions about these issues, scientific ap-
proaches to this material frequently seem to be pitted against more
empthetic and 'humane' ones. A striking feature of this exhibition is
the manner in which it confounds that simplistic dichotomy. For here,
the methodical work of osteologists helps to reunite these bones with
fascinating, but otherwise hidden, elements of their life stories.(Arnold
2008: 6)

In this excerpt, we can identify an attempt to justify the exhibition, and
the research on and display of human remains, by saying that it brings part
of the skeletons' life stories out in the open. Arnold continues by stressing
the empathetic character of science in this exhibition: 'This show is about

how the scientific study of bones can add to rather than detract from our emotional encounters with this material.' (Arnold 2008: 6)

I interviewed one of the curators in March 2007, when the exhibition was being prepared. He explained:

> The idea for exhibition is . . . and this is where the skill and artistry comes in . . . would be to, you know, to bring them back to life, i.e. with the skill of the osteoarchaeologists and medical professionals to say, you know, we can tell this person died somewhere between 1650–1680, they were obviously they were found in Chelsea, they were probably middle class . . . we can tell from their teeth they had this in their diet, so you can kind of almost, see this ghostly apparition rising out of a skeleton.

Here the curator described the display of human remains, and the skill of the medical professionals, as actions that would 'bring them back to life'. He continued by saying: 'the more that the medics tell us about this, the more humanity and the more the human values of these, these, gone people come back together'. This would appear to be an attempt to justify the work of curators and medical professionals working on human remains as research objects, at a time when this is questioned, through the presentation of a humanized approach.

Here we can see that some of those researchers making the case for the research and display of human remains are beginning to incorporate the criticism of their traditional approach. Accused of being insensitive and cold, the researchers repose their potential contribution as humanizing. The dead bodies remain on display, but they are discussed slightly differently, with a deliberate emphasis on the emotional aspect of science, with more reflection on the identity of the skeletons, by scientists attempting to re-legitimize their work

Skeletons: London's Buried Bones was reviewed in the magazine *Museum Practice*, the sister journal of the *Museums Journal*, by Helen Rees Leahy (2008), who is director of the center for museology at the University of Manchester. She found the exhibition 'unusually rehumanizing' (p. 38), and compared it to the exhibition, and ethics, of Gunther von Hagens, whom she accuses of anonymizing the corpses on display. The rehumanizing that Leahy refers to relates to the Wellcome Collection's contextualization of where and when the remains were found, giving them more of a personal identity Rees Leahy writes that von Hagens' *Body Worlds* exhibition:

> [I]mplicity promotes the myth of a universal human being, from whom distinguishing marks of colour, age and sometimes sex have been erased. The Wellcome Collection took a very different approach, enabling visitors imaginatively to construct the lives and conditions of

the people they encountered through the fragments of their skeletons. (Leahy 2008: 38)

This is counterpoised to the more imaginative and positive approach taken by the Wellcome Collection, using the following example:

A young women with ulcerated lesions on her skull caused by syphillis also had bowing of the bones in her legs, a sign of rickets. She was buried in the Cross Bones cemetery for paupers and prostitutes. (Leahy 2008: 38)

The approach to displaying human remains that explains the social background of the skeletons and the diseases that affected or killed them is considered by Rees Leahy to be humanizing. The skeletons are accompanied by information about their different biographies, in particular their health and the disease from which they suffered, which is well illustrated in some cases by the damage to the bone. This reflects the medical orientation of the Wellcome Trust and this particular exhibition. It also in part reflects contemporary interest in the health-orientated body, as discussed in the previous chapter. In this respect, the exhibition can be seen as an attempt to re-authorize scientific research on the display of bodies in emotional terms and by reference to its contribution to broader issues of identity work. In claiming that the exhibition contributed to an understanding of the self and, in particular, health and the body, it received a moderately favorable reception within museology.

Concluding Thoughts

'It's a pretty safe bet that most of the children you can hear round about me are also headed for the Egyptian Mummies [. . .] Here is where most people begin where they visit a museum.' So stated Neil MacGregor, director of the British Museum, as he launched a major BBC Radio 4 series in January 2010. *A History of the World in a Hundred Objects* was a prominent, well-publicized series of programmes that sought to tell the history of humanity by profiling 100 objects from the British Museum. The first episode focused on Hornedjitef's mummy case, the casket of a priest that lay in the Temple of Amun at Karnak during the reign of Ptolemy III (246–222 BC), and discussed what mummies reveal about human history. 'Telling history through things, whether it's a mummy's coffin or a credit card, is what museums are for and, because the British Museum has collected things from all over the globe, it's not a bad place to try to tell a world history,' declared Neil MacGregor. He went on examine what the scientific advances of the past decades could tell us about Hornedjitef's life and the society in which he lived, revealing how Egypt was connected to the rest of the world at the time. But despite the universalism of his analysis, MacGregor qualified his approach to history. 'Of course it can only be "a" history of the world, not "the" history. When people come to the museum, they choose their own objects and make their own journey round the world and through time,' he said.

In the remainder of the broadcast, MacGregor directly addressed the centrality of mummies to the role of museums, arguing that particular contested objects, including the Lewis chessman and the Parthenon marbles, should be held in the British Museum's collection. Holding these objects together under one roof, he argued, demonstrates the relationships between cultures, which 'reminds the world of our common heritage'. This reminder, said MacGregor, is 'more important now then ever before.'

Here MacGregor provides an example of engaging in 'boundary work'. There is an attempt to re-establish the authority of the museum, by incorporating some of the challenges to the traditional role of the institution and positing that it can play a social role, a role that is essential in the contemporary political climate. Alongside MacGregor, in developing this

argument for the social contribution of the institution, is James Cuno, President and Eloise W. Martin Director of The Art Institute of Chicago. They make the case that, in the context of a world that is experiencing a dramatic resurgence in nationalism and sectarian violence, museums can encourage understanding and tolerance between cultures (Cuno 2009). In the edited collection *Whose Culture? Museums and the debate over antiquities*, MacGregor writes that the British Museum can be a space that promotes the 'oneness of the world' and can subvert 'the habits of thought that keep us from seeing other cultures except in categories of superiority and difference.' (MacGregor 2009: 43–44) These directors of major museums are promoting the idea that museums can make a positive contribution to society and politics in building tolerance and social cohesion, keying into broader concerns about conflicts over identity, and in response to critics from within the sector who argue that the museum is monolithic, didactic and Eurocentric. The internal wrangling over the role of the museum continues.

Taken together, the chapters in *Contesting Human Remains in Museum Collections* consider how, by whom, and why, human remains in British collections became a prominent controversy. The academic literature tends to understand changes to museums as a result of external factors, especially the repatriation issue. The central point argued in this book is there are significant internal influences from sector professionals who have focused on this problem as a vehicle through which the authority of the museum can be challenged. Through a weak social constructionist approach, I demonstrate that the issue has been, and continues to be, promoted by influential museum professionals, and that resistance to these challenges has, at times, failed, is weak, or is in flux.

The symbolic character of human remains in locating this problem is informed by the unique properties of dead bodies and their broader cultural context. The latter is influenced by the significance of the body as a scientific object, its association with identity work, and the way the body figures as a site of political struggle in the late modern period. Human remains have been caught up with a search for new purpose for the museum and competing ideas of what that might be. But the implication of using human remains to challenge authority, legitimate claims, and empower voices is to avoid tackling the underlying issues head on. Ironically, given all the talk of 'respect' for human remains, skeletons and body parts are being used to fight the battles of the living.

Despite attempts to resolve the problem of the contestation over human remains, and indirectly the crisis of the museum's cultural authority, it would appear that possible solutions have a provisional and limited quality because vocal members of the sector continue to disown their own authority. As we have seen with the continued attempts by issue entrepreneurs to extend the issue from contested human remains to all human remains, the sustained attempt to problematize decision-making discussed in Chapters

3 and 4, and the targeting of the Egyptian mummies discussed in Chapter 6, a questioning stance is consistently adopted. This would suggest that the search for legitimacy is not resolved by this process, nor by such acts as repatriation. The questioning of authority continues regardless. Members of the sector appear uncomfortable not only with the museum's foundational traditional authority, but also the very *idea* of authority.

As we have seen, the cultural theorist Stuart Hall argues for the need to challenge the implicit universalism of the museum display and to develop an explicit subjectivism that shows how unreliable, temporary and relative interpretations of cultural objects can be. Let us recall the keynote address he gave at the Tate in London, as chair of the Institute of International Visual Arts:

> Museums have to understand their collection and their practices as what I can only call 'temporary stabilizations' . . . [The museum] has to be aware that it is a narrative, a selection, whose purpose is not just to disturb the viewer but to itself be disturbed by what it cannot be, by its necessary exclusions. It must make its own disturbance evident so that the viewer is not trapped into the universalized logic of thinking whereby because something has been there for a long period of time and is well funded, it must be 'true' and of value in some aesthetic sense. Its purpose is to destabilize its own stabilities. (Hall S. 2001: 22).

Today, this position of 'destabilizing their own stabilities' appears to be a key principle held by professionals. Of course, this is not the first time that the authority of cultural institutions has been contested. In particular, major challenges developed to the institutions of the Church and the state in the eighteenth century, and modern western society was largely created through a revolt against traditional authority. However, the reaction against authority today is different. Instead of coming from different factions outside institutions, those previously defending their professional status and elevated position now question it. The cultural elite has joined in. Senior professionals either attack the role of the institution, or find its rationale difficult to articulate.

The implications of this are far reaching. The role of the museum, and the impact of the social and intellectual shifts of the twentieth century, have been the focus of a corpus of literature resulting, theorists argue, in changes in the remit of the institution, or maybe even its demise, primarily, it is argued, due to the influence of market forces and postmodernism. According to some critics, the museum has become like other spaces of entertainment, with the institution becoming part of the 'apparatus of capture' (Deleuze and Guattari 1988: 424). Postmodern writers in the cultural studies tradition, including Fredric Jameson (1998) argue that the museum is an institution designed to stimulate visitors to act as consumers. For Baudrillard (1982), the dominance of the market and the growth of consumer

culture have negatively altered the ethos of the museum. He describes the Beauberg Museum in Paris as a 'hypermarket of culture' which 'has all the semblance of housebreaking or the sacking of a shrine' (Baudrillard 1982: 10), as the audiences consume and are manipulated by sensation and spectacle. For this scholar, high culture collapses under the weight of mass consumption Mike Featherstone (2007) echoes this critique, arguing that museums have become like shops, directed at the consumer, orientated towards sensation, experience, spectacle and consumption.

Sociologist Nick Prior (2002; 2003; 2006) takes issue with the conclusions of those who suggest that we are witnessing the decline of the museum as a result of market forces and postmodernism. While Prior recognizes the trends identified by the theorists discussed above, he concludes that they do not signal the demise of the institution, suggesting instead that museums are involved in 'double coding' (2006: 52), where they promote different and apparently contradictory values at the same time. Throughout history, argues Prior, museums have promoted contrary sets of values: for example, practicing an elitist notion of scholarship as well as presenting a popular democratic institution, and servicing ceremonial ritual over secularized objects. According to Prior the new changes are not a serious disjuncture, but a continuation of the contradictions and fashions that have always influenced and been influenced by cultural institutions.

Prior qualifies, however, that these contradictions in purpose may be more pronounced in the contemporary period. He notes that the museum is a 'radically syncretic institution' (2003: 63), influenced, like all modern institutions, by the feature of institutional self-consciousness. He relates this observation to the theories of reflexive modernization put forward by Beck, Giddens and Lash (1994), which see organizations in a process of continual self-examination. Prior concludes that museums remain institutions of social distinction, but, in what he sees as a positive development, suggests they are able to hold greater contradictions than in the past, indicated by more socially inclusive exhibition strategies.

Furthermore, Prior argues that audience research demonstrates that visitors are able to negotiate and overturn the meanings offered by different media: they are not a mass block, as characterized by critics, but far more diverse, and they are intelligent rather than passive recipients. This leads him to the conclusion that the 'spectacle' aspect of museums is not as domineering as theorists propose, and thus that the counterposition between the traditional and postmodern museum is overstated (Prior 2006). This emphasis on the sophistication and diversity of the audience is a point also made by other scholars, partly as a response to the thesis that posits the institution as an institution of dominant ideology. It is argued that audiences should not be interpreted in such passive or homogenized fashion (see Merriman 1991; 1989; Hooper-Greenhill 2006). Gordon Fyfe (2006) has suggested that the museum's traditional function is resisted by audiences who have grown and broadened through the expansion of visitors. Fyfe also observes

that the growing diversity of museums means that the idea that these orga-
nizations reinforce the dominant ideology needs reconsideration.

Other theorists have responded in a similar vein, and see the orientation
towards the visitor and the growth of marketing not just as market driven,
but also as audience orientated. This, they suggest, represents a positive
shift in power. One such article, 'Rethinking the Museum: an emerging
new paradigm', describes what Stephen Weil characterizes as the rise of
a 'superseding paradigm' (Weil 1990: 58). Weil traces the move in the
museum industry's definition of purpose from a collector to an institution
for educating and servicing the public; from a focus on the collection to one
that is now concerned with interpretation, communication and audiences.
Gail Anderson, editor of the collection *Reinventing the Museum* (2004),
concurs, arguing that the end of the twentieth century saw a paradigm shift
from institutions organized around collections to those organized around
visitors.

Reflecting on shifts in the museum's remit, Tony Bennett (1998) asserts
the need to discard old universalist logic and calls for greater space to dis-
cuss diverse narratives and values:

> [I]t is imperative that the role of curator be shifted away from that of
> the source of an expertise whose function is to organize a representa-
> tion claiming the status of knowledge and towards that of the pos-
> sessor of a technical competence whose function is to assist groups
> outside the museum to use its resources to make authored statements
> within it. (Bennett T. 1998: 103–104)

According to Bennett, the museum should not aim to establish a sin-
gular truth claim or narrative, or universal standards of 'the best', but to
establish the inherent instabilities of truth claims and narratives, and give
different individuals and ethnic or social groups the opportunity to present
their own versions of cultural value. Bennett's theorization of the role of
institutions itself leaves in doubt such notions of 'intrinsic value', scholar-
ship, beauty, and autonomy, and excellence, which had historically been
the basis of the legitimacy of cultural institutions. Bennett insists that cul-
tural value is determined entirely by its functional use in the exercise of
power. Cultural institutions are increasingly expected to become facilita-
tors of identity and narrative construction, rather than guardians of objec-
tive knowledge and expertise.

What is interesting about this position is that while Bennett advocates
changes in the role of the museum, he disagrees with how other theorists
have conceptualized this outlook. He criticizes Bauman's characterization
of the broad shift of intellectual work in society, moving from holding legis-
lative authority to becoming a facilitator. Bennett also disagrees with James
Clifford's interpretation of the museum institution as a site that promotes
cross-cultural understanding. Bennett argues that the shifting role of intel-

lectuals, and the museum as a facilitator for identity work, rather than legislator of objective knowledge, is not a neutral shift but an important and positive one that remakes the museum into a different kind of authority. Bennett posits that while the contemporary museum, which operates as a 'contact zone', holds a different role to that it held in the nineteenth century, it is still in the service of government. Bennett writes that Bauman and Clifford do not fully appreciate that the museum is 'still a programme of the same type—a move, ultimately, in the same space as a part of the same set of relations of government and culture' (Bennett T. 1998: 212). For Bennett, the involvement of the institution in the politics of recognition and the prescriptive social character of contemporary cultural policy bears some resemblance to the Victorian moralism of the nineteenth century, which regarded culture as a tool to fashion correct behavior and attitudes. Museums may play the role of facilitator, he acknowledges, but the museum and the professional are still of central importance in reinforcing cultural ideas and norms.

As an example, Bennett cites the processes in present-day Australian museums that promote the development of cross-cultural understanding between whites and indigenous Australians. He contends that all these different innovative approaches are highly skilled and important in ways that traditional intellectual work was not. It is 'a task of cultural management which requires a degree of administrative inventiveness and an utterly sedulous attention to questions of administrative detail that would have been well beyond the reach of Bauman's nineteenth century cultural legislators', he states (Bennett T. 1998: 104). For Bennett, the interpreter and facilitator role of the contemporary museum is more central and significant to government than theorists such as Clifford and Bauman realize. It does hold authority, but it is not the authority to define true knowledge. Bennett, like Nick Prior, contends that the museum remains true to type in reinforcing the values of the political elite, and that the shifts in practice that have taken place in museums do not alter the central role that it plays in the service of government.

I take a different view to Prior and Bennett. While there are contradictory elements within this institution that have been present historically, Prior's analysis may overstate historical continuity and underestimate the significance and extent of the institutional reflexivity that he identifies. Firstly, his observation that museums have not significantly altered is predominately based on an analysis of audiences. Prior explains that on the basis of visitor figures, attending museums and galleries is still a form of cultural distinction and therefore the original Bourdieun analysis—that the museum is an institution of class distinction—is still correct. Thus he suggests that the museum's contemporary remit is consistent with its traditional role. But while this analysis of audiences is important, it does not alter the point that elite practice in running museums is altered by the self-questioning of this role, and that the remit of the museum has been significantly challenged.

Prior's analysis conflates visiting practices with the idea of what a museum is, as if these were the same thing rather than related things. Also, while audiences may be highly sophisticated in negotiating spectacle, to concentrate on the response of visitors neglects an analysis of why the sector employs spectacle, instead of concentrating its energies on the collection. These conclusions, while adding to research on audience engagement, do not sufficiently reflect on the changing rationale for the activities of the professional. It also takes for granted that practices carried out in the name of the audience are driven by visitors. Rather, it is possible that the museum's preoccupation with the audience represents a defensiveness on the part of the cultural elite, which is unsure of imposing its own authority about what the museum should be or do. In this regard, it should be noted that the process of audience consultation occurs with particular audiences and groups: those selected by the cultural professionals.

The most important point is that cultural institutions no longer consistently hold up the values and sense of purpose integral to their formation in the eighteenth and nineteenth centuries. As a consequence of a broader crisis of cultural authority, there has been a profound shift in the idea of the purpose and the remit of the museum held by those working in the sector, the extent of which has not been adequately appreciated. Nor have they found a stable and convincing alternative rationale. The default position is to question, challenge and destabilize any status quo. The distinctive finding of this book is that the museum institution and the professionals within it are unable to sustain and demonstrate authority, and this, I suggest, challenges Bennett's conclusion. The museum of the Victorian period may have operated in the service of government, but the sector did not constantly question its role and position. It did not hold that truth and cultural value should be constantly under attack. Similarly, the museum of the present period may continue to serve the government, as Bennett contends, but it congruently questions its legitimacy to do this. The cultural authority accorded to the museum by Bennett and Prior is different to that of the past because it lacks legitimacy.

One outcome of this process will be the encouragement of new claims-makers. The lack of certainty about the authority of authority itself, as well as the doubts about the legitimacy of the museum, is both an encouragement to claims-making and to its contestation. Claims-making has always been competitive. Today this competition has become further complicated by the fact that the authority or authorities to which it appeals are also intensely contested. This process fuels internal and external challenges, as demonstrated by the case study on Pagan claims-makers. Continued internal questioning leaves the remit of the institution open to challenges from outside and within the sector, either from new claims-making groups or from issue entrepreneurs within the profession. The museum may still aim to perform the functions of social cohesion and the reproduction of society's values, but professionals in this sector continue to question its authority to do so, as will new external communities, leaving its remit highly unstable.

Notes

NOTES TO CHAPTER 1

1. See Fforde (1992a, 1992b, 1992c, 1992d, 1992e, 1992f, 1992g, 1992h, 1992i, 2002, 2004).
2. *Museums Journal* 94, 4. London: Museums Association; 23–28, 25, 28–31, 29, 32–34.
3. *Today* Programme (2004). BBC Radio Four. May 18, 08:30.
4. *The Melbourne Age* (2002). 'Pioneering journey home for Truganini'. May 30.
5. See Dewar and Boddington (2004) for an analysis of the rhetorical frames and motifs used in the Royal Liverpool Children's Inquiry.

NOTES TO CHAPTER 2

1. See HTTP: http://www.nps.gov/history/nagpra/TRAINING/Cultural_Affiliation.pdf. (accessed March 25, 2010).
2. Payne, cited in BBC News report July 28, 2004. See HTTP: <http://news.bbc.co.uk/1/hi/sci/tech/3930697.stm> (accessed March 25, 2010).
3. While members were sympathetic to repatriation, it should be noted that this view encompasses different degrees and reasons for such support. Even so, the following members of the committee were known to be sympathetic to repatriation: Tristram Besterman, director, Manchester University Museum; Maurice Davies, deputy director, Museums Association; Sally MacDonald, manager, Petrie Museum of Egyptian Archaeology; Professor Sir Peter Morris, President, Royal College of Surgeons; Laura Peers, curator at the Pitt Rivers Museum, University of Oxford; and Dame Marilyn Strathern, Professor of Social Anthropology at the University of Cambridge. Two members who were resistant were Dr John Mack, Keeper of Ethnography, the British Museum; and Neil Chalmers, director of the Natural History Museum.
4. See NMGW 2006; B&H 2006; BM 2006; LCMS 2006; MUM 2007; MoL 2006; NHM 2006b; NML 2006; OUM 2006; PRMO 2006; RCM 2006; Science Museum 2006; Bolton Museum 2007; UCL 2007; WT 2007; HEM 2009.

NOTES TO CHAPTER 3

1. See the *Oxford Times* (2007), 'Should shrunken heads stay in museum?' February 14.
2. The Museum Studies course at Leicester is known for its endorsement of the new museology and social inclusion agenda.

NOTES TO CHAPTER 4

1. Broadcast on February 22, 2010. BBC2.
2. See Jenkins (2009) for a discussion of a claim made by the Druid Paul Davies on ancient human remains in Avebury, and the responses by English Heritage and the National Trust.
3. The *Heaven and Earth Show*, June 24, 2007. BBC1.
4. See HTTP <http://www.honour.org.uk/> Accessed March 25, 2010.
5. See HTTP <http://www.honour.org.uk/> Accessed March 25, 2010.
6. See HTTP <http://www.honour.org.uk/> Accessed March 25, 2010.
 Also HTTP http://druidry.org.uk/had.htm> Accessed March 25, 2010.
7. See HTTP <http://www.honour.org.uk/> Accessed March 25, 2010.
8. The conference was held at Manchester University Museum on May 26, 2007. A program for the event is available here: HTTP < http://www.many-gods.org.uk/meet/conferences/2007programmetext.pdf> Accessed March 25, 2010.
9. Note here that Restall Orr refers to 'we' are getting him. The 'we' she means is Manchester University Museum and HAD who worked together on the creation of the exhibition of Lindow Man.
10. See HTTP: http://www.museum.manchester.ac.uk/medialibrary/documents/respect/respect_conference_programme.pdf. Accessed March 2010.
11. Personal communication, 22 June, 2007.
12. Personal communication, July 10, 2007.
13. Personal communication, July 2, 2007.

NOTES TO CHAPTER 5

1. Approximately 30,000 people disappeared in Argentina between 1976–1983 under a military dictatorship. The group the 'Mothers of the Disappeared' was formed in response. The group subsequently split in 1986 over a disagreement between members who believed the bodies of those who had disappeared should be exhumed as evidence versus those that objected stating it was necessary to concentrate on the trial of the guilty.
2. A similar argument is advanced by István Rév (2005) in his examination of post-communist Hungary and Eastern Europe in which he discusses political burials and exhumations linked to concepts of national identity and the legitimacy of the past.
3. See SM, 2001; NMGW, 2006; B&H, 2006; BM, 2006; LCMG, 2006; MUM, 2007; MoL, 2006; NHM, 2006b; NML 2006; OUM, 2006; PRM, 2006; SM, 2006; Bolton Museum, 2007; UCL, 2007; WT, 2007.

NOTES TO CHAPTER 6

1. See HTTP: http://news.bbc.co.uk/1/hi/england/manchester/7413654.stm. Accessed March 25, 2010.
2. Also spelt Truganni in some accounts: for example, Woodhead 2002.
3. These are: SM, 2001; NMGW, 2006; B&H, 2006, BM, 2006; LCMS, 2006; MUM, 2007; MoL, 2006; NHM, 2006b; NML, 2006; OUM, 2006; PRMO, 2006; SM, 2006; RCM, 2006; Bolton, 2007; UCL, 2007; WT, 2007; HEM, 2006.

Bibliography

Abt, J. (2006) 'The Origins of the Public Museum', in Macdonald, S. (ed.) *A Companion to Museum Studies*, Oxford/Victoria: Blackwell: 115–134.

Alberge, D. (2004) 'Museum bones "should have a Christian burial"'. *The Times*, London, January 6.

Alberti, A., Bienkowski, P., Chapman, M. and Drew, R. (2009) Should we display the dead? *Museum and Society*, 7, 3: 133–149.

Alberti, S. J. M. M. (2009) *Nature and Culture: objects, disciplines and the Manchester Museum*, Manchester: Manchester University Press.

Ames, M. M. (1992) *Cannibal Tours and Glass Boxes: the anthropology of museums*, Vancouver: UBC Press.

Anderson, B. (1983) *Imagined Communities: reflections on the origins and spread of nationalism*, London: Verso.

Anderson, G. (ed.) (2004) *Reinventing the Museum: historical and contemporary perspectives on the paradigm shift*, Walnut Creek//Oxford: AltaMira Press.

Andrews, L. and Nelkin, D. (1998) 'Whose Body Is it Anyway? Disputes over body tissue in a biotechnology age'. *Lancet*, 351: 53–57.

Appadurai, A. and Beckenridge, C. A. (1992) 'Museums are Good to Think: heritage on view in India', in Karp, I., Kreamer, C. M. and Lavine, S. D. (eds) *Museums and Communities: the politics of public culture*, Washington DC and London: Smithsonian Institution Press.

Arendt, H. (1973) *The Origins of Totalitarianism*, London: Penguin Group.

Arendt, H. (1977) *Past and Future: eight exercises in political thought*, Harmondsworth: Penguin.

Arnold, K. (2008) Skeletons: *London's Buried Bones*. London, Wellcome Trust.

Arksey, H. and Knight, P. (1999) *Interviewing for Social Scientists*, London//Thousand Oaks/New Delhi: Sage.

Ariès, P. (1981) *The Hour of Our Death*; trans. Helen Weaver, London: Allan Lane.

Armstrong, D. (1987) 'Silence and Truth in Death and Dying', *Social Science and Medicine*, 24: 651–657.

B&H (2006) *Policy for the Care and Treatment of Human Remains*. Brighton and Hove Museums.

Barbian, L., Berndt, L. 1999. 'When Your Insides are Out: Museum Visitor Perceptions of Displays of Human Anatomy.' Conference Paper—*Human Remains: Conservation, Retrieval & Analysis*. 7–10. November 1999, The Colonial Williamsburg Foundation, Virginia USA.

Barkan, E. (2003) 'Restitution and amending historical injustices in international morality', in Torpey, J. (ed.) *Politics and the Past: on repairing historical injustices*, Lanham, Maryland: Rowman & Littlefield Publishers, Inc.

Barkan, E. and Bush, R. (eds) (2002) *Claiming the Stones Naming the Bones: cultural property and the negotiation of national and ethnic identity*, Los Angeles: Getty Publications.

Barkham, P. and Finlayson, A. (2002) 'Museum returns sacred samples'. *The Guardian*, London, May 31.

Barringer, T. and Flynn, T. (1998) *Colonialism and the Object: empire, material culture and the museum*, London/New York: Routledge.

Batty, P. (2005) 'White Redemption Rituals: reflections on the repatriation of Aboriginal secret-sacred objects', *Arena*, 23: 67–81.

Baudrillard, J. (2001) *Selected Writings*, Cambridge: Polity Press.

Bauman, Z. (1987) *Legislators and Interpreters: on modernity, post-modernity, and intellectuals*, Cambridge: Polity Press.

Bauman, Z. (1992) *Intimations of Postmodernity*, London/New York: Routledge.

Beck, U. Giddens, A. and Lasch, S. (1994) *Reflexive Modernization: politics, tradition and aesthetics in the modern social order*, Cambridge: Polity Press.

Bender, B. (1993) 'Stonehenge—Contested Landscapes (Medieval to Present Day)', in Bender, B. (ed.) *Landscape: politics and perspectives*, Oxford: Berg.

Bennett, O. (1996) *Cultural Policy and the Crisis of Legitimacy: entrepreneurial answers in the United Kingdom*, University of Warwick: Centre for the Study of Cultural Policy.

Bennett, O. (2001) *Cultural Pessimism: narratives of decline in the postmodern world*, Edinburgh: Edinburgh University Press.

Bennett, T. (1992) 'Putting Policy into Cultural Studies', in L. Grossberg, Nelson, C. and Treichler, P. (eds) *Cultural Studies*, New York: Routledge.

———. (1995) *The Birth of the Museum: history, theory, politics*, London/New York: Routledge.

———. (1998) *Culture: a reformer's science*, London: Sage.

Berger, P. and Luckmann, T. (1966) *The Social Construction of Reality: a treatise in the sociology of knowledge*, London: Penguin Books.

Best, J. (1987) 'Rhetoric in Claims-Making: constructing the missing children problem', *Social Problems*, 34, 2: 101–121.

———. (1990) *Threatened Children: rhetoric and concern about child-victims*, Chicago/London: The University of Chicago Press.

———. (1993) 'But Seriously Folks: the limitations of the strict social constructionist interpretation of social problems', in Holstein, J. and Miller, G. (eds) *Reconsidering Social Constructionism: debates in social problems theory*, New Jersey: Transaction Publishers.

———. ed. (1995) *Images of Issues: typifying contemporary social problems*, New York: Aldine De Gruyter.

———. (1999) *Random Violence: how we talk about new crimes and new victims*, Berkeley/Los Angeles/London: University of California Press.

———. ed. (2001) *How Claims Spread: cross-national diffusion of social problems*, New York: Aldine De Gruyter.

Besterman, T. (2004) *Returning the Ancestors*, Manchester: University of Manchester Museum.

Bienkowski, P. (2006) 'Persons, Things and Archaeology: contrasting world-views of minds, bodies and death'. Paper presented to *Respect for Ancient British Human Remains* conference, November 17, 2006, Manchester University Museum.

Bienkowski, P. and Chapman, M. (2007) 'Authority and Decision-Making over British Human Remains: issues and challenges'. Paper presented to the *Ninth Annual Conference of the British Association for Biological Anthropology and Osteoarchaeology*, September 16, University of Reading.

Blain, J. and Wallis, R. (2003) 'Sites, Sacredness, and Stories: interactions of archaeology and contemporary paganism', *Folkore*, 114, 3: 307–321.
———. (2004) 'Sacred Sites, Contested Rites/Rights', *Journal of Material Culture*, 9, 3: 237–261.
———. (2007) *Sacred Sites-Contested Rites/Rights: Pagan engagements with archaeological monuments*, Eastbourne: Sussex Academic Press.
Blair, T. and Howard, J. (2000) *'Prime Ministerial Joint Statement on Aboriginal Remains'*. July 4. Press release. London: Office of the Prime Minister.
Bloch, J. P. (1998) *New Spirituality, Self, and Belonging: how New Agers and Neo-Pagans talk about themselves*, Westport, Connecticut/London: Praeger.
Bloom, A. (1987) *The Closing of the American Mind: how higher education has failed democracy and impoverished the souls of today's students*, New York: Simon and Schuster.
BM. (2006a) 'British Museum Decides to Return Two Tasmanian Cremation Ash Bundles', press release. London: British Museum.
BM. (2006b) *British Museum Policy on Human Remains*, London: British Museum.
Bolton. (2007) *Human Remains Policy*, Bolton: Bolton Museum and Archive Service.
Bottomley, F. (1979) *Attitudes towards the Body in Western Christendom*, London: Lepus Books.
Bourdieu, P. (1984) *Distinction: a social critique of the judgement of taste*, London: Routledge & Kegan Paul.
Bourdieu, P. (1996) *The Rules of Art*, Cambridge: Polity Press.
Bowman, M. (1995) 'Cardiac Celts: Images of the Celts in Paganism', in Hardman, C. and Harvey, G. (eds) *Paganism Today: Wiccans, Druids, the goddess and ancient earth traditions for the twenty-first century*, London, Thorsons (Harper Collins).
Bromilow, G. (1993) 'Finders Keepers?' *Museums Journal*, 93, 3: 31–34.
Brooks, M. and Rumsey, C. (2006) 'The Body in the Museum', in Cassman, V., Odegaard. N. and Powell, J. (eds) *Human Remains: guide for museums and academic institutions*, Lanham, Maryland: Altamira Press.
Brooks, M. and Rumsey, C. (2007) 'Who Knows the Face of his Bones? Rethinking the Body on Display: object, art or human remains?' in Knell, S. J., MacLeod, S. and Watson, S. (eds) *Museum Revolutions: how museums change and are changed*. London/New York: Routledge.
Brothwell, D. (2004) 'Bring out your dead: people, pots and politics', *Antiquity*, 78, 300: 414–418.
Browitt, J. and Milner, A. (2002) *Contemporary Cultural Theory*, Crows Nest/N.S.W: Allen & Unwin.
Brown, M. F. (2003) *Who Owns Native Culture?* Cambridge, Massachusetts/London: Harvard University Press.
Brown, W. (1995) *States of Injury: power and freedom in late modernity*, Princeton, New Jersey: Princeton University Press.
Butchart, A. (1998) *The Anatomy of Power: European constructions of the African body*. New York: St. Martin's Press.
Carroll, Q. (2005) 'Bodies—Who Wants to Rebury Old Skeletons?' *British Archaeology* May/June: 11–15.
Cassman, V. and Odegaard, N. (2007) 'Examination and Analysis. Human Remains Guide for Museums and Academic Institutions', in Cassman, V., Odegaard, N., and Powell, J. (eds) *Human Remains: guide for museums and academic institutions*, Lanham, Maryland/New York/Toronto/Oxford: Rowman & Littlefield Publishers, Inc.
Chamberlain, A. T. and Parker Pearson, M. (2001) *Earthly Remains: the history and science of preserved human bodies*, London: The British Museum Press.

Chatters, J. (2002) *Ancient Encounters: Kennewick Man and the first Americans*, New York: Simon & Schuster.

Church of England and English Heritage. (2005) *Guidance for Best Practice for Treatment of Human Remains Excavated from Christian Burial Grounds in England*, London: Church of England, English Heritage.

Clifford, J. (1997) *Routes: travel and translation in the late twentieth century*, Cambridge, Massachusetts/London: Harvard University Press.

Clifton, C. S. and Harvey, G. (eds) (2004) *The Paganism Reader*. New York/London: Routledge.

Coleman, C. and Dysart, E. V. (2005) 'Framing of Kennewick Man against the backdrop of a scientific and cultural controversy', *Science Communication*, 27, 1: 3–26.

Conn, S. (1998) *Museums and American Intellectual Life, 1876–1926*, Chicago: Chicago University Press.

Conner, S. (2003) 'Alarm raised over return of human remains'. *The Independent*, May 16.

Corsane, G. (ed.) (2005) *Heritage, Museums and Galleries: an introductory reader*, London/New York: Routledge.

Cove, J. H. (1995) *What the Bones Say: Tasmanian Aborigines, science and domination*, Ottawa: Carleton University Press.

Cox, M. (2003) 'Written Submission to the Working Group on Human Remains', *Report of the Working Group on Human Remains*, London: Department of Culture Media and Sport.

Culture Media and Sport Select Committee. (2000) *Culture, Media and Sport— Seventh Report*, London: Department of Culture Media and Sport.

Cuno, J. (ed.) (2009) *Whose Culture? The promise of museums and the debate over antiquities*, Princeton, New Jersey, Princeton University Press.

Cumming, L. (2000) 'Blood, blood, glorious blood'. *The Observer*, December 17.

Curtis, N. (2003) 'Human Remains: the sacred, museums and archaeology'. *Public Archaeology* 3,1: 21–32.

Davies, M. (1993) 'Editorial'. *Museums Journal*, 94, 4:3.

Davies, M. (1994) 'Editorial', *Museums Journal*, 93, 3:1.

Davies, P. (1997) 'Respect and Reburial', *The Druids' Voice: the magazine of contemporary Druidry*, Summer, 8: 12–13.

Davies, P. (1997) 'Speaking for the Ancestors', *The Druids' Voice: the magazine of contemporary Druidry*, Winter, 9: 10–12.

Davis, P. (1999) *Ecomuseums: a sense of place*, Leicester: Leicester University Press.

Day, J. (2006) *The Mummy's Curse: mummymania in the English-speaking world*, London: Routledge.

DCMS. (2003a) *ScopinSurvey of Historic Human Remains in English Museums undertaken on behalf of the Ministerial Working Group on Human Remains*, London: Department of Culture Media and Sport.

———. (2003b) *Report of the Working Group on Human Remains*, London: Department of Culture Media and Sport.

———. (2004) *Consultation on the Care of Historic Human Remains*, London: Department of Culture Media and Sport.

——. (2005) *Guidance for the Care of Human Remains in Museums*, London: Department of Culture Media and Sport.

Deleuze, G. and Guattari, F. (1988) *A Thousand Plateaus: capitalism and schizophrenia*, London: Althone.

Deloria, V. J. (1995) *Red Earth, White Lies: Native Americans and the myths of scientific fact*, New York: Scribner.

Department of Health. (2004) *The Human Tissue Act 2004*, London: HMSO.

Department of Health. (2001) Bristol Royal Infirmary Inquiry *Report*, London: HMSO.

Docherty, T., ed. (1993) *Postmodernism: a reader*, New York: Harvester Wheatsheaf.

Domanska, E. (2006) 'The Material Presence of the Past', *History and Theory* 45: 337–348.

Douglas, M. (1966) *Purity and Danger: an analysis of concepts of pollution and taboo*, London: Routledge and Kegan Paul.

Dubin, S. C. (1999) *Displays of Power: memory and amnesia in the American museum*, New York/London: New York University Press.

Dubin, S. C. (2005) '"Culture Wars" in Comparative Perspective', in Macdonald, S. (ed.) *A Companion to Museum Studies*, Malden, Massachusetts/Oxford/Victoria: Blackwell Publishing.

Duncan, C. (1995) *Civilizing Rituals: inside public art museums*, London/New York: Routledge.

Duncan, C. and Wallach, A. (1980) 'The Universal Survey Museum', *Art History*, 3, 4: 448–469.

Eagleton, T. (1993) *The Crisis of Contemporary Culture*, Oxford: Clarendon Press.

———. (2000) *The Idea of Culture*, Oxford: Blackwell Publishers Ltd.

———. (2003). *After Theory*, London/New York: Allen Lane.

Engelhardt, T. and Linenthal, E. T. (1996) *History Wars: the Enola Gay and other battles for the American past*, New York: Metropolitan Books.

Fagan, B. (2007) Foreword to Cassman, V. Odegaard, N. and Powell, J. (eds) *Human Remains Guides for Museums and Academic Institutions*, Lanham, Maryland/ New York/Toronto/Oxford: AltaMira Press.

Fairclough, N. (2003) *Analysing Discourse: textual analysis for social research*, London/New York: Routledge.

Featherstone, M. (2007) *Consumer Culture and Postmodernism*, London: Sage.

Featherstone, M. (1991) 'The Body in Consumer Culture', in Featherstone, M. Hepworth, M. and Turner, B. (eds) *The Body: social process and cultural theory*, London: Sage.

Fforde, C. (1992a) 'English Collections of Human Remains, an Introduction', *World Archaeological Bulletin*, 6: 1–4.

———. (1992b) 'The Williamson Collection', *World Archaeological Bulletin*, 6: 2021.

———. (1992c) 'The Royal College of Surgeons of England: A brief history of its collections and a catalogue of some current holdings', *World Archaeological Bulletin*, 6: 22–32.

———. (1992d) 'Some Current Holdings in the Oxford University Museum', *World Archaeological Bulletin*, 6: 32–33.

———. (1992e) 'Some Alleged Holdings in the Oxford Institute of Biological Anthropology', *World Archaeological Bulletin*, 6: 33–35.

———. (1992f) 'Catalogue of the North American Indian Human Remains in the Pitt Rivers Museum, Oxford', *World Archaeological Bulletin*, 6: 35–36.

———. (1992g) 'Some Current Holdings in the Horniman Museum, London', *World Archaeological Bulletin*, 6: 36–37.

———. (1992h) 'Some Current Holdings in the Natural History Museum, London', *World Archaeological Bulletin*, 6: 37–52.

———. (1992i) 'The Posthumous History of William Lanne', *World Archaeological Bulletin*, 6: 63–69.

———. (2001) 'Submission to the Working Group on Human Remains', *Human Remains Working Group Report*, London: Department of Culture Media and Sport.

———. (2002) 'Collection, Repatriation and Identity', in Fforde, C., Hubert, J. and Turnbull, P. (eds) *The Dead and Their Possessions: repatriation in principle, policy and practice*, London/New York: Routledge.

———. (2004a) *Scoping Survey of pre-1948 Human Remains in UCL Collections*, London: University College London.

———. (2004b) *Collecting the Dead: archaeology and the reburial issue*, London: Duckworth.

Fforde, C. and Hubert, J. (2002) 'Introduction: the Reburial Issue in the Twenty-First Century', in Fforde, C., Hubert, J. and Turnbull, P. (eds) *The Dead and Their Possessions: repatriation in principle, policy and practice*, London/New York: Routledge.

Fforde, C., Hubert J., and Turnbull, P. (eds) (2002) *The Dead and Their Possessions: repatriation in principle, policy and practice*, London/New York: Routledge.

Fitzpatrick, M. (2001) *The Tyranny of Health: doctors and the regulation of lifestyle*, London: Routledge.

Foley, R. (2004) 'The Flores remains could have been lost to science', *The Observer*, October 31.

Folytn, J. L. (2008) 'The Corpse in Contemporary Culture: identifying, transacting, and recoding the dead body in the twenty-first century', *Mortality*, 13, 2: 99–104.

Foster, H. (ed.) (1985) *Postmodern Culture*, London/Sydney: Pluto Press.

Foucault, M. (1973) *The Birth of the Clinic: an archaeology of medical perception*, London: Tavistock.

Foucault, M. (1977) *Discipline and Punish: the birth of the prison*, London: Allen Lane.

Francis, N. R. and Lewis, W. (2001) 'What Price Dissection? Dissection literally dissected', *Journal of Medical Ethics*, 27, 1: 2–9.

Fraser, N. (1995) 'From Redistribution to Recognition? Dilemmas of justice in a "post-socialist" age', *New Left Review*, 212: 68–92.

Fukuyama, F. (1995) *Trust: the social virtues and the creation of prosperity*, London: Hamish Hamilton.

Fuller, C. (ed.) (1998) *The Old Radical: representations of Jeremy Bentham*, London: University College London.

Fuller, N. (1992) 'The Museum as a Vehicle for Community Empowerment: the Ak-Chin Indian community ecomuseum Project', in Karp, I., Kreamer, C. M. and Lavine, S. D. (eds) *Museums and Communities: the politics of public culture* Washington DC and London, Smithsonian Institution Press.

Furedi, F. (2003) *Therapy Culture: cultivating vulnerability in an uncertain age*, London/New York: Routledge.

———. (2004) *Where Have All The Intellectuals Gone? Confronting 21st century philistinism*, London: Continuum Publishing.

Fyfe, G. (2006) *Sociology and the Social Aspects of Museums*, in Macdondald, S. (ed.) *A Companion to Museum Studies*, Malden, Massachusetts/Oxford/Victoria: Blackwell Publishing.

Gabe, J., Kelleher, D. and Williams. G. (eds) (1994) *Challenging Medicine*, London: Routledge.

Gaither, E. B. (1992) '"Hey! That's Mine": thoughts on pluralism and American museums', in Karp, I., Kreamer, C. M. and Lavine, S. D. (eds) *Museums and Communities: the politics of public culture*, Washington DC/London: Smithsonian Institution Press.

Gallagher, T. and Laqueur, T. (eds) (1987) *The Making of the Modern Body: sexuality and society in the nineteenth century*, Berkeley: University of California Press.

MA (2002) *Code of Ethics for Museums*. London, Museums Association.

Geary, P. (1986) 'Sacred Commodities: the circulation of medieval relics' in Appadurai, A. (ed.) *The Social Life of Things: commodities in cultural perspective*, Cambridge: Cambridge University Press.

Gilman, S. (1985) 'Black bodies, white bodies: toward an iconography of female sexuality in late nineteenth century art, medicine and literature', in Gates, H. L. (ed.) *Race, writing, and difference*, Chicago: University of Chicago Press.

Gitlin, T. (1994) 'From Universality to Difference: notes on the fragmentation of the idea of the left', in. Calhoun. C. (ed.) *Social Theory and the Politics of Identity*, Cambridge Massachusetts, /Oxford: Blackwell.

Gitlin, T. (1995) *The Twilight of Common Dreams: why America is wracked by culture wars*, New York: Henry Holt and Company, Inc.

Gray, C. (2000) *The Politics of the Arts in Britain*, Basingstoke: Macmillan.

Greenfield, J. (2007) *The Return of Cultural Treasures*, 3rd edn, Cambridge: Cambridge University Press.

Gross, P. R. and Levitt, N. (1994) *Higher Superstition: the academic left and its quarrels with science*, Baltimore: Johns Hopkins University Press.

Gross, P. R. and Levitt, N. (1997) *The Flight from Science and Reason*, New York: Annals of the New York Academy of Sciences.

Habermas, J. (1987) *Legitimation Crisis*, trans. Thomas McCarthy, Cambridge/ Oxford: Polity Press.

HAD (undated) *HAD Feedback on the DCMS Guidance for the Care of Human Remains in Museums*, Honouring the Ancient Dead.

———(2006) *A Committal Rite for Reburial of Human Remains*, Honouring the Ancient Dead.

———(2007) *Policy on Consultation on Human Remains of British Provenance*, Honouring the Ancient Dead.

———(2008) *Guidance for the Display of Human Remains in Museums*, Honouring the Ancient Dead.

Hafferty, F. W. (1988) 'Cadaver Stories and the Emotional Socialization of Medical Students', *Journal of Health and Social Behaviour*, 29, 4: 344–356.

———. (1991) *Into the Valley Death and the Socialization of Medical Students*, New Haven/London: Yale University Press.

Hail, N. H. (1994) 'Treasured Bones', *Museums Journal*, 94: 32–34.

Hall, S. (1992) 'Cultural Studies and its Theoretical Legacies', in Grossberg, L., Nelson, C. and Treichler, P. (eds) *Cultural Studies*, London: Macmillan.

———. (2001) *Modernity and Difference*, London: Institute of International Visual Arts: 8–23.

Hallam, E., Hockey, J. and Howarth, G. (1999) *Beyond the Body: death and social identity*, London/New York: Routledge.

Hammil, J. (1995) 'Cultural Imperialism: American Indian remains in cardboard boxes', *World Archaeological Bulletin*: 1.

Hammil, J. and Cruz, R. (1989) Statement of American Indians against Desecration before the World Archaeological Congress, in Layton, R. (ed.) *Conflict in the Archaeology of Living Traditions*, One World Archaeology, London: Unwin Hyman: 195–200.

Hannigan, J. A. (1995) *Environmental Sociology: a social constructionist perspective*, London/New York: Routledge.

Harding, S. (1991) *Whose Science? Whose Knowledge?* Ithaca: Cornell University Press.

Harding, S. (1998) *Is Science Multicultural?: postcolonialisms, feminisms and epistemologies*, Bloomington: Indiana University Press.

Hardman, C. and Harvey, G. (eds) (2000) *Pagan Pathways: a complete guide to the ancient earth traditions*, London: Thorsons.

Harris, P. and Connolly, K. (2002) 'World trade in bodies is linked to corpse art show'. *The Observer*, March 17.

Harth, M. (1999) 'Learning from Museums with Indigenous Collections: beyond repatriation', *Curator: the museum journal*, 42, 4: 274–284.

Harvey, G. and Hardman, C. (eds) (1995) *Paganism Today: Wiccans, Druids, the goddess and ancient earth traditions for the twenty-first century*, London/San Francisco: Thorsons (Harper Collins).

HEM (2009) *Human Remains Policy*, Haselmere, Surrey. Haselmere Educational Museum.

Heaney, S. (1975) *Bog Poems*, London: Rainbow Press.

Henare, A. J. M. (2005) *Museums, Anthropology and Imperial Exchange*, Cambridge: Cambridge University Press.

Hetherington, K. (2000) *New Age Travellers: vanloads of uproarious humanity*, London/New York: Cassell.

Hewison, R. (1987) *The Heritage Industry: Britain in a climate of decline*, London: Metheun.

———. (1991) 'Commerce and Culture Enterprise and Heritage Crosscurrents of National Culture', in Corner, J. and Harvey, S. (eds) Enterprise and Heritage: crosscurrents of national culture, London: Routledge.

———. (1995) *Culture and Consensus: England, art and politics since 1940*, London: Methuen.

Heywood, F. (2009) Many Happy Returns? *Museums Journal* 109: 32–35.

Hillson, S. (2001) 'Submission to the Human Remains Working Group', *Report of the Working Group on Human Remains*, London: Department of Culture Media and Sport.

Hinde, J. (2007) 'Invaluable resource or stolen property?' *The Times Higher Education Supplement*, London, September 21.

Hirschauer, S. (2006) 'Animated Corpses: communicating with post mortals in an anatomical exhibition', *Body and Society*, 12, 4: 25–52.

Historic Scotland (1997) *The Treatment of Human Remains in Archaeology*, Edinburgh: Historic Scotland.

Hole, B. (2007) 'Playthings for the Foe: the repatriation of human remains in New Zealand', *Public Archaeology*, 6, 1: 5–27.

Honneth, A. (1995) *The Fragmented World of the Social: essays in social and political philosophy*, Albany, New York: SUNY Press.

Hooper-Greenhill, E. (1989) 'The Museum in the Disciplinary Society', in Pearce, S. (ed.) *Museum Studies in Material Culture*, Leicester: Leicester University Press.

———. (2006) Studying Visitors, in Macdonald, S. (ed.) *A Companion to Museum Studies*, Malden, Massachusetts/Oxford/Victoria, Australia: Blackwell Publishing.

Hubert, J. (1989) 'A Proper Place for the Dead: a critical review of the "reburial" issue', in Layton, R. (ed.) *Conflict in the Archaeology of Living Traditions*, London: Unwin Hyman.

Hubert, J. and Fforde, C. (2005) 'The Reburial Issue in the Twenty-First Century', in Corsane, G. (ed.) *Heritage, Museums and Galleries: an introductory reader*, London/New York: Routledge.

Hunter, J. (1991) *Culture Wars: the struggle to define America*, New York: Basic Books.

Hurst Thomas, D. (2000) *Skull Wars: Kennewick Man, archaeology, and the battle of Native American identity*, New York: Basic Books.

Hurst Thomas, D. (2006) 'Finders Keepers and Deep American History: some lessons in dispute resolution', in Merryman, J. H. (ed.) *Imperialism, Art and Restitution*, Cambridge: Cambridge University Press.

Hurst Thomas, D. (2005) 'Are we Still Fighting the Skull Wars?', in Horse Capture, G., Campagne, D. and Jackson, C. C. (eds) *American Indian Nations: yesterday, today and tomorrow (Contemporary Native American Communities)*, Lanham, Maryland: AltaMira Press.

Hutton, R. (1995) 'The Roots of Modern Paganism', in Hardman, C. and Harvey, G. (eds) *Paganism Today: Wiccans, Druids, the goddess and ancient earth traditions for the twenty-first century*, London/San Franciso: Thorsons.

Hutton, R. (2001) *The Triumph of the Moon: a history of modern pagan witchcraft*, Oxford: Oxford University Press.

ICOM (2002) *Code of Ethics for Museums*. International Council of Museums. Paris; France.

ICOM (2006) *Code of Ethics for Museums*. International Council of Museums. Paris, France.

IoI (2003) *Objects to Bury or Ancestors to Study?* Debate transcript, London: Institute of Ideas. Online. Available HTTP: <http://www.instituteofideas.com/transcripts/human_remains.pdf> (accessed March 25, 2010).

Jameson, F. (1993) 'On Cultural Studies', *Social Text*, 11, 29: 17–52.

———. (ed.) (1998) *The Cultural Turn: selected writings on the postmodern 1983–1998*, London/New York: Verso Press.

Jeffries, S. (2002). 'The naked and the dead', *The Guardian*, March 19.

Jenkins, P. (1992) *Intimate Enemies: moral panics in contemporary Great Britain*, New York: Aldine De Grutyer.

Jenkins, P. (1996) *Paedophiles and Priests: anatomy of a contemporary crisis*, New York/Oxford: Oxford University Press.

Jenkins, T. (2003) 'Who Owns Human Remains?' *Open Democracy*, 3 December. Online. Available HTTP: <http://www.opendemocracy.net/democracy-apologypolitics/article_1623.jsp> (accessed March 25, 2010).

Jenkins, T. (2004) 'Human Remains: Objects to study or ancestors to bury?' *Occasional Paper*. London: Institute of Ideas.

Jenkins, T. (2009) 'British museums: the Druids are at the gates', *spiked*. Online. Available HTTP: <http:// www.spiked-online.com/index.php?/site/article/6177/> (accessed March 25, 2010).

Jones, G. (2000) *Speaking for the Dead: cadavers in biology and medicine*, Aldershot/Brookfield/Singapore/Sydney: Ashgate.

Jupp. P. C. and Howarth. G. (eds) (1997) *The Changing Face of Death: historical accounts of death and disposal*, Basingstoke: Macmillan.

Kåks, P. (1998) 'Human Remains and Material of Ritual Significance', *ICOM Special Issue*, 10–11.

Karp, I. and Lavine, D. (eds) (1991) *Exhibiting Cultures: the poetics and politics of museum display*, Washington DC: Smithsonian Institution Press.

Karp, I., Kreamer, C. M. and Lavine, S. D. (eds) (1992) *Museums and Communities: the politics of public culture*, Washington DC/London: Smithsonian Institution Press.

Kennedy, H. (2006) 'Knowledge or humanity', *The Guardian*, March 28.

Kennedy, M. (2008) 'The great mummy cover-up', *The Guardian*, May 23.

Kilmister, H. (2003) 'Visitor Perceptions of Ancient Egyptian Human Remains in Three United Kingdom Museums', *Papers from the Institute of Archaeology*,14: 57–69.

Lasch, C. (1979) *The Culture of Narcissism: American life in an age of diminishing expectations*, New York: Warner Books.

Laster, K. and O'Malley, P. (1996) 'Sensitive New-Age Laws: the reassertion of emotionality in law', *International Journal of the Sociology of Law*, 24: 21–40.

Layton, R. (ed.) (1989) *Conflict in the Archaeology of Living Traditions*, One World Archaeology, London: Unwin Hyman.

LCMG (2006) *The Curation, Care and Use of Human Remains in Leicester City Museums Service*, Leicester: Leicester City Museums Service.

Lee, E. (2003) *Abortion, Motherhood, and Mental Health*, New York: Aldine De Gruyter.

Legget, J. A. (2000) *Restitution and Repatriation: guidelines for good practice*, London: Museums and Galleries Commission.

Levitt, S. and Hadland, L. (2006) 'Museums and Human Remains', paper presented to: *Respect for Ancient British Human Remains conference*, November 17, 2006.

Lincoln, B. (1989) *Discourse and the Construction of Society: comparative studies of myth, ritual, and classification*, New York/Oxford: Oxford University Press.

Lindee, S. M. (1998) 'The Repatriation of Atomic Bomb Victim Body Parts to Japan: natural objects and diplomacy', in Low, M. F. (ed.) *Beyond Joseph Needham: science, technology, and medicine in East and Southeast Asia*, Chicago: University of Chicago Press.

Lindfors, B. (1985) 'Courting the Hottentot Venus', *Africa*, 40: 133–148.

Lohman, J. (2006) 'Parading the Dead, Policing the Living', in Lohman, J. and Goodnow, K. (eds) *Human Remains and Museum Practice*, Paris/London: Unesco and the Museum of London.

Loseke, D. R. (2000) *Thinking about Social Problems: an introduction to constructionst perspectives*, New York: Aldine De Gruyter.

Lowthenthal, D. (1985) *The Past is a Foreign Country*, Cambridge: Cambridge University Press.

Lumley, R. (1988) *The Museum Time Machine: putting cultures on display*, London: Routledge.

Lupton, D. (2003) *Medicine as Culture: illness, disease and the body in western societies*, London/Thousand Oaks/New Delhi: Sage.

Lynn Foltyn, J. (2008) 'The Corpse in Contemporary Culture: identifying, transacting, and recoding the dead body in the twenty-first century', *Mortality*, 13, 2: 99–104.

Lyotard, J. (1984) *The Postmodern Condition: a report on knowledge*, trans. Geoff Bennington and Brian Massumi, Manchester: Manchester University Press.

MA (1993) *Museums Journal*, 93, London: Museums Association.

MA (1994) *Museums Journal*, 94, London: Museums Association.

MA (2002) *Code of Ethics for Museums*. London, Museums Association.

MA (2005) *Response to consultation on the draft code of conduct for the Care of Human Remains in Museums*, London: Museums Association.

Macdonald, H. (2006) *Human Remains: dissection and its histories*, London: Yale University Press.

Macdonald, S. (1998a) Supermarket Science? Consumers and 'The Public Understanding of Science. In Macdonald, S. (ed) *The Politics of Display: museums, science, culture*, London: Routledge. 118–138.

——. (1998b) *The Politics of Display: museums, science, culture*, London, Routledge: 1–24.

——. (2002) *Behind the Scenes at the Science Museum*, Oxford/New York: Berg.

Macdonald, S. (ed.) (2006). *A Companion to Museum Studies*, Malden, Massachusetts/Oxford/Victoria: Blackwell Publishing.

Macdonald, S. and Fyfe, G. (eds) (1996) *Theorizing Museums: representing identity and diversity in a changing world*, Oxford: Blackwell.

MacGregor, N. (2009) 'To Shape the Citizens of "that Great City, the World"', in Cuno, J. (ed.) *Whose Culture? The promise of museums and the debate over antiquities*, Princeton, New Jersey: Princeton University Press.

Maffesoli, M. (1996) *The Time of The Tribes: the decline of individualism in mass society*, London: Sage.

Malik, K. (2004) 'Analysis: who owns culture?' BBC Radio 4, July 29.

Malik, K. (2008) *Strange Fruit: why both sides are wrong in the race debate*, Oxford: Oneworld Publications.

Marcus, George E. and Michael M.J. Fischer (1986) *Anthropology as Cultural Critique: an experimental moment in the human sciences*. Chicago: University of Chicago Press.

Marontate, J. (2005) 'Museums and the Constitution of Culture', in Jacobs, M. D. and Hanrahan, N. W. (eds) *The Blackwell Companion to the Sociology of Culture*, Malden, Massachusetts/Oxford/Victoria: Blackwell Publishing.

McAdam, D. and Rucht, D. (1993) 'The Cross-National Diffusion of Movement Ideas', *Annals of the American Academy of Political and Social Science*, 528: 56–74.

McGuigan, J. (1996) *Culture and the Public Sphere*, London/New York: Routledge.

———. (1999) *Modernity and Postmodern Culture*, Buckingham/Philadelphia: Open University Press.

McKie, R. (2003) 'Scientists Fight to Save Ancestral Bone Bank', *The Observer*, September 28.

McLaughlin, M. (2008) 'Picking the Bones Out of Our Imperial Past', *The Scotsman*, July 8.

MEG (1991) *Museum Ethnographers Group Guidelines on Management of Human Remains*, Museum Ethnographers Group. (See www.museumethnographsgroup.org.uk). Accessed 7, June, 2010).

Melbourne Age (2002) 'Pioneering journey home for Truganini', *The Melbourne Age*, May 30.

Merriman, N. (1991) *Beyond the Glass Case: the past, the heritage and the public*, Leicester: Leicester University Press.

Merriman, N., Bienkowski, P. and Chapman, M. (2008) 'Voicing Contradictory Feelings', *British Archaeology*, January/February: 53.

Mihesuah, D. (ed.) (2000) *Repatriation Reader: who owns American Indian remains?* Lincoln: University of Nebraska Press.

Milner, A. and Browitt, J. (2002) *Contemporary Cultural Theory: an introduction*, London/New York: Routledge.

Mirza, M. (2005) 'The Therapeutic State: addressing the emotional needs of the citizen through the arts', *International Journal of Cultural Policy*, 11, 3: 261–273.

Mitchell, J. and Oakley, A. (1976) *The Rights and Wrongs of Women*, Harmondsworth/New York: Penguin.

Monroe, D. (1993) 'Repatriation: a new dawn', *Museums Journal*, 93, March: 29–30.

Moore, K. (2008) *Disrupting Science: social movements, American scientists, and the politics of the military, 1945–1975*, Princeton, New Jersey: Princeton University Press.

Morris, J. (2002) 'Bones of contention', *The Guardian*, July 9.

Morris, J. and Foley, R. (2002) 'Should British Museums Repatriate Human Remains?' *Science and Public Affairs*, December: 4–5.

Mugubane, Z. (2001). 'Which Bodies Matter? Feminism, poststructuralism, race, and the curious theoretical odyssey of the "Hottentot Venus"', *Gender and Society*, 15, 6: 816–834.

Mulvaney, D. J. (1991) 'Past Regained, Future Lost: the kow swamp pleistocene burials', *Antiquity* 65, 24: 12–21.

MUM (2003) *Annual Report 2002–2003*, Manchester: Manchester University Museum.

———(2007) *Policy on Human Remains*, Manchester: Manchester University Museum.

———(2008a) *Official Statement on Covering Egyptian Mummies*, Manchester: Manchester University Museum.

———(2008b) 'Egyptian Mummies: we're listening to your views', press release, Manchester: Manchester University Museum.

MoL. (2006) *Human Remains Policy*, London: Museum of London.

Nail, N. H. (1994) 'Treasured Bones', *Museums Journal*, 94, 7: 32–43.

Narain, J. (2008) 'Fury as museum bosses cover up naked Egyptian mummies to protect "sensitivities" of visitors', *Daily Mail*, May 21.

Netto, P. (2005) 'Reclaiming the Body of the "Hottentot"', *European Journal of Women's Studies*, 12, 2: 149–163.

NHM (2006a) *Natural History Museum Human Remains Advisory Panel Advice to Trustees Meeting 16th November 2006*, London: Natural History Museum.

———. (2006b) *Policy for the Care and Treatment of Human Remains*, London: Natural History Museum.

NMGW (2006) *Collection Management Policies: policy on human remains*, Cardiff: National Museum and Galleries of Wales.

NML (2006) *Policy on Human Remains*. Liverpool: National Museums Liverpool.

Nolan, J. L. (1998) *The Therapeutic State: justifying government at century's end*, New York/London: New York University Press.

Nordström, N. (2007) *De odödliga Förhistoriska individer i vetenskap och media*, Lund: Nordic Academic Press.

Olick, J. K. and Coughlin, B. (2003) 'The Politics of Regret: analytical frames' in J. Torpey (ed.) *Politics and the Past: on repairing historical injustices*, Lanham, Maryland/Oxford: Rowman & Littlefield Publishers, Inc.

Ormond Parker, L. (1997) 'A Commonwealth Repatriation Odyssey', *Aboriginal Law Bulletin*, 3, 90: 9.

OUM (2006) *Policy on Human Remains*, Oxford: Oxford University.

Owens, C. (1985) 'The Discourse of Others: feminists and postmodernism', in Foster, H. (ed.) *Postmodern Culture*, London/Sydney: Pluto Press.

Oxford Times (2007) 'Should shrunken heads stay in museum?' February 14.

Payne, S. (2004). 'Handle with Care: thoughts on the return of human bone collections', *Antiquity* 78, 300: 419–420.

Peers, L. (2004) 'Repatriation: a gain for science?' *Anthropology Today*, 20, 6: 3–4.

Peers, L. (2007) 'On the Social, the Biological and the Political', in Parkin, D. and Ulijaszek, S. (eds) *Holistic Anthropology: emergence and convergence*, New York/Oxford: Berghahn Books.

Peers, L. and Brown, A. K. (eds) (2003) *Museums and Source Communities. a Routledge reader*, London: Routledge.

Peirson Jones, J. (1993) 'Bones of Contention', *Museums Journal*, 93, 3: 24–25.

Perera, S. (1996) 'Claiming Truganini: Australian national narratives in the year of indigenous peoples', *Cultural Studies*, 10, 3: 393–412.

Pescasolido, B. A., Tuch, S. A. and Martin, J. A (2001). 'The Profession of Medicine and the Public: examining America's changing confidence in physician authority from the beginning of the "health care crisis" to the era of health care reform', *Journal of Health and Social Behaviour*, 42, 1: 1–16.

Phillips, R. B. and Johnson, E. (2003) 'Negotiating New Relationships: Canadian museums, first nations, and cultural property', in Torpey, J. (ed.) *Politics and the Past: on repairing historical injustices*, Lanham, Maryland/Boulder/New York/Oxford: Rowman & Littlefield Publishers.

Pointon, M. (1994) *Art Apart: museums in North America and Britain since 1800*, Manchester: Manchester University Press.

Porter, R. (1988) 'Death and the Doctors in Georgian England', in Houlbrooke, R. (ed.) *Death, Ritual and Bereavement*, London: Routledge.

———. (1991) 'History of the Body', in Burke, P. (ed.) *New Perspectives on Historical Writing*, Cambridge: Cambridge University Press.

———. (1999) 'The Hour of Philippe Ariès', *Mortality*, 4, 1: 83–90.

———. (2003) *Flesh in the Age of Reason*, London: Penguin.

Prior, L. (1981) *The Social Organization of Death: medical discourse and social practices in Belfast*, Basingstoke: Palgrave Macmillan.

Prior, N. (2002) *Museums and Modernity: art galleries and the making of modern culture*, Oxford: Berg.

———. (2003) 'Having One's Tate and Eating it: transformation of the museum in a hyper-modern era', in McClellan, A. (ed.) *Art and its Publics: museum studies at the millennium*, Oxford: Blackwell.

———. (2006) 'Postmodern Restructurings', in Macdonald, S. (ed.) *A Companion to Museum Studies*, London: Blackwell.

PRM. (2006) *Human Remains in the Pitt Rivers Museum*, Oxford: Pitt Rivers Museum.

Quinn, R-B. M. (1998) *Public Policy & the Arts: a comparative study of Great Britain and Ireland*, Aldershot: Ashgate Publishing.

RCM (2006) *Policy on Human Remains*, Truro: Royal Cornwall Museum.

RCS (2002) 'The Royal College of Surgeons of England Repatriation of All Australian Aboriginal Human Remains', press release, London: The Royal College of Surgeons.

Rees Leahy, H. (2008) 'Under the skin', *Museum Practice*, 43: 36–40.

Restall Orr, E. (2004) 'Honouring the Ancient Dead', *British Archaeology*, 77: 39.

———. (2006) 'Human Remains: the acknowledgement of sanctity', paper presented to *Respect for Ancient British Human Remains conference*, November 17, 2006. Manchester University Museum.

Restall Orr, E. and Bienkowski, P. (2006) 'Respectful Treatment and Reburial: a practice guide', paper presented to *Respect for Ancient British Human Remains conference*, November 17, 2006. Manchester University Museum.

Rév, I. (2005) *Retroactive Justice Prehistory of Post-Communism*, Stanford, California: Stanford University Press.

Richardson, L. (1989) 'The Acquisition, Storage and Handling of Aboriginal Skeletal Remains in Museums: an indigenous perspective', in Layton, R. (ed.) *Conflict in the Archaeology of Living Traditions*, New York/London: Routledge.

Richardson, R. (2001a) 'Respectful storage of dead patients needs to be addressed', *British Medical Journal*, 323: 7309.

———. (2001b) *Death, Dissection and the Destitute*, Chicago: University Of Chicago Press.

Riding In, J. (2000) 'Repatriation: A Pawnee's Perspective', in Mihesuah, D. (ed.) *Repatriation Reader: who owns American Indian remains?* Lincoln/London: University of Nebraska Press.

Rieff, P. (1966) *The Triumph of the Therapeutic: uses of faith after Freud*, London: Chatto and Windus.

Ross, A. (ed.) (1996) *Science Wars*. Durham/London: Duke University Press.

Ross, M. (2004) 'Interpreting the New Museology', *Museums and Society*, 2, 2: 84–103.

Royal Liverpool Children's Inquiry (2001) *The Royal Liverpool Children's Inquiry Report*, London: The Stationery Office.

Royal Society (2004) 'Scientific Value of Human Remains Must be Given Proper Recognition', press release, London: The Royal Institution.

Sawday, J. (1995) *The Body Emblazoned: dissection and the human body in renaissance culture*, London: Routledge.

Schlesinger, M. (2002) 'Loss of Faith: the sources of reduced political legitimacy for the American medical profession', *The Milbank Quarterly*, 80: 185–235.

Scottish Museums Council (2005) 'Scottish Museums Council Chairs Human Remains Working Group', press release, June 9. Edinburgh: Scottish Museums Council.

Seale, C. (1998) *Constructing Death: the sociology of dying and bereavement*, Cambridge: Cambridge University Press.

Seale, et al. (2005) 'Effect of media portrayals of removal of children's tissue on UK tumour bank', *British Medical Journal*, 331: 401–403.

Seale. C., Cavers. D. and Dixon-Woods, M. (2006) 'Commodification of Body Parts: by medicine or by media?' *Body and Society*, 12, 1: 12–25.

Searle, A. (2002) 'Getting under the skin', *The Guardian*, London, March 23.

Selwood, S. (2001) *The UK Cultural Sector*, London: Policy Studies Institute.

Sennett, R. (1980) *Authority*, London: Secker & Warbury.

Sherman, D. J. and Rogoff, I. (eds) (1994) *Museum Culture: histories, discourses, spectacles*, London: Routledge.

Shilling, C. (2003) *The Body and Social Theory*, London/Thousand Oaks/New Delhi: Sage.

Shilling, C. (2005) *The Body in Culture, Technology and Society*, London/Thousand Oaks/New Dehli: Sage.

Silverman, L. H. (2002) 'The Therapeutic Potential of Museums as Pathways to Inclusion', in Sandell, R. (ed.) *Museums, Society, Inequality*. London/New York: Routledge.

Sinclair, A. (1995) *Arts & Cultures: the history of the 50 years of the Arts Council of Great Britain*, London: Sinclair-Stevenson.

Simes, A. (1995) 'Mercian Movements: Group Transformation and Individual Choices Amongst East Midland Pagans', in Hardman, C. and Harvey, G. (eds) *Paganism Today: Wiccans, Druids, the goddess and ancient earth traditions for the twenty-first century*, London/San Francisco: Thorsons (Harper Collins).

Simpson, M. (1994) 'Burying the Past'. *Museums Journal*, 94, 7: 28–32.

——. (1996) *Making Representations: museums in the Post-Colonial Era*, London: Routledge.

——. (1997) *Museums and Repatriation: an account of contested items in museum collections in the UK, with comparative material from other countries*, London: Museums Association.

——. (2001) 'Submission to the Department of Culture Media and Sport', *Human Remains Working Group Report*, London: Department of Culture Media and Sport.

——. (2002) 'The Plundered Past: Britain's challenge for the future', in Fforde, C. Hubert, J., and Turnbull, P. (eds) *The Dead and Their Possessions: repatriation in principle, policy and practice*, London/New York: Routledge.

——. (2005) 'Repatriation as a Stimulus for Cultural Revitalization', paper presented to *The Meanings and Values of Repatriation: a multidisciplinary conference*, National Museum of Australia, July 8–10. Canberra: Centre for Cross-cultural Research, Australian National University.

———. (2006) 'Revealing and Concealing: museums, objects and the transmission of knowledge in Aboriginal Australia', in Marstine, J. (ed.) *New Museum Theory and Practice: an introduction*, Malden, Massachusetts/Oxford/Carlton: Blackwell Publishing.

———. (2007) 'Charting the Boundaries: indigenous models and parallel practices in the development of the post-museum', in S. J. Knell, MacLeod, S. and Watson, S. (eds) *Museum Revolutions: how museums change and are changed*, Leicester: University of Leicester Press.

———. (2008) 'Indigenous Heritage and Repatriation—a Stimulus for Cultural Renewal', in Gabriel, M. and Dahl, J. (eds) *Utimut: past heritage—future partnerships*, Copenhagen: International Working Group for Indigenous Affairs (IWGIA).

Sinclair, A. (1995) *Arts & Cultures. The history of the 50 years of the Arts Council of Great Britain*, London: Sinclair-Stevenson.

Sitch, B. (2007a) *Lindow Man Consultation Report*, Manchester: Manchester University Museum.

Sitch, B. (2007b) *Feedback to Lindow Man Project Participants*, Manchester: Manchester University Museum.

Sitch, B. (2009) 'Courting controversy—the Lindow Man exhibition at the Manchester Museum', *University Museums and Collections Journal*, 2: 51–54.

SM. (2001) *Guidelines on Policy for Human Remains in Surrey Museums*, Woking Surrey Museums.

SM. (2006) *Human Remains Policy*. London: Science Museum.

SMC (2003) 'Scientists Respond to Report on Collections of Human Remains', press release, Science Media Centre, London: The Royal Institution.

Smith, L. (2004a) *Archaeological Theory and the Politics of Cultural Heritage*, New York/London: Routledge.

Smith, L. (2004b) 'The Repatriation of Human Remains—problem or opportunity?'. *Antiquity*, 78: 404–413.

Southworth, E. (1994) 'A Special Concern', *Museums Journal*, 7: 23–26.

Spector, M. and Kitsuse, J. I. (1977) *Constructing Social Problems*, Menlo Park, CA/London: Cummings.

Starn, R. (2005) 'A Historian's Brief Guide to New Museum Studies', *The American Historical Review*, 110, 1: 68–98.

Starr, P. (1982) *The Social Transformation of American Medicine: the rise of a sovereign profession and the making of a vast industry*, New York: Basic Books.

Stead, I. M., Bourke and J. B. and Brothwell, D. (1986) *Lindow Man: the body in the bog*, London: The British Museum.

Stern, M. (2006) 'Dystopian Anxieties Versus Utopian Ideals: medicine from Frankenstein to The Visible Human Project and Body Worlds', *Science as Culture*, 15, 1: 61–84.

Stone, P. (2001) 'Submission to the Working Group on Human Remains by the World Archaeological Congress', *Human Remains Working Group Report Submissions*, London: Department of Culture Media and Sport.

Strang, D. and Meyer, J. W. (1993) 'Institutional Conditions for Diffusion', *Theory and Society*, 22: 487–511.

Strathern, M. (2005) *Kinship, Law and the Unexpected: relatives are always a surprise*, Cambridge: Cambridge University Press.

Stringer, C. (2003a) 'Bones of Contention: vital scientific research could be at risk if museums are forced to repatriate human remains', *The Daily Telegraph*, November 12, London.

Stringer, C. (2003b) 'Human Evolution: out of Ethiopia', *Nature Magazine*, 423: 692–695.

Synott, A. (1992) Tomb, temple, machine and self: the social construction of the body, *British Journal of Sociology*, 43, 1, 79–110.

Swain, H. (1998) 'Displaying the Ancestors', *The Archaeologist*, 33: 14–15.

Swain, H. (2002) 'The Ethics of Displaying Human Remains from British Archaeological Sites', *Public Archaeology*, 2, 2: 95–100.

TAC (2001) 'Submission to the Working Group on Human Remains'. *Human Remains Working Group Report*, London: Department for Culture, Media and Sport.

Taylor, C. (1992) *Multiculturalism and 'The Politics of Recognition'*, Princeton, NewJersey: Princeton University Press.

Thornton, R. (2002) 'Repatriation as healing the wounds of the trauma of history: cases of Native America in the United States of America', in Fforde, C. Hubert, J. and Turnbull, P. (eds) *The Dead and Their Possessions: repatriation in principle, policy and practice*, London/New York: Routledge.

Tilden Rhea, J. (1997) *Race Pride and the American Identity*, Cambridge, Massachusetts/London: Harvard University Press.

Tivy, M. (1993) 'Passing the Point of No Return', *Museums Journal*, 93, March: 25–28.

Torpey, J. (2003). 'Introduction: Politics and the Past', in Torpey, J. (ed.) *Politics and the Past: on repairing historical injustices*, Lanham, Maryland/Oxford: Rowman & Littlefield Publishers, Inc.

Torpey, J. (2006) *Making Whole What Has Been Smashed: on reparation politics*, Cambridge Massachusetts/London: Harvard University Press.

Turnbull, P. (1991). *Science, National Identity and Aboriginal Body Snatching in Nineteenth Century Australia*, London: Sir Robert Menzies Centre for Australian Studies Institute of Commonwealth Studies, University of London.

———. (1993) 'Ancestors not Specimens: reflections on the controversy over the remains of Aboriginal people in European scientific collections', *Contemporary Issues in Aboriginal and Torres Strait Islander Studies*, 4.

———. (1994) 'To What Strange Uses: the procurement and use of Aboriginal peoples' bodies in early colonial Australia', *Voices*, 4, 3: 5–20.

———. (2002) 'Indigenous Australian People, their Defence of the Dead and Native Title', in Fforde C., Hubert, J. and Turnbull, P. (eds) *The Dead and Their Possessions: repatriation in principle, policy and practice*, London/New York: Routledge.

Turner, B. S. (1996) *The Body and Society: explorations in social theory*, Oxford: Basil Blackwell.

Turner, B. S. (1995) 'Aging and Identity: some reflections on the somatization of self', in Featherstone, M., Hepworth, M., and Wernick, A. (eds) *Images of Aging*, London: Routledge.

Turner, C. (1986) 'What is lost with skeletal reburial', *Quarterly Review of Archaeology*, 7: 1.

Turner, R. C. and Scaife, R. S. (eds) (1995) *Bog Bodies: new discoveries and new perspectives*, London: British Museum Press.

Twigg, J. (2006) *The Body in Health and Social Care*, Hampshire/New York: Palgrave Macmillan.

Ubelaker, D. H. and Grant, L.G. (1989) 'Human Skeletal Remains: preservation or reburial?' *Yearbook of Physical Anthropology*, 32: 249–287.

Ucko, P. (1987) *Academic Freedom and Apartheid: the story of the world archaeological congress*, London: Duckworth.

Ucko, P. (1989) 'Introduction' in Layton R. (ed.) *Conflict in the Archaeology of Living Traditions*, London: Unwin Hyman: ix–xvii.

UCL (2007) *UCL Policy on Human Remains*, London: University College London.

UMGUK (2004) *Care of Historic Human Remains Response to the DCMS consultation on the Report of the WGHR*, Manchester University Museums Group UK.

Urry, J. (1989) 'Headhunters and Body-Snatchers', *Anthropology Today*, 5, 5: 11–13.

Vaswani, R. (2001) 'Remains of the Day', *Museums Journal*, 101, 2: 34–35.

Vaswani, R. (2003) 'Attitudes Towards Treatment and Return of Human Remains: a British perspective', paper presented to *International Congress of Anthropology Conference*, November 21–22, Athens.

Verdery, K. (1999) *The Political Lives of Dead Bodies: reburial and postsocialist change*, New York/Chichester/West Sussex: Columbia University Press.

Vergo, P. (ed.) (1989) *The New Museology*, London: Reaktion.

WAC (1990) *Vermillion Accord*, Southhampton. World Archaeological Forum.

Walker, P. (2000) 'Bioarchaeological ethics: a historical perspective on the value of human remains', in Katzenberg, M. A. and Saunders, S. R. (eds) *Biological Anthropology in the Human Skeleton*, New York: Wiley.

Wallach, A. (2003) 'Norman Rockwell at the Guggenheim', in McClellan, A. (ed.) *Art and its Publics: museum studies at the millennium*, Malden, Massachusetts/Oxford/Melbourne/Berlin: Blackwell Publishing Ltd.

Walter, T. (1993) 'British Sociology and Death', in Clark, D. (ed.) *The Sociology of Death*, Oxford: Blackwell Publishing

Walter, T. (2004) 'Body Worlds: clinical detachment and anatomical awe', *Sociology of Health and Illness*, 26, 4: 464–488.

Watson, N. and Cunningham-Burley, S. (2001) *Reframing the Body*, Basingstoke: Palgrave.

Weber, M. (1968) *Economy and Society: an outline of interpretive sociology*, New York: Bedminster Press.

Weil, S. E. (1990) *Rethinking the Museum and Other Mediations*, Washington DC/London: Smithsonian Institution Press: 57–65.

Williams, P. (2007) *Memorial Museums: the global rush to commemorate atrocities*, Oxford/New York: Berg.

Williams, R. (2001) 'Culture is Ordinary', in Higgens, J. (ed.) *The Raymond Williams Reader*, Oxford: Blackwell.

Woodhead, C. (2002) '"A Debate Which Crosses all Borders", The Repatriation of Human Remains: more than just a legal question', *Art Antiquity and Law*, 7, 4: 317–347.

Woolgar, S. (1988) *Science: the very idea*, Chichester: Ellis Horwood.

WT (2007) *Full Wellcome Trust Policy on the Care of Human Remains in Museums and Galleries*, London: Wellcome Trust.

York, M. (1995) *The Emerging Network: a sociology of the new age and neo-pagan movements*, London: Rowman and Littlefield Publishers, Inc.

York, M. (2003) *Pagan Theology Paganism as a World Religion*, New YorkLondon: New York University Press.

Young, I. M. (1990) *Justice and the Politics of Difference*, Princeton, New Jersey/Oxford: Princeton University Press.

Zimmerman, L. (1989) 'Human Bones as Symbols of Power: Aboriginal American belief systems towards bones and "grave robbing" archaeologists', in Layton, R. (ed.) *Conflict in the Archaeology of Living Traditions*, London: Unwin Hyman.

Zolberg, V. L. (1996) 'Museums as Contested Sites of Remembrance: the Enola Gay affair', in Macdonald, S. and Fyfe, G. (eds) *Theorizing Museums: representing identity and diversity in a changing world*, Blackwell Publishers/The Sociological Review: 69–82.

Index

Made in the USA
Columbia, SC
10 October 2017